How to look at Impressionism

Françoise Barbe-Gall

F

FRANCES LINCOLN LIMITED

PUBLISHERS

Introduction

.
.
.
.

A ray of sunlight, a gust of wind, an outlined figure . . . Impressionism seems to have no need to explain itself in detail. Everybody can recognise something familiar in the paintings, something they have once experienced, or simply glimpsed, an ordinary situation or a passing sensation. Falling somewhere between the complexity of ancient painting in which a basic level of information is required in order to understand the subject, and what is often perceived (whether deservedly or not is another question) as the hermetic nature of modern art, the Impressionist image, demanding as it does no prior knowledge, represents a comforting refuge for the contemporary spectator.

At first, however, the understanding of these works was far from easy: the artists encountered almost unimaginable resistance to their work. The Franco-Prussian war of 1870 had ended with a bitter defeat for France, the Paris Commune had torn the city apart, the second Empire had come to an end and the Third Republic was just beginning. Against this background it was no surprise that these young painters, with their totally new outlook on the world, caused consternation. It was felt that their independence of spirit, and freedom with both brushstrokes and subject matter did not indicate true professionalism, and consequently failed to show any degree of proper respectability. Paintings which today appear pleasant and innocent, seemed at the time of their creation to herald a gale of anarchy in a society which had no desire to see its last certainties blown to the winds.

Since then of course we have seen far worse horrors in the world, and alongside the familiarity we have developed with Impressionism perhaps we feel, too, subconsciously, a little gratitude for these comforting images of a world in which nothing, it seems, can threaten the sweetness of everyday life. This can make it difficult to appreciate just how revolutionary these paintings were and how strong their impact – to us they seem far too gentle and likeable to have ever represented any kind of threat to the established order of things.

Therefore in order to examine Impressionist painting properly one should try to reach beyond its immediate charm and ask oneself why it made such an impact. In this way we may discover something of the singular originality of this group of painters, all born around 1840, who gathered together without any set programme or theory, and went on to produce such different works of art.

4

In this book I explore the period between the 1860s and the beginning of the twentieth century, examining a selection of seminal paintings, without attempting a history of Impressionism. I aim to simply appreciate as fully as possible the exuberant use of materials and the expression of something well beyond a mere evocation of the weather or the leisure activities of townsfolk.

It has been necessary to include painters outside the Impressionist canon in order to show more clearly how radical a transformation took place. At the beginning of each chapter there is a more traditional painting, sometimes an extremely academic one, so as to remind us of what painting meant to the general public at that time.

I was sorry to have to leave out a great many artists for reasons of space. Frédéric Bazille and Johan Jongkind, to take just two examples, were certainly important painters. But the former died young, at the start of the war of 1870, and therefore played no part in the early days of the group that gathered around Nadar. And I chose Eugène Boudin rather than Jongkind, even though the two had worked together in Normandy, because Boudin was the true mentor to the young Claude Monet.

Only the early Impressionists appear in these pages, with two important exceptions: Édouard Manet, who avoided them at first but later drew closer and who was one of the most innovative artists of the time, and Mary Cassatt, who came later, under the influence of Edgar Degas. The final part of the book concerns the legacy of the Impressionist movement, crucial to the beginnings of modern art. Each commentary on a painting is followed by connecting themes, which sometimes include extracts from the writings of contemporary critics and authors, there simply to help the reader in his or her personal exploration of the images.

.
.
.
.
.
.
.

Contents

Prologue . **Early morning**
Claude Monet, *Impression, Sunrise*. 11

chapter 1 . page 14

Getting out of the house

.

□
A change of mood
Charles Gleyre, *Lost Illusions* or *Evening*
18

●
Fresh air
Eugène Boudin, *Vacationers on the
Beach at Trouville*
20

●●
Watching time go by
Claude Monet, *Women in the Garden*
28

●●●
Flirting with the sun
Pierre-Auguste Renoir, *Bathing in the
Seine* or *La Grenouillère*
34

●●●●
Strolling around town
Gustave Caillebotte, *Le Pont de l'Europe
(The Bridge of Europe)*
42

●●●●●
Wearing clogs
Camille Pissarro, *Hoarfrost*
50

●●●●●●
Waiting for evening
Jean-Baptiste Armand Guillaumin,
Sunset at Ivry
58

chapter 2 . page 64

Seizing the moment

.

□
Fixing a memory
Pascal-Adolphe-Jean Dagnan-Bouveret,
The Wedding Photograph
68

●
A sideways glance
Mary Cassat, *Young Mother Sewing*
70

●●
Hearing a distant sound
Claude Monet, *A Train in the Countryside*
78

●●●
Just in time
Edgar Degas, *The Racecourse, Amateur
Jockeys near a Carriage*
84

●●●●
Choosing happiness
Pierre-Auguste Renoir, *The Luncheon of
the Boating Party*
92

●●●●●
Daring to be bold
Edgar Degas, *After the Bath, Woman
Drying Her Neck*
100

●●●●●●
Uniting the present
Paul Cézanne, *Still Life with Plaster Cast*
108

chapter 3 . page 116

Seduced by appearances

.

□
Finding another truth
Jules Lefebvre, *La Vérité*
120

●
In love with youth
Pierre-Auguste Renoir,
Study. Torso, the Effect of Sunlight
122

●●
Forgetting decorum
Edgar Degas, *In a Café* or *The Absinthe
Drinker*
128

●●●
Neglecting the machine
Claude Monet, *Gare Saint-Lazare*
134

●●●●
No need for a path
Camille Pissarro, *The Red Roofs,
Corner of a Village, Winter*
142

●●●●●
Absorbing sensation
Alfred Sisley, *Snow at Louveciennes*
148

●●●●●●
Burned by the limelight
Edgar Degas, *La Chanteuse de café
(Café Singer* or *Singer with a Glove)*
154

chapter 4 . page 160

Simplifying painting
.

Abandoning the stories
Thomas Couture,
The Romans of the Decadence
164

Opting for discretion
Berthe Morisot, *The Cradle*
166

Being there
Édouard Manet, *Bar at the Folies-Bergère*
174

Renouncing drama
Alfred Sisley, *The Flood at Port-Marly*
182

Getting into a rhythm
Gustave Caillebotte, *The Floor Planers*
190

Allowing a shortcut
Edgar Degas, *The Millinery Shop*
198

Sticking to a theme
Claude Monet, *Haystacks, End of Summer, Giverny (Les Meules, fin de l'été à Giverny)*
206

chapter 5 . page 212

Immersing yourself in nature
.

The end of boudoir painting
Alexandre Cabanel, *The Birth of Venus*
216

Drunk with colour
Pierre-Auguste Renoir,
The Path through the Long Grass
218

Painting the wind
Claude Monet, *Woman with a Parasol turned to the Right*
226

Caressing the light
Edgar Degas, *Group of Dancers*
232

Building a home
Paul Cézanne, *Mont Sainte-Victoire*
240

Giving shape to time
Claude Monet, *Waterlillies, Morning with Weeping Willows*
248

Starting again
Paul Cézanne, *Bathers (Les Grandes Baigneuses)*
256

chapter 6 . page 264

The heirs of Impressionism
.

Taking things into account
Alfred Roll,
Portrait of Adolphe Alphand
268

Avoiding chance
Georges Seurat, *A Sunday Afternoon on the Island of La Grande Jatte*
270

Away from there
Paul Gauguin, *The White Horse*
278

Being strident
Vincent Van Gogh, *The Starry Night*
284

Sharpening the line
Henri de Toulouse-Lautrec,
The Salon at the rue des Moulins
292

Wanting to be dazzled
Pierre Bonnard, *The Omnibus*
298

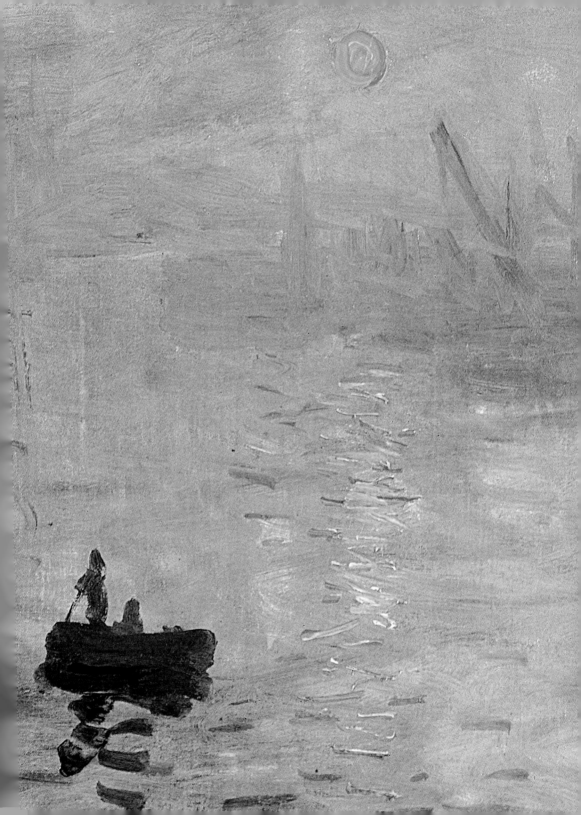

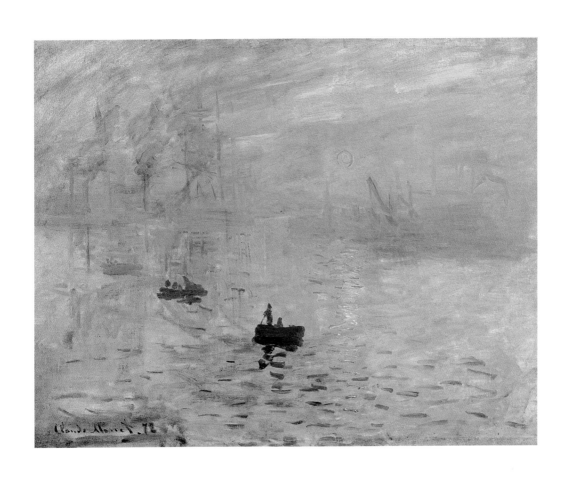

Early morning

Claude Monet (1840–1926)
Impression, Sunrise, 1872
Oil on canvas, 48 × 63 cm
Musée Marmottan, Paris

You are there at dawn, today and every day to come. You are absorbed into this space which gradually becomes lighter as the mist evaporates. You are alone in the midst of the hazy colours, your mind empty of thought but watching all the time, guessing at shapes that slowly appear and then melt away almost immediately. You are not really expecting anything to happen. You just tell yourself that the world is recreating itself by the minute, and that recording that process could fill an artist's entire life.

A bright orange disc drowning in the blue background: the morning sun is reflected in the water, dropping shavings of light, little sticks of colour which quiver and split into a zigzag of rough brushstrokes. The artist didn't know what he was going to find, he just had to improvise on the spot, not following an obvious direction, throwing in a bit more colour, making use of chance, working with it. A boat sits still at the centre of the canvas, just a dab of paint, but identifiable; further back there's another one, which would be nothing without the first; then a third, almost indecipherable. Perhaps later, when the day has matured a little, there will be more. But Monet won't wait until then – the freshness of this moment is sufficient.

The paintbrush relentlessly captures the light, and the rosy heat spreads through the sky with rough strokes. He works fast to catch the right note, without delays or conventional preparations. He avoids precision, and is

careful to note his own thoughts and preconceptions: these great oblique masts and the curved shape of the port are still almost invisible at this time of day, so he must not add anything to make it more real, he must not return to it. It's finished. The moment has passed, and the canvas is there, bathed in colour.

You can see the blurred shapes of those boats over there, the smoke rising between two blue lines, hints of matter which could be put to some new use, a few brief scribbles on a pad, the precise light of that developing morning. But for the passer-by this is no more than raw material, enough to act as a starting point for a conventionally composed scene. There are details to be refined, to be placed in the backgrounds and corners of some more elaborate composition. There is nothing here to excite the envy of a painter in search of a subject. Monet is on his own – no-one is going to steal this view from him.

People who see nothing here are right, because they are looking for something they have already seen in other pictures. And they will search in vain. The artist goes straight from fumbling gestures to a slap in the face. The drawing is cursory, the forms elusive. The image does not lend itself to any discussion, but it evades criticism by basing itself on a single glance, with all that that entails – poverty of expression, doubts, limitations, but also surprises and intimate delights. Just a single glance? So what are other artists trying to achieve, with all that they know, all that they have learned? How can people agree about a painting if everyone just records their own private impression, taking no notice of the rules of art? What are we to think if there are no criteria left with which to judge what is beautiful, what departs from the principles, what is ugly, or what is just mediocre? What are we to do when anyone who comes along can decide to make a picture out of a passing sensation, a mere fancy?

Everything would have to start again from scratch, because Monet was refusing to keep the world under control, refusing to stay within neat lines and controlled colours. His canvas does not attempt to convey a speech or a lesson, or anything that could be found in a book or on a stage. There is nothing there to understand. All reasoning disintegrates in the face of the simple sweetness of the moment. It is only one second in a lifetime, but it's a magical second that will never be forgotten – that morning long ago, when he saw the fresh wildness of the dawn light, that morning of his youth when he happened to have gone out earlier than usual. That morning . . .

The birth of Impressionism

In 1874 thirty painters, organised by Monet and Pissarro, held an exhibition in Paris on the fringe of the official Salon in premises lent by the photographer Nadar at 35 boulevard des Capucines. Grouped into a 'limited company' of painters, engravers and sculptors, they included Eugène Boudin, Paul Cézanne, Edgar Degas, Armand Guillaumin, Claude Monet, Berthe Morisot, Camille Pissarro, Pierre-Auguste Renoir and Alfred Sisley. There were 165 canvases in the exhibition. This new initiative by artists determined not to submit to academic rules represented a key moment in the history of Western art. Monet exhibited, alongside six other paintings, *Impression, Sunrise*, which provoked this derisive comment from Louis Leroy, the art critic for Le Charivari: 'Impression [. . .] yes I was sure of it. I told myself that since I was impressed, there must be an impression somewhere in there [. . .] and what freedom there is, how easy it is to make! Wallpaper in its embryonic state is more finished than that painting.' Gustave Geffroy, a novelist and journalist, would, on the other hand, become one of the most fervent admirers of this group of artists, 'first called "Impressionnalists" and then "Impressionists". They had every bit as much wit as the critics and gossip columnists, and they accepted the joke, the word, and the banner. And a new school of painting was founded.'

The importance of the sketch

Already, by the middle of the eighteenth century, Denis Diderot, the first great art critic, had begun to expound on the importance of the sketch in various articles written to coincide with the 1765 Salon exhibition: 'Sketches have in common a flame that the painting does not possess. It is the moment of heat for the artist, of pure energy, with none of the adornments that reflection adds to everything; the very soul of the painter is expressed on the canvas. [. . .] In a painting I see something enunciated: in a sketch I guess at things that are hardly even expressed!' He even compared the sketch to a kind of incomplete syntax, a concept which applied perfectly to the language of the Impressionists a century later: 'When he is in the throes of violent passion, a man will drop connecting words, he will start a sentence without finishing it, he will let a word escape, give a cry, fall silent. And yet I will have heard and understood everything. It is the sketch of a speech. Passion produces only sketches. What can a poet do when he has completed everything? He can only turn his back on nature.' He continued: 'Why does a beautiful sketch please us more than a beautiful painting? Because it contains more life and less form. As soon as form is introduced, life disappears.'

Unfinished work

For most of the 1874 public Monet's painting was no more than a sketch. And although sketches could be admired if presented as such, thanks to the influence of Diderot and a lingering attachment to Romanticism, there was still very little tolerance for sketches passing themselves off as paintings – they were seen to be evidence of flawed technique combined with dishonest intention. There was nothing new about this particular attitude. In the middle of the sixteenth century, Pietro Aretino, the Italian author, playwright, poet and satirist, was already complaining that Titian had painted his portrait far too rapidly: 'If he had been given more florins, the materials would certainly have been brighter, softer and thicker, more faithfully portraying satin, velvet and brocade.' In the nineteenth century the idea of a mere 'impression' automatically held a lesser value, as it was seen more as evidence of the disappearance of important skills rather than of a desire for sincerity. Even more than this, the Impressionist painting, by diminishing the importance of visible shapes and putting the emphasis on the rapid and passing glance, was perceived as an example of culpable wastefulness and extravagance.

Getting out of the house

The studio would no longer suffice for the work they were planning to do. The young artists felt suffocated by the chocolate brown and olive green walls of traditionally decorated studios that we see everywhere in academic paintings forming colourless decors and atonal backgrounds to portraits. There they had learned the elements of sound technique, of drawing and composition, from masters who taught them in good faith and tried to channel their enthusiasm. But the conventional elegance of the models and the icy distinction of the subjects had failed to convince them of the value of such teaching. They wanted something more; above all they wanted to interpret the world outside the studio, something that did not seem to them in any way to contradict the aims of great art. Modern life was full of unexplored subjects – all they needed to do was to find them, taking along their boxes filled with new-fangled tubes of paint. Their desire to see everything took them not to a faraway land of the imagination, but rather to their own doorsteps, to the bottom of their gardens, to the streets. They were not searching for traditional subject matter – anything exceptional or exemplary – for these artists everything around them would henceforth be considered important material.

The Impressionists were not the first to work *en plein air*. A few painters of the preceding generation had approached nature in this simple manner, without preconceptions, gradually separating landscape painting from its historical and literary trappings. Painters from the Barbizon school, such as Théodore Rousseau and Charles-François Daubigny, would place their easel in front of a clump of trees or on a boat. Jean-Baptiste-Camille Corot, who painted from the point of view of a wanderer, reacting to the slightest change in the light, or Gustave Courbet, who had grappled with the familiar and the real, had produced a flood of original subject matter. And Eugène Boudin too, who would have been quite happy to use the sky as his only subject. Each in their own way had helped to establish a foundation for a new vision of life.

What changed irreversibly, overthrowing everything, was that the clear bright light into which they travelled would now invade the paintings themselves, with such energy and clarity, and such truth, that the movement could no longer be stopped.

A change of mood

Charles Gleyre (1806-74), *Lost Illusions* or *Evening*, 1843
Oil on canvas, 156 × 238 cm, Musée du Louvre, Paris

Evening has come, and all that remains are sad memories of what has gone forever: unsatisfied desires, betrayals in love, dreams of glory or riches, unkept promises – all setting sail, away from the shore, carrying with them the fleeting youth of a stricken man. He has reached a final moment of exhaustion and defeat. Night can now fall, all hope is gone. The work of Charles Gleyre, who would later become the teacher of Monet, Renoir and Bazille, admirably fulfils all that was expected from a painting in the middle of the nineteenth century. His scrupulous draughtsmanship follows a tradition which stretches right back to the Renaissance and the noble variety of the poses would satisfy the most demanding of tastes.

This painting can be read like a poem – a poem that has been carefully composed and written in the peace and quiet of the studio. It seems to spring from a kind of waking dream, describing a scene that nobody has eve[r] observed, both tragic and grandiose and, above all, filled with a sense of the ideal. For art to fulfil its purpose it had to distance itself from any suggestion of triviality. The spectator is absorbed into the melancholic nature of the subject, but also raised to a totally unfamiliar level of experience. With the help of careful back-lighting, the owner of the painting, in the peace and silence of their drawing room, will be able to allow their thoughts to drift along with the pace of the allegory, and meditate in tranquillity whilst admiring the virtuosity of the artist.

Fresh air

Eugène Boudin (1824–98)
Vacationers on the Beach at Trouville, 1865
Oil on canvas, 104 × 67 cm
Institute of Arts, Minneapolis

.
.
.
.
.

The sky is brightening. The canvas is laid open by a surge of whitening clouds. All the artist had to do was stand back and wait, poised in front of his easel. The crowds are gathering. Most of the regular visitors are already there, others continue to arrive, meeting up with acquaintances, breathing in the healthy sea air. Without realising it, they are in the process of forming a colourful rampart for the painter, a kind of moving, multi-coloured frieze which dissolves every evening to be re-formed the next morning, like a child's sandcastle.

Once they are settled in their chosen positions the cautious city-dwelling amblers don't move around very much. From time to time one of them gets up and takes a few steps; one figure wanders off and disappears in the remaining mist. Children run around, never very far away. An elongated black dog, his nose stretched forwards, wonders whether to approach some newcomers – another dog has just entered the picture. On the other side of the painting the eye is drawn towards a light-coloured dress, brighter than all the others. Against the background of the tiny lapping waves, conversations between people reflect the simplicity of the moment, remaining light and low key. Their thoughts wander about, absorbed by the surroundings. Sometimes a gust of wind interrupts a conversation. Those involved pause patiently, holding their veils a little tighter, and then conversation resumes, perhaps on another subject – the previous one was leading nowhere. Ideas occur and then fade away. News from Paris perhaps. A chair leg suddenly sinks into the sand, causing a little merriment. Nothing serious, but it's a little bit of excitement all the same – someone might have

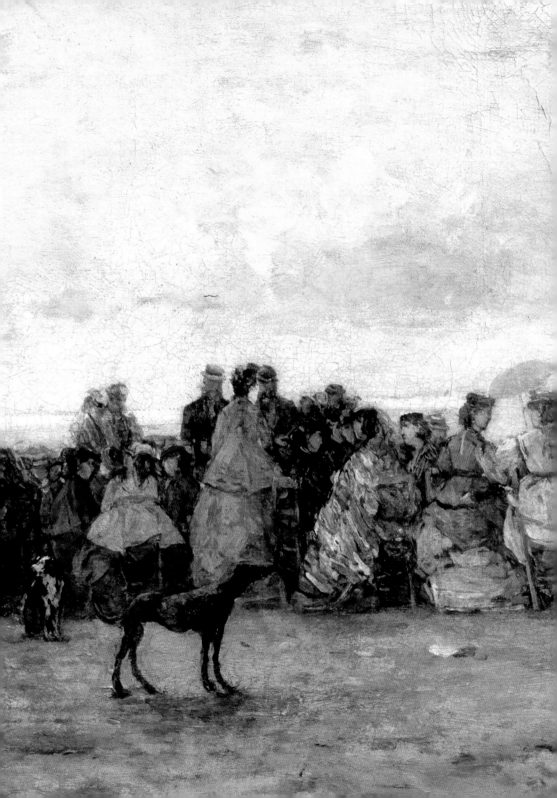

Seaside fashion

During the last part of the eighteenth century taking the air and visiting the seaside, at first used for entirely therapeutic purposes, had become popular in England. Then Parisian aristocrats, following the fashion for anything English, literally invented French beaches. 'Society's elites are made anxious by their artificial desires, their listlessness, their neuroses. They are unable to participate in the rhythms of nature owing to the fevers and passions common to their sort. [...] Nowadays it is thought that the sea will calm their anxiety, re-establish some harmony between body and soul, and restore the vital energy that seemed to be diminishing, particularly amongst their children, daughters, wives and their intellectuals. It is expected that the sea will remedy the ill effects of urban civilisation, and correct the ill effects of too much comfort, whilst always respecting the demands of privacy.' (Alain Corbin, *The Lure of the Sea: The Discovery of the Seaside, 1750-1840*) As a young child Napoleon III bathed at Dieppe. His wife, the Empress Eugénie, made Biarritz fashionable (they were married there in 1853) whilst the Duc de Morny launched the town of Deauville in the 1860s. Trouville, visited during the 1820s by painters such as Charles Mozin, Paul Huet, Eugène Isabey and Xavier Leprince, became very fashionable around 1830, and in 1860 was declared 'the queen of beaches'.

Boudin and Monet

Boudin was a cabin boy on his father's boat, a steamship that operated between Honfleur and Le Havre. He then became a clerk for a printer in Le Havre and later opened a framing shop there. He began to paint, encouraged by artists passing through who sometimes exhibited their paintings with him. He would in turn become a mentor to a very young Monet, who came to show him his caricatures. He urged him to work out of doors and to try to capture changes in the light. He would say later of his own marine landscapes that they seemed to him 'of very little merit when set against the great talents of the present day. If I do not deserve to be considered alongside them, I may perhaps have played a very small part in influencing the movement which took painting outside towards the study of light, open air and the singularity of the effects produced by the sky. If several of those whom I had the honour of pointing in that direction, such as Claude Monet, have then been taken further by their personal temperament and talent, they may yet feel some slight gratitude towards me, such as I have felt myself towards those who advised me and showed me examples to follow.' Indeed, Monet was later to say: 'If I became a painter, it was thanks to Boudin.'

The need for figures

The presence of figures was more a response to the public taste for anecdotal painting than a necessity for Boudin, who was above all interested in atmospheric variety. He may well have noted the wise comments of the poet Baudelaire, who had greatly admired the studies of sea and sky that he had seen in Boudin's studio: 'He knows well that his painting is the product of a poetic impression recollected at will; and he is not pretentious enough to give us notes to explain it. Later on there is no doubt that he will be able to display in his finished works the extraordinary magical effects of air and water.' Although Baudelaire himself did not regret the absence of figures, he did not advise it for Boudin: 'If he wishes to gain a little popularity, he must not assume that the public shares an equal enthusiasm for solitude.'

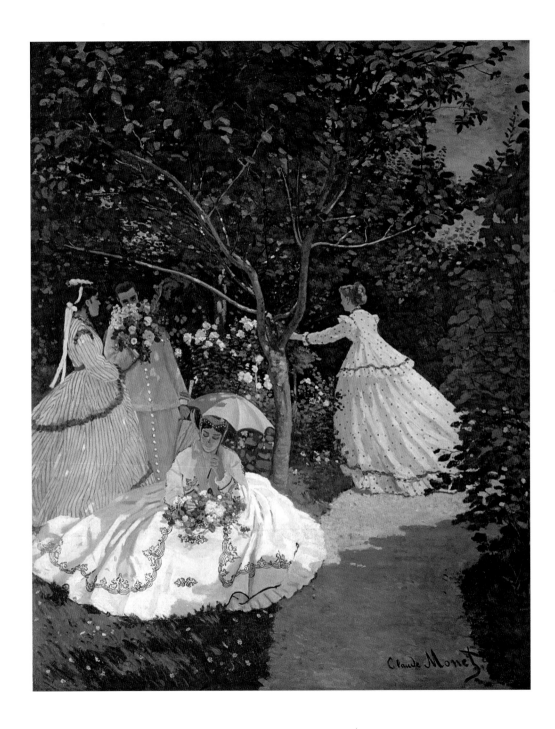

Watching time go by

Claude Monet (1840–1926)
Women in the Garden, 1867
Oil on canvas, 255 × 205 cm
Musée d'Orsay, Paris

The young women have, quite naturally, sought the comfort of the shade.
One of them, sitting on the grass, is arranging some flowers on her lap. Her
dress spreads out in a large circle at the edge of the path. Two of her
companions are chatting beneath the leafy branches which filter the rays of
the sun, whilst a third walks around some bushes, away towards the back of
the picture, perhaps to the end of the garden. It is a sparkling day, one spring
morning amongst many others. In the heat beneath the pale parasol, the
light fades to a soft grey.

Each separate figure represents a variation in attitude and position. Faces are
concealed and there are no visible details in the expressions. They are
represented more as feminine presences than actual women, and any
individuality of feature is subsumed into the general rhythm of the painting.
One might, looking at this scene, imagine oneself at the beginning of a story or
a play: the backdrop has been well prepared, and these attractive figures are
about to embark upon some intrigue which will reveal their identity, or at least
what has brought them into this garden. Unless, of course, we are witnessing
an interval between more exciting episodes. In which case the place itself
would assume its true importance – perhaps some significant development
will occur which could lead us to something else. But what exactly? Nobody
does anything. Nothing gets decided. And in the end it appears that nothing
will actually happen, not even the most minor of incidents. Since the painting

has no anecdotal existence, one can search in vain for any indications of emotion or feelings. Monet is using the models without any romantic purpose – they are simply anonymous elements in a supple and mobile composition. It is the women's dresses rather than their personalities which bring substance – flesh, even – to the painting. One of the young women hides behind a bunch of flowers, without bothering to strike any pose. Her gesture is too real for the painter to ignore. She introduces a new element to the image – the idea of perfume, or, better still, a longing for perfume.

The sky is hardly visible through the gaps between the leaves, and it is the dresses which provide all the light in the picture. The pale green, pink and ochre of the materials, their spotted and striped patterns, the dark edging of the parasol – all emphasise the brightness of the scene through carefully contrived contrasts. And the entire space is articulated by the soft curves of skirts and bodices, the curves themselves emphasised by motifs of black lace or darker embroidered edges.

In the foreground, at the entrance to the picture, the shade cast by the trees adds a level of complication to the arrangement of the subjects. It slices the path in two: a bluish grey shadow cuts into the beautiful circle formed by the white dress, melting further into the folds of the material. In the past this chiaroscuro, an effect which took a long time to master, was used to illustrate volume and show their precise gradations. Great artists had all, in their time, mastered the technique. But now Monet, outside the studio, had discovered that the division between light and shade, far from coinciding with the actual shape of things, in fact just superimposed its own patterns on the object. Wrapped up in history, sheltered by the traditions of fine art, all painters had needed to do was to establish shapes, contours and settings – after that they were masters of their domain. But from now on they would be assailed by all the contradictions and the anarchy of the outside world.

The young women, bathed in a light that picks up colour as it passes through the leaves or the material of the parasol, are living through this new experience. A slightly green shade on the hidden profile of one face, a vaguely mauve kind of grey on another: these young ladies have lost their healthy glow, and those perfect flesh-tints that painters were always so fond of belong in the past.

We may seem to be making a lot of what appears to be just a few reflections and a stray shadow. But for the artist's contemporaries, this painting is playing a double game, plunging the viewer into an unexpected state of uncertainty. The way the dress falls, the exact tonality of the skin – how are you supposed to judge

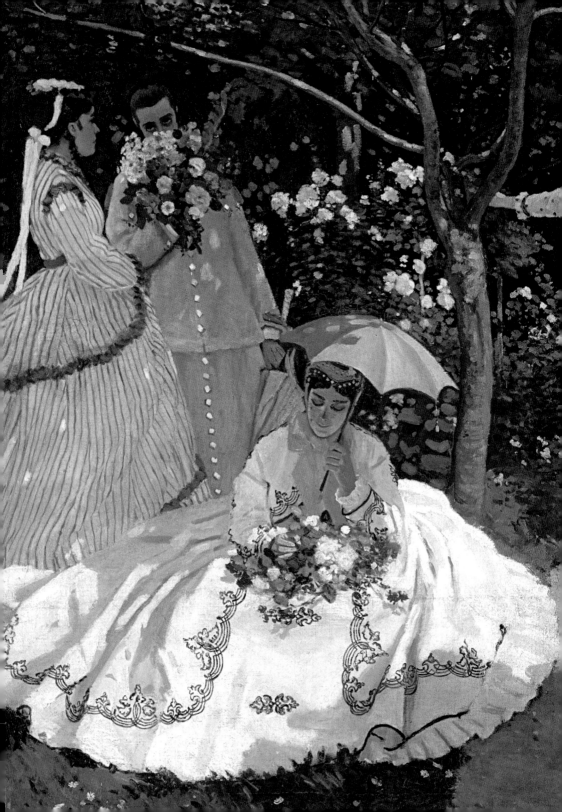

these things? What could you learn from looking at a painting like this? No doubt you would have to agree that in reality it would all depend on the place, the light and the time of day. But does an artist have to capture that? Surely a painting should be selective when dealing with the disorder of nature? Does art no longer have a responsibility to select what deserves to endure, and to place emphasis on the permanent and the essential? It seems that you can no longer trust in those principles. And the day had begun so well: a big picture through which the spirit could wander, agreeable company, a welcoming garden. That importunate shadow besmirching the bottom of the canvas reminds you of the great versatility of nature.

Monet willingly embraced the conditions that came with working in the open air, and all the difficulties it could entail, but he did not for all that abandon himself to spontaneity. What at first appears to be a simple, fresh and delightful scene is in fact built upon a structured framework. Gradually, the solid foundation and the consistency of the motifs are revealed: the voluminous skirts which flare out around the tree are a symmetrical reflection of the mass of greenery which occupies the upper part of the canvas; they reflect too, on a larger scale, the shape of the open parasol and the sleeve. The tree at the centre is an important reference point: everything in the picture, the women, the shadow and the light, the arrangement of the dresses and the mass of leaves painted in rapid thick brushstrokes – everything revolves around that thin trunk, which you might not have noticed initially, when the eye was seduced by the radiant brightness of the moment.

The painting is ordered by a unique circular movement, which draws the viewer's eye firmly around a peaceful path. We thus become absorbed by the idea of the circularity of time. We might then, like the Ancients, watch the movement of the shadows without anxiety. We might, at the corner of this very ordinary path, pick up the echoes of colours that shimmer between the leaves on a tree, watch them fade away, no longer feeling that this is the end of life. Because, like modern-day Graces whose silhouettes meet and part in a carefree and constantly renewed world, these young women in this garden are marking time and watching it pass by. The space depicted by Monet in this garden, like the space occupied by a sundial, suggests that nothing ever really disappears, and that these patches of light scattered here and there, reflected from flower to flower, will not collapse in the suffocating heat of the day, but will come back again – later, and in this very same place.

A direct link with nature

From 1862 until 1864, Monet studied painting in the studio which Charles Gleyre had been running since 1843. He was attached, in his own work, to the tradition of great classical subjects and the formal rules of antiquity, and did not share his young pupils' interest in the immediate reality of nature. Also working in his studio were Bazille, Renoir and Sisley. It appears that Gleyre, who was a shy, humble man, a dreamer, a true idealist and extremely generous, was never at all didactic towards them. Many years later, Monet would however give an example of their differences in outlook: he quoted Gleyre as saying 'dryly', 'whenever you embark on something you must think about Antiquity . . . That very evening I took Sisley, Renoir and Bazille aside and said "we must leave this place. It is unhealthy: there is a lack of sincerity". We left after fifteen days of such lessons.' The truth was that Charles Gleyre was forced to close his studio in 1864 because of his failing eyesight, thus 'liberating' his last generation of pupils. Monet would henceforth devote himself to working out of doors.

The lost integrity of form and colour

One of the advantages of traditional studio-based painting was that all the figures in a picture were sheltered from reflections and changes in the light. All the treatises and art manuals were filled with remarks on the subject, Louis Delaistre noting for example, 'that it is advisable to arrange around the model objects whose colours reflect advantageously, or preferably not at all, since all reflection is deceptive and tends to affect the principal colour. In the end talent consists in arranging a background which increases the brilliance of the subject by the attenuation of its own tones.' Monet and his group were resolutely opposed to such theories, and he would always paint in the true light of his garden at Ville-d'Avray. Also, by allowing shadows to cut through his models' dresses, he abandoned all notions of the integrity of form, previously re-garded as indispensable, both in reality and in art. Charles Blanc wrote: 'Unity of form can be found triumphant in women's clothing, as it can be made lighter with an overlaid drawing in the same colour, or by some sober variation of tone, or by the work of the weaver who can pass the material through a roller and print a moiré effect, thereby introducing rivers of light, and so bringing in variation in pattern without any new drawing or colour.'

A large painting

The large size of *Women in the Garden* is unusual in the work of the outdoor painters. Its size can be explained by Monet's desire to exhibit at the official Salon: the paintings there were hung on lines, close together, and only the very large ones were really visible. Monet, never balking at any kind of discomfort, 'had had a trench dug amongst his flower-beds, and used a pulley to manoeuvre the canvas, so as to be able to paint the top half.' (Gustave Geffroy, *La vie artistique*) The painting, which was refused by the Salon in 1867, was acquired by the state in 1921. Most Impressionist paintings were much smaller, and therefore easier to transport, and more accessible to willing buyers.

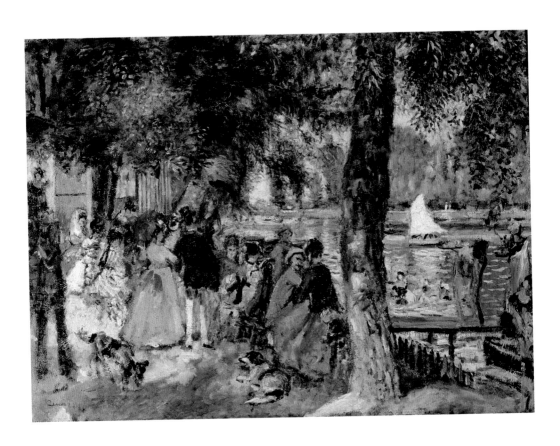

Flirting with the sun

Pierre-Auguste Renoir (1841–1919)
Bathing in the Seine or *La Grenouillère*, 1869
Oil on canvas, 59 × 80 cm
Pushkin Museum, Moscow

When you see the lightness of touch with which this picture deals with its subject matter, it seems as though painting has now completely left behind anything to do with salons and academies. You have to blink your eyes and look at it several times in order to identify any particular detail within the image. Anyway, you don't feel it is really necessary to do so anymore.

They have all arrived together and it is easy to recognise the others from afar by the way they are standing or approaching one another, by the tilt of a top hat, by the fact that they are there again despite the uncertain weather, on yet another Sunday. Renoir, with just two brushstrokes, ties a red sash on to a dress to emphasise a slender waist. Another dark ribbon adorns a small hat. The sunlight drifts along the embankment and slips between the walkers. A patch of deep sea blue has landed on a parasol – light breaks through so quickly here.

They are not all friends; some are just people who happen to bump into one another, week after week, and with whom they spend a few hours on a Sunday, relaxing on the banks of the Seine. Most of their names would mean little to anybody. For some time now, La Grenouillère has been a fashionable place to visit, and everybody rushes to get there as soon as the weather is fine. The railway has changed everything. Even the Emperor himself has heard of the place, and has come there with his family, and so given his seal of approval in the eyes of the world. That will certainly bring in the crowds. Not that any of these people care much about that – the sun will go on shining whoever comes.

Paris is close by, but seems unreal through this mist of colour hovering on the surface of the water. The artist has spread a light translucent scumble over the whole canvas, without highlighting any of the contours. In any case they would have been artificial, or recreated, which for him equates to the same thing. The fact is, everything is in motion here: the air, the people, the heat pulsating between the trees, the rustling dresses, even the dogs playing. The relaxed happiness of this day out cannot be confined within hard lines – they would stifle every breath of air and would convey an image that would be far too cautious and orderly and rigidly formal.

Renoir is of course observing the scene from a distance. But his great strength is that his painting is not in the least detached. What he shows us here, these hazy fluttering colours and shapes, does not just stem from a desire to re-create a certain atmosphere and to produce a seductive image – these are the actual sensations, this his own edgy enthusiasm transposed on to the canvas with the criss-crossing rays of sunshine and the warmth and lightness of the breeze. There certainly isn't the time to set up more elaborate poses, and in this sort of context small details would escape even the closest examination. It does in fact require the greatest virtuosity to suggest the entire reality of a subject with such a minimum of actual reproduction: a white triangle over there and you have a sailing boat riding with the wind, a few rubbings of soft green and the trees are suddenly covered in leaves, one or two smudges of colour and there we have bathers venturing into the water.

The artist has placed his trust in the spectator to decipher all the allusions, which have been conveyed with perfect dexterity. The most important thing, however, is that he has invented a language which is capable of cutting short the conventional and rational vocabulary of the visible world in order to convey the sensuality of the moment as it is lived. The imprecision of the drawing cannot only be explained by the difficulties of working out of doors. It stems just as much from a desire not to freeze the passing smiles, the expressions on faces reflecting fleeting emotions, or the murmur of half-spoken remarks. He paints without any certainty: the dampness of the air, the dust on delicate shoes, a hand brushing against another – no that meant nothing – a peal of laughter.

Renoir seems to caress the painting, very gently, and perhaps in a slightly distracted manner. He seems to play with the colours which mingle together without appearing to. He is having fun, using the tips of his fingers, and in his hands this unpretentious scene is lit up by his own enjoyment and transformed, for him, into a real fête galante. La Grenouillière, in this last part of the nineteenth century, is nothing more than a place of popular

entertainment, but that is all Renoir wants – he certainly has no desire to return to Kythera or to start imagining frolicking gods and nymphs, escaped from the fables of antiquity. The island of love is no longer the poetic ideal, or even a piece of stage scenery, and the little Cupids from a previous generation's art have cheerfully evaporated into the natural background. Still something does remain of their mischievous playfulness, a sort of gentle rustling of branches that might be taken for the sound of the breeze in the trees. One could swear that, to please Renoir, Venus would gladly have left her mythical waters to join these young ladies on the banks of the Seine.

The painter was not entirely happy at leaving his studio, and in fact he brought something of it with him, in spirit at least. Despite the spontaneous nature of his subject matter he never tries to conceal his admiration for the great and venerable paintings that hang on the walls of the Louvre. One needs no literary knowledge to appreciate his painting of *La Grenouillière*, and there is no need to consult any tales of mythology or history in order to appreciate its humour and generosity of spirit. However, the simplicity of the subject does not negate its distinguished heritage. Renoir's eye, alert as it is to all this life swarming around him, and the novelty of these situations and settings, is also fed by the works of earlier artists like Jean-Antoine Watteau. He builds a network of connections between what he sees here and now and what he has assimilated in those long hours spent in the Louvre. What he has learned from the great masters does have an effect on what at first appears to be a spontaneously direct perception of nature. It is not a question of memories and quotations from the masters – they are quite simply a part of him. That is why this particular scene, as contemporary and directly accessible as it appears, does also carry with it some of the delightful elegance, grace and freedom of spirit of the art of the eighteenth century.

It is today in this picture, and yesterday as well. Renoir's vision of the present is always enriched by a consciousness of the past. His work combines immediacy and memory; he loves the present moment but cannot deny the past. The couples in the painting come together and draw apart with one small stroke of paint. Renoir, who had such respect for the great paintings of past centuries, seems not to dare to imagine that *La Grenouillère* might truly become one of them. At first he does not exhibit it, or even sign it. It would take another thirty years for this beautiful Sunday scene to become an official work of art, and for the artist himself to feel liberated from the past.

La Grenouillère

La Grenouillère was a fashionable café and bathing spot on the banks of the island of Croissy, near Bougival, painted by both Renoir and Monet. We have a detailed description of the place from a journalist on *L'Evènement Illustré* who wrote in 1868: 'La Grenouillère is the Trouville of the banks of the Seine, a popular rendezvous for noisy, elegant Parisians leaving town for the summer and settling in Croissy, Chatou or Bougival. A wooden shack painted in green and white has been built on an old well-tarred barge, firmly moored to the side. You reach the floating house over a series of very picturesque but extremely primitive bridges; one starts on the island and is propped up by a tiny island only about ten meters long, in the midst of which is a single tree, which appears most surprised to be there at all. And this island is crammed with a mass of curious people keen to gape at humankind reduced to its most basic expression.' Renoir found Maupassant's 1881 description of it in *La Femme de Paul* much exaggerated (a place 'which sweats stupidity, stinks of vulgarity and the squalor of the bazaar'). According to Renoir: 'We knew how to laugh in those days! [. . .] we had time to enjoy life, and we didn't criticise each other for that.'

The futility of the shimmering light

The art-lover of the 1860s was either seduced or disconcerted by the changes produced on materials by the play of light on cloth. They would discover, with surprise, a depiction of indistinct shapes, as well as a conception of colour itself, which contravened all the rules they were used to. The problem then progressed from criticism of the image to a moral judgement, as the two were often connected: the indeterminate nature of the colours was seen as an absence of principle, and the freedom in the use of light was taken as a sign of frivolity. The art critic Edmond Duranty, in his naturalist novel *Le Malheur Henriette Gérard*, which appeared in 1860, was able to suggest the futility of a woman's character by describing the shimmering effect produced by her dress: 'Henriette was annoyed by Madame Baudouin's dress, whose pigeon-gray colour changed disagreeably with her every movement. She felt like saying to her: "Take that off, and I'll be able to hear you better!"'

Memories of Watteau

La Grenouillère can to a great extent be seen as an updated transposition of the world of Watteau. For the young Renoir this was a natural progression: he had very early on absorbed that tradition and brought it back to life through his observation of his contemporaries. The story of his early days in a porcelain factory in the Marais between 1854 and 1858, demonstrates how important these eighteenth-century images were to him: 'At the age of thirteen I had to earn my living. My job was to scatter little bunches of flowers on to a white background, for which I was paid five sous per dozen. [. . .] When I became a little more sure of myself, I gave up the little bouquets and launched myself into the human figure, still paid at a starvation rate: I remember that I would get eight sous for a profile of Marie-Antoinette. [. . .] In my lunch hour, my recreation was to run to the Louvre to practise drawing from classical subjects. [. . .] After four years, once my apprenticeship was complete, I saw opening up before me, at seventeen, a brilliant career as a painter on porcelain, at six francs a day.' When machine printing took the place of hand-painting, Renoir changed course: 'I began to paint fans. I lost count of how many times I copied *The Embarkation for Kythera!* That is why the first painters I became familiar with were Watteau, Lancret and Boucher.' After a time spent very successfully painting pictures of Saint Vincent de Paul on blinds, he finally went to learn 'great painting' with Gleyre.

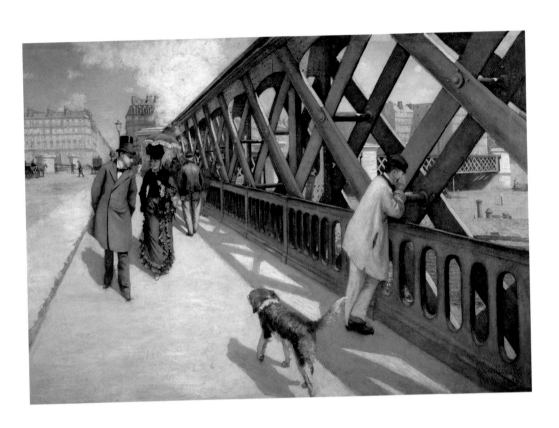

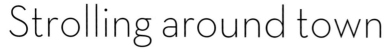

Strolling around town

Gustave Caillebotte (1848–94)
Le Pont de l'Europe (The Bridge of Europe), 1876
Oil on canvas, 177 × 123 cm
Musée du Petit Palais, Geneva

There will hardly be time to get a clear look at the approaching woman: the dog, with his nose to the wind, is going too fast. Next time we'll remember to put him on a lead. The little veil covering the lady's features would make it hard to see her properly, but it would have been easier if we were moving a little more slowly. The man passing her has had the same idea and is starting to turn round. It's hard to tell whether she is insulted and if so whether she is showing it.

The person strolling peacefully into the picture has not got enough time to be disappointed. The fact is the city is absorbing all their attention and energy. Its great pale avenues are made to be hurried along. The whole scene, which draws the eye right back to the gap between the apartment buildings, takes on unexpected proportions, enlivened by the dynamic effect of this perspective. Quite apart from any other subject matter, the street itself is an abstract dramatisation. The essential element of the painting lies in this elongated uncluttered perspective, as if the real interest resides in what will be, and what will happen further away, elsewhere. It is a constantly deferred project, a space lurking somewhere in the fictitious depths of the picture.

The delightful art of the gentle stroll has been transformed, leaving no time for idle digression. Caillebotte, outside the narrow confines of the studio, observes how, in the city, new relationships are formed between body and space. The object of any journey becomes an urgent obligation. And that is why

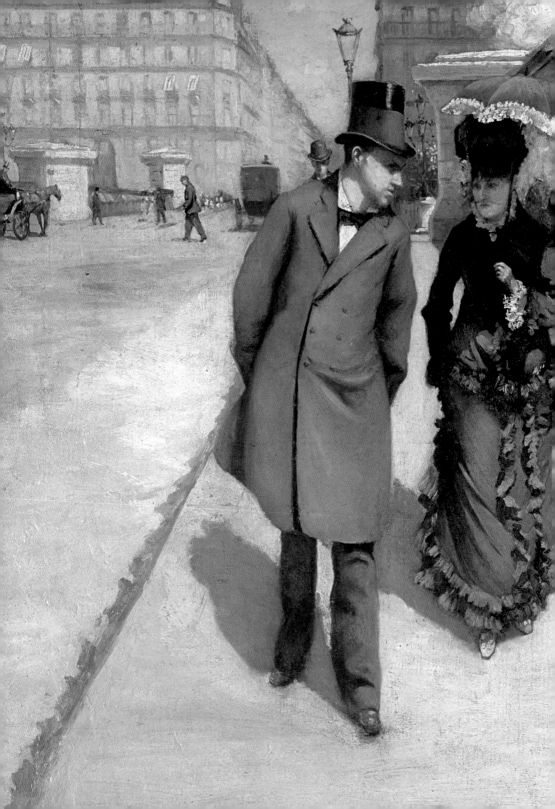

the meeting never takes place; it remains just a vague possibility, one of those unexpected and pleasant moments, which, if they do occur, are hardly ever remembered. As soon as we've crossed the bridge we'll be looking elsewhere. Our steps will be drawn towards other avenues, other boulevards, themselves just as rich in promise. This simple discovery of wide avenues, with no more complicated backstreet networks and alleys to get lost in, leads on to a vision of an orderly and understandable world, cleared forever of its dark corners and shadows.

The figures that appear in the painting are not expected to come any closer than they are to each other. On the contrary, their attitudes indicate opposite and incompatible directions; and their expressions, one emphatic, the other sharp, inquisitive or thoughtful, mirror our own. These are, above all, independent lives that are portrayed: the lady walking through the city unaccompanied is the clearest example of this. We have here a break in custom, which will certainly upset the more traditional amongst us. What is she doing? Why saunter along dressed like that if not in search of some nefarious adventure? If we were to look at a painting in the same way as we might read a novel, we might start imagining things. In the end, we might allow ourselves to indulge in speculations that have no foundation in what is really at stake in the picture: it is not the story that counts but the fact that it is proposing an unverifiable hypothesis. It has to remain in the realm of the unknown, just as we cannot know where the bridge is leading to.

In this perfect embodiment of the modern city, which Caillebotte has chosen to depict in an entirely dispassionate manner, there is no question of any romantic or even psychological message. Anything like that would drag the image into a complicated maze of interpretations, with endless about-turns and digressions, parentheses and changes of mood. The whole idea of a message would weigh the canvas down. The figures certainly play an essential role in the mechanics of the image, but the star of the picture is the clear space opened up and liberated by the bridge itself.

The lady we are about to pass may quite possibly be nothing more than a symbol of the atmosphere of anticipation which characterises this painting. Each of the figures here is moving towards another space, not just because they are physically in motion, but also because the composition of the picture draws them along, encouraging them by the discipline of the diagonal lines. The figures at the centre of this precisely drawn scene then introduce a set of different rhythms, and one senses that the artist has chosen them carefully, for the variety of pace which they bring to the painting. We can almost hear the

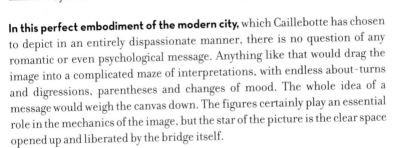

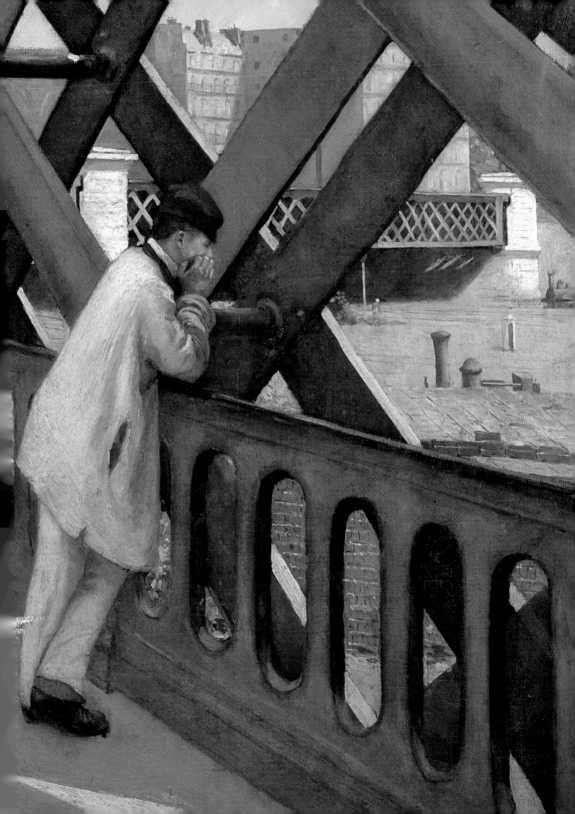

different sounds which accompany their movements: the trotting paws of the dog, the small steps taken by the lady, hindered by her narrow skirt, the large striding pace of the man in the top hat, and the more cautious steps taken by the elderly gentleman in the distance. Then there is the workman rubbing his soles on the pavement as he watches the railway below, and listens to its constant roar. He is the only person standing still in the picture, although, at least in his mind, he is the one travelling furthest, concentrating on the arrival or departure of a train, which will remain invisible to the rest of us. His cap and smock identify him as an artisan, the chosen witness to this new chapter in history and the upheavals brought by the industrial revolution. Perhaps he symbolises thought, but he certainly represents the unbridgeable gap between the old world and the new.

The complicated structure of the metal girders scales down the powerful nature of the images that it intersects, and which the picture can only show a small part of: an avenue opens up here, a bridge over there, the railway stretches out further in one direction, whilst everywhere the colour of the steel harmonises with the soft blue of the slate roofs. The artist seems to be taking great strides across this city and its constantly changing features, drawn by every point in the compass. He has created a spotless town, artificially elegant with its entire gamut of the shades of grey, and the radiant blue sky which breaks up the monochromatic effect, already sliced through by the white vapour from the steam engines. On the pavement, the blue and mauve shadows sound a muted tone. The geometrical nature of the image provides both a structure for thought and a way of setting it free.

Caillebotte was fascinated by the linear structure of the city, and would revive a connection with the spirit of the Renaissance painters, for whom architecture represented the triumph of ideas over matter, whilst also providing an opportunity for man to set his own behaviour against the rigour of an ideal structure. The ideal would not be a moral one, simply that of a clear-sighted surveyor, for whom the straight line was not necessarily a sign of virtue. Caillebotte is showing us here an entirely modern version of those perfect towns built in the fifteenth century – thought to be ideal then, because nobody had yet broken their harmonious lines. In Caillebotte's city, however, the inhabitants are drawn into the design. As a true Impressionist, he recognised the importance of the accidental and the fortuitous, and the true value of the individual. The unknown passer-by, fragile, transitory, and quite simply human, now takes their place in history.

The geometry of the city

In 1877, Caillebotte exhibited three works which feature the city as the main element: *The Bridge of Europe (Le Pont de l'Europe), Paris Street; Rainy Day (Rue de Paris; temps de pluie)* and *The Painters (Peintres en batiment)*. In each of these paintings, the dominant structure of the composition refers to the new face of Paris, after the work commissioned by Baron Haussmann who was the city planner for the Department of the Seine from 1853 until 1870. With the unswerving support of Napoleon III, he had the unhealthy slums and narrow streets of mediaeval Paris razed to the ground, and opened up huge avenues and boulevards designed to erase memories of the 1830 barricades. The workers whose homes had been demolished were replaced with a new population of wealthy bourgeoisie. Haussmann was fired just before the fall of the Empire, and wasn't able to complete his ambitious projects and to extend his programme throughout the whole of France. He was accused by Victor Fournel (and others) of having created 'the monotonous equality of a banal magnificence, by imposing the same geometric and rectilinear streets everywhere, stretching out in mile-long perspectives, with row after row of identical buildings.'

A democratic space

At the time of the Impressionists, the recent tragedy of the 1870 Franco-Prussian war was often associated, in the eyes of the public, with the spirit incarnated by Haussmann – that of an authoritarian regime, which favoured the rich bourgeoisie. In the early years of the Third Republic, after the war had ended, the city composed itself in an effort to re-establish its democratic credentials. It is in this intellectual and political context that *Le Pont de l'Europe* introduces figures from different social classes – bourgeois, artisan, workman. Caillebotte's 'ideal town' is shown here as a space in which people from different levels of society can effectively cohabit, despite the perceived damage wrought by Haussmann.

Perspective

Perspective, used from the fifteenth century onwards to create an illusion of depth in a painting, is one of the fundamental elements of Renaissance art. Founded on the notion, long regarded as ineradicable, that 'the painting is a window open on to the world', according to the architect and theorist Leon Battista Alberti, the artist's job was to make the viewer forget that what they saw only existed in two dimensions. This entailed careful calculation of distances, and the choice of a single point of view in order to fix the position of the vanishing point. By the 1870s the application of this technique had lost some of its importance, as it was increasingly perceived as something artificial and distant from the realities of perception. And yet it was just at this moment, when it was losing its theoretical importance, that perspective became an obsessive motif in many paintings, in the landscapes of Pissarro, Sisley and Monet, as much as in Caillebotte's work. Used in a spectacularly exaggerated manner, it became a theme in itself, displaying clearly a technique that was supposed to be hidden, whilst the brushstrokes, more and more crudely visible, would henceforth be a constant reminder of the painter's actual materials.

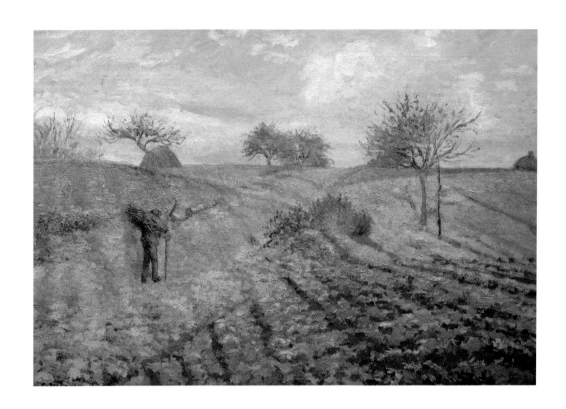

Wearing clogs

Camille Pissarro (1830–1903)
Hoarfrost, 1873
Oil on canvas, 65 × 93 cm
Musée d'Orsay, Paris

The labourer's feet sink heavily into the hard soil. The artist's breath mingles with the evaporating morning mist. The sky hardly seems to weigh on the horizon. Wherever you look, you see the same pale colour; it is impossible to estimate the distances. It might have been better to go back and find some semblance of safety, rather than allow yourself to be carried along regardlessly, without following a proper path. It would certainly have been easier. But there is nothing threatening about the countryside here – it's just that someone who is not used to wearing clogs might find the journey exhausting.

You don't know how long you've been walking for, nor why you set out on this expedition – it's not really an expedition any more, now that you have left the path. Perhaps there never was a path, or perhaps it was to be found in another painting. You thought you were going on a simple outing, and now the going is becoming difficult, from field to field, with nature making itself felt. It's hard to make any progress, with muddy furrows as far as the eye can see. There's nobody to talk to. A peasant over there, with his stick in hand and a bundle of kindling on his shoulder, seems further away than first thought. He's the single human presence in the picture, it would be nice to approach him, but he's got other things to do. It's no use trying to catch up with him – you can't chat in this cold weather.

Pissarro has eliminated any foreground which might have provided some support. It is impossible to get going again. The landscape has opened up, you are suddenly right in the middle of it. It's not done abruptly; the artist isn't trying to create any kind of spectacular effect – he simply drops the viewer into the middle of these fields, without any preamble. His painting has no time for the sorts of settings which in the past would lead the viewer away from everyday reality: a rock of some sort, a large tree, some way of attaching oneself to the edge of the frame; there might perhaps eventually be some winding paths, a river – maybe embellished with a little bridge, cottages where you might have stopped, and only then, when all these possibilities had been explored, the beautiful vast horizon . . . Here in Pissarro's canvas there is none of this subtle progression, and no mercy is shown towards the exhausted traveller. This landscape does not have a clear objective and that is what we, as the viewer, find disconcerting. Instead of hanging this picture in the drawing room we might as well just open the window and gaze into the distance. But is that not what paintings have been supposed to do for centuries?

Unless, of course, you actually wanted to find yourself there, isolated in the midst of nature. That is all Pissarro is offering, but he offers it wholeheartedly. The stark composition induces a powerful sensation of being condemned to either remain in this place, or carry on walking, but with no guarantee of arriving anywhere. Pissarro simply paints what is there, not seeking any softening element, or any supposedly picturesque motif. He paints what is. It is an image of life itself, not a theoretical discourse on fine and grand principles, illustrated by a grandiose subject. No, what we have here is life, nothing else. But what can life be, in a painting, if you have no story to tell? Well, it's the sensation of biting cold and frozen feet, of being alone in the world, even if, of course, that isn't the case: after all there is that man over there, going on his way. It is the consciousness, then, of being alone with yourself. Without warning, the painting captures the incredible notion – quite separate from the conscious reasonings and constraints of society – that one is simply alive and that nature, which has seen it all before, is there, wide open, with no pre-judgements, lying before us.

All that from just a field? Are we going too far when all we are looking at is a completely banal rustic scene? The large brushstrokes don't bother with any detail. The artist is speaking to us with rough gestures. In any case, we might think that with Pissarro everything hinges on the unimportant detail. He shows us so few of them: a patch of land striped with violet shadows, an unknown figure who does not even turn around to face us. But he also shows us a space in which nothing is held back, a pale light which we know will

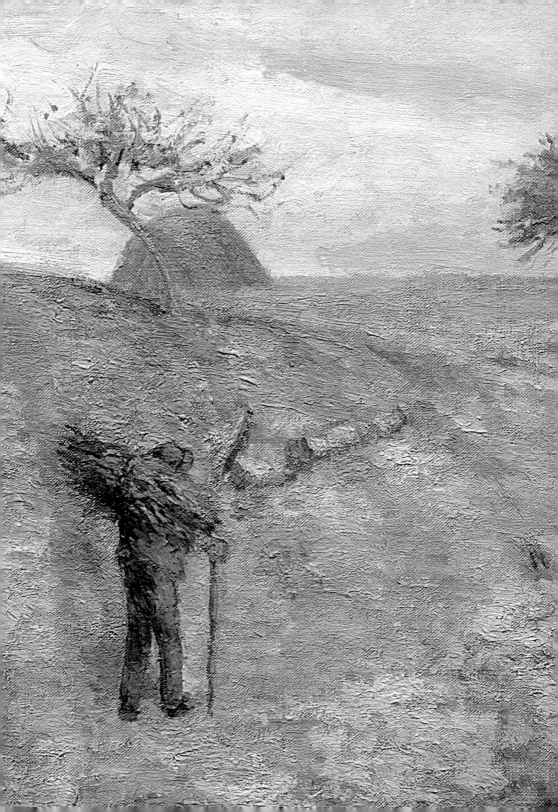

increase and become brighter. It is true that this is almost nothing, but the image of this 'almost nothing' endures, which is more than can be claimed by many moments of great and important history.

The viewer sinks into the picture. We would like to spring forwards, but we find ourselves weakening. The mud weighs us down, and we understand that the artist does not really allow us to advance properly, or at any rate not yet. First we must experience gravity, the way we are rooted to the earth and unable to proceed. For Pissarro everything must be done gradually – each brushstroke is clearly separated from the other, each furrow is important, everything that is painted has a meaning. The construction of the painting is elusive, it almost seems not to exist: the landscape is indistinguishable from the canvas itself. Instead of retreating into the distance, creating an illusion of depth, it seems to limit itself to its confines and spread out within them. Anyone who thinks they can simply plunge inside the picture will bump their face against the actual painting, and find themselves flat out in the mud, as frustrated as a badly equipped city-dweller who has set out on an ill-fated expedition.

And so, we don't quite know where to look: towards the back, to the sides – nothing obviously draws the eye, and any choice will be arbitrary. There is no correct decision. The paint simply envelops us into its own magma of mud and frost. We could simply remain there, waiting for the approaching warmth. The light will gradually overcome the frost which is immobilising the new shoots. The artist is patient: to start with there will be no great change, just an imperceptible shift in the colour of the earth and the fragile balance of the retreating shadows. There will be other colours, already bright and strong, which we will hardly notice appearing. At the heart of this painting is the promise and expectation of all these most subtle of changes.

The onlooker can only remain attentive, a scarf wrapped around your neck, careful not to lose your balance. You must leave enough time to notice tiny details which gradually become bolder and expand, like gusts of fresh air. None of the usual approaches are suitable when one is confronted with this canvas, which celebrates the awakening of the earth. Pissarro is not taking the viewer 'elsewhere'. Instead of leading us towards an imaginary horizon, he offers us comfort. The painted landscape is imprinted with traces of all that has come before, and so it is communal land, in which all feeling can take root.

Making head or tail of it

The painting was one of five canvases which Pissarro presented to the 1874 exhibition. The critic Louis Leroy, in his account of the event, invents an imaginary visitor, a supposedly 'respectable' artist: 'When he saw this extraordinary landscape, the fellow thought there must be something wrong with the lenses of his spectacles. He wiped them carefully and put them on again. "What on earth is this?" he cried. "Well you can see . . . a white frost over deep furrows." "Those are furrows? That is frost? All there is are scrapes from the palette on a dirty canvas. There is no head nor tail to it, no top or bottom, no front or back." "Perhaps . . . but the impression is there." "Oh yes, funny kind of impression!"' He intended to taunt Pissarro by pointing out the obviously new elements: the abandonment of the traditional reference points which normally transformed an image into a stage setting; the homogeneity of both colour and light which removes the illusion of depth by emphasising the materials on the canvas; the visible and tangible signs of the painter's work, which forces the viewer to realise that the painting is the result of the artist's subjection to the image itself rather to any external rules.

Landscape painting after Corot

'Worldly people who have no artistic education – they resist any instruction as they have such a high opinion of themselves – can only judge a painting by the workmanship involved. They like to believe that the only interest a painting can have is in direct relation to the number of scenes it can depict, and the size of the landscape it can embrace. What they do not realise is that the most splendid panorama will nearly always be the poorest work of art.' Frédéric Henriet wrote this in his 1876 book *Le Paysagiste aux champs, impressions et souvenirs, texte et dessins.* Pissarro went against the conventional principles denounced by Henriet, and chose everyday vistas, with no clear focal point, depicting the most ordinary of scenes. With Corot the search for the exceptional view had already been abandoned – he was one of the great innovators in modern landscape painting, and Pissarro, who hardly knew him but greatly admired his work, had for a long time considered him to be his master. Pissarro visited Corot when he arrived in Paris in 1855, at a time when Corot's work was still little appreciated, and the master had spoken to him encouragingly: 'You are an artist, you don't need any advice, except this: you must study the values (shades of colour) . . . We do not see things in the same way: you see things in green, I see them in grey and gold.'

A discerning Émile Zola

Zola was aware early on of the value and originality of Pissarro's work. He described it as 'serious and austere painting, determined to be accurate and truthful, both rough and strong-willed,' and adding, 'Sir, you are clumsy and awkward – the sort of artist that I love.' Writing about him at the end of the 1860s, before the Impressionist label had been invented, Zola analysed with great precision the qualities in Pissarro's work which he would still admire ten years later: 'He places himself in front of a patch of nature, and sets himself the task of interpreting the solid width of the horizons, without seeking to add any invented decoration. He is neither a poet nor a philosopher, but just simply a naturalist, a maker of skies and landscape. [. . .] Never have paintings seemed to me to contain such authority and depth. One can hear the deep voices of the earth itself, and one can sense the powerful life within the trees. The austerity of these horizons, the lack of any kind of disturbance and the complete absence of sharp notes – all bring some sort of epic grandeur to the ensemble. Reality such as this is greater than any fantasy or dream. The frames are narrow and so one finds oneself facing the great open country.'

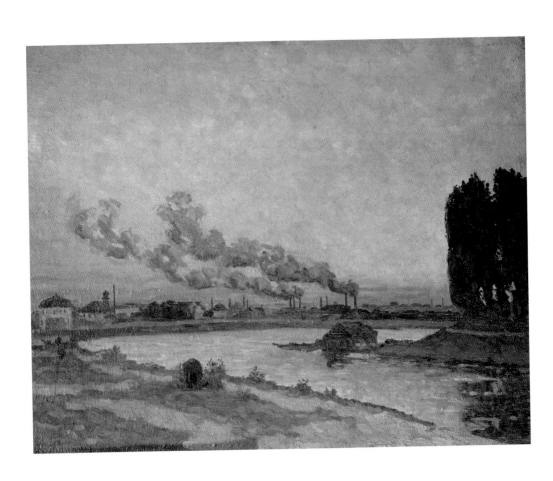

Waiting for evening

Jean-Baptiste Armand Guillaumin (1841–1927)
Sunset at Ivry, 1874
Oil on canvas, 65 × 81 cm
Musée d'Orsay, Paris

The town is piled up on itself at the bend in the river. The wind blows the smoke from the factory chimneys towards the west, as though to accelerate the ending of the day. The smoke streaks the orange and yellow sky with grey as it passes, overlaying the natural sky with dark plumes that are never completely exhausted. They are thicker than clouds and more persistent than the darkness of winter days, purple stains constantly floating, increasing with the approach of evening.

Paintings of the Seine, and even more so of sunsets, no longer excite anyone. Flaming skies have been a classical theme for a very long time. But in this case the dramatic atmosphere and sense of grandeur normally found in such paintings have been diminished, or relegated to the background. Nevertheless, Guillaumin still remembers those romantic ecstasies and even retains some of that excitement, exaggerating the tones so that the yellows and pinks compete with the blues, which in turn have become almost turquoise on the surface of the water. The trees stand silhouetted against the light, enclosing the picture; they seem to delineate the edge of some unknown lonely park. Snatches of light seem to drift along with the current. But night is not far off and tiredness is beginning to affect the imagination. The chimneys continue to spew out their vapour. The paintbrush is weighed down by the mass of colour, and the air is already becoming opaque.

This is certainly a new type of landscape. It is too simple and unrefined for the traditional canon, with which it no longer has much in common: it is neither heroic nor rustic, and it is a long way from the townscapes which have been

civilised by the ruler and the compass. It is as ignorant of work in the fields as it is of weekend entertainment. It is an everyday painting, with limited ambitions. Ordinary, and not just because of its simplicity. It takes into account what is really happening every day. Although you can't actually see the factory workers toiling, the belching chimneys speak for them. They are the real spirits of the place, replacing those dryads who, not so long ago, dwelt in the depths of the woods and of most paintings too. No doubt those tree nymphs satisfied some need for a poetic experience, and they made themselves gracious, sometimes endearing, and always attractive. Guillaumin's knowledge of the great traditional landscapes served as a sort of counterfoil to his work. He was not rebelling against it, just developing a different form – a reversed myth, without arguments or accessories, and free of imaginary presences.

Factories were being built wherever they could be: they needed space and water of course, but machines do not need ancient spirits or fabled love stories in order to function. And so Guillaumin painted this new naked world, concentrating only on the present, which provided him with a living. His landscape is pared down to the quick as though the thick paint has just landed there, with no foundation. There is no drawing beneath it any more than there are memories. In the Middle Ages they often built churches on the sites of pagan temples, and chapels beside springs that had been visited by the ancient gods. Thus the spirits never really went away, they just quietly changed their names, and the respective worshippers were not made to suffer any brutal change in their habits. Painting proceeded in much the same way, gently drawing away from the great historical subjects in order to concentrate on the landscapes that surrounded them; at first they left plenty of room for the figures of gods and heroes, and then gradually less and less, and eventually none at all. Guillaumin's generation reaped the benefit of this long process: painting now depicted lands deprived of words. They were perhaps no longer necessary.

In a way, Guillaumin was also following in another great tradition, that of the northern painters of the seventeenth century who would skilfully depict the windmills which were the source of their country's prosperity. Their skies, in beige and white, punctuated with a soft blue, were swollen by magnificent clouds. The paintings made one forget that they were meant to provide a discourse on the economy and freedom of the nation. Likewise the sun setting above Ivry could make one forget the noisy rumbling of the turbines there.

Adjusting, composing, inventing, cutting out anything that upsets the balance of the picture – all these activities are part of the painter's arsenal, and it was, in the past, only to be expected that nature should be represented through

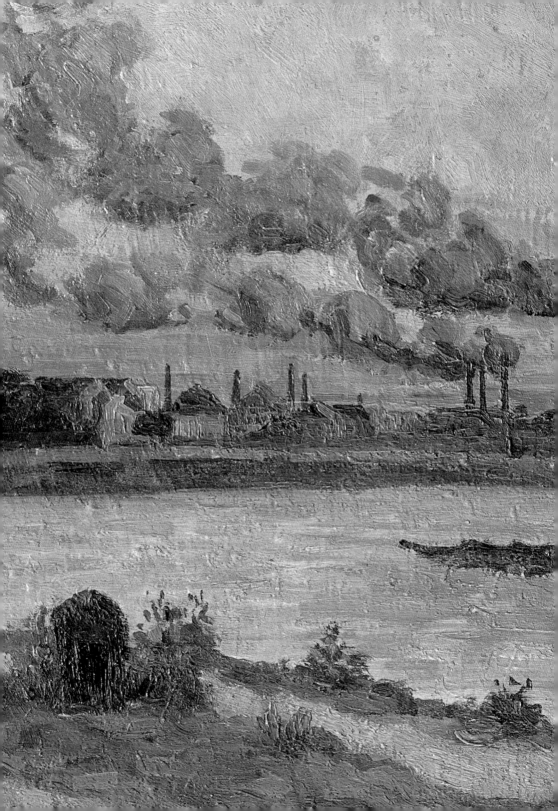

artifice, when artifice was what mattered most. Guillaumin, on the other hand, never modifies or corrects the image he sees before him in order to observe any conventional criteria of charm or elegance. He goes straight to the point. The canvas exists only when it has connected its subject with crude reality. All it has to do is tell the truth. The painter has no inventing to do, nothing to study, and the factory is certainly not going to play the part of any picturesque detail. After all, Guillaumin is a worker too, like anyone else. Painting is almost a rest for him.

And so the artist paints what he knows best. The connection between his everyday life and the world within his paintings gives his work a weight which perhaps hadn't been foreseen. His sunset marks the end of long hours of real work and is the precursor of many more. Hours which he will spend checking the condition of roads and verges, clearing the earth from the sides of lanes, smoothing asphalt and repairing collapsed pathways. The great clouds of smoke never cease, inordinately large on the canvas. The chimneys, although far in the distance, seem enormous. This powerful theme creates an effect which combines both thunder and clear skies. The great dark bands remove the colour so that the turquoise sky and sumptuous sunset stand out against the grey clouds.

It was a way of living as well as a way of painting. He was able to stride along the banks of the Seine in the evening, observing the changing sky filling up with smoke that would eventually become a part of the darkness of night. The painter would stop his work then – he had other work to do. Guillaumin's aesthetic choices were governed by his personal desire to draw attention to areas such as these, which were overlooked by the creators of supposedly nobler images. His art was that of a worker painter, that is to say that of an artist who was immersed in the mundane realities of the world. The era of painters immured in their studios, sheltered from the world outside by the very nature of their art, now seemed very far away. Guillaumin brought a different perspective to this world of open air freedom, a long way from virginal nature or rural countryside – this was an examination of the industrial suburbs which would open a new chapter in the history of landscape painting. The change of atmosphere in the artistic world which was occupying the attention of his colleagues is here inseparable from the profound transformation of the landscape itself. You could now see history in action just by watching the grey smoke rising into the Ivry sky. The painting re-enacts the transformation of the world, opening its sky up to the dying day, while the sluggish air gradually takes on the colours of dust.

Abandoning the conventional landscape

Already, by 1847, Horace Lecoq de Boisbaudran, a painter and teacher at the Royal School of Drawing in Paris, was bringing attention to the changes in the landscape genre: 'A few years ago there still existed a prix de Rome for landscapes. All the young landscape artists competed eagerly for this prize, outdoing one another at mastering the required style, known then as the historical style. The only views they sought for their studies of nature were those which resembled the compositions of Poussin [. . .]. This resulted in such an absence of truth and initiative, and such dreary repetition of pretentious and conventional formats, such boredom, such disgust, that in the end both competition and prize were closed down. Once this great decision had been taken, the young people, now freed from these gloomy and overbearing obligations, began to look at nature in a much simpler way, with no precon-ceptions, and with only one aim – to transmit the impression of what they actually saw.' When he taught drawing from memory, he would emphasise the fact that it is also possible to 'paint with a remarkable degree of truth a few horizons or effects of the moon or the sun when rapidly observed in nature'. He was disapproved of in official circles, but much admired by numerous artists – Fantin-Latour, Whistler, Manet, Rodin – as a forthright spokesman for the concerns and beliefs of the Impressionists.

Painting by day, working by night

It was only in 1891, when he was fifty, that Guillaumin was able to devote himself entirely to painting. Fortune smiled on him when he won a hundred thousand francs in the lottery, allowing him to retire and live comfortably with no more material worries. Previously, unable to live on the small sums earned by his paintings, he had at first, like Renoir, painted blinds, and then had become a municipal employee, working for the highways department. 'He works by day at his painting, and by night at his ditches – what courage he has!' Pissarro would exclaim, in a letter to his friend Guillemet in 1872. Often, Père Tanguy, a paint merchant whose portrait was later painted by Van Gogh, would exchange materials for paintings. His paintings of the suburbs, Bercy, Ivry, Vanves, display a profound sense of social consciousness, which was moreover shared by Pissarro, who was, like him, an anarchist. Guillaumin, who had his first one-man exhibition in 1888, in the premises of *La Revue Indépendante*, had probably enrolled in the Académie Suisse in 1861, where he met Pissarro and Cézanne. The latter had met Bazille at a mutual friend's house, and thus the link was formed between the two founding groups, that of the Académie Suisse and that of Gleyre's pupils (Monet, Bazille, Renoir, Sisley). Guillaumin was present at the 1874 exhibition, and was, until the end of his life, an essential part of the Impressionist movement.

Guillaumin and the younger generation

Guillaumin was closely linked to Paul Gauguin, who owned many of his paintings, and also to Paul Signac, whom he met in 1888. Thanks to him he got to know Georges Seurat, the founder of neo-Impressionism. He was a friend of Doctor Gachet, and he advised Van Gogh during his time in Paris, probably playing an important part in his artistic development. He was much admired by Othon Friesz as early as 1901, and was seen as a precursor of the early Fauvists. But Guillaumin remained loyal to the Impressionist vision and would never allow himself to be drawn into any other movement, despite the fact that he offered young painters an example of more and more free and explosive use of colour.

Seizing the moment

They had to be on the lookout for anything that might happen. They had to paint fast, and on the spot. Some touching up could be done back at the studio if necessary, but without compromising the first image. They had to abandon forever the conventional patina provided by those brown-tinged varnishes. This ever-moving world was depriving painters of all their acquired techniques. The precision of line, the nuances of light and shade, careful scene-setting and the comfort of controlled lighting – all that had disappeared overnight. The subjects of the paintings appeared before their eyes, here, there, everywhere. And disappeared again just as fast. Nobody really posed any more. You had to grab what you could from this reality as it passed by. You hardly had time to pick one subject out of the thousand possibilities that didn't even exist a few years previously.

At that time the acute awareness of modern life that characterised the images created by the Impressionists clashed with popular attitudes of the day which saw value only in the solid and the enduring: material, moral and aesthetic values were all inextricably linked. How could people who only wanted to paint the ephemeral, the passing moment be trusted? Could a painting be reduced to just one second of pleasure? Could an artist, with impunity, just allow the torrents of life to flow past?

There is no doubt that the audience at the time would often feel dispossessed in the face of these new paintings. And perhaps it was not only because they seemed almost criminally futile – they might also lament the fact that they were henceforth deprived of the consolation that art had previously offered, that of preserving that which would otherwise disappear. Surely one of art's principle functions had been to arrest the effects of all-devouring time, to slow down the erosion and rescue reality from its grasp. Now time was playing its own part, emphasising the transitory nature of all things.

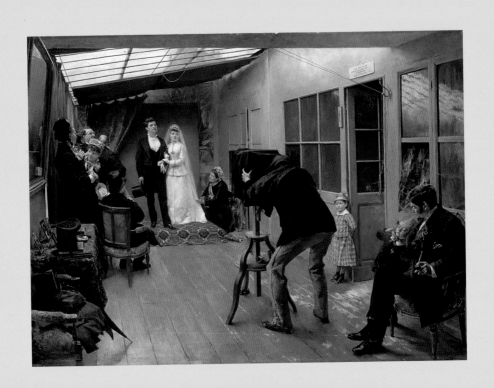

Fixing a memory

Pascal-Adolphe-Jean Dagnan-Bouveret (1852–1929), *The Wedding Photograph*, 1879
Oil on canvas, 85 × 122 cm, Musée des Beaux Arts, Lyon

.
.
.
.
.

The family has withdrawn so as not to get in the way of the photographer, and waits for the posing session to be over. It takes time and patience. An elderly lady, likely the mother of the bride, is straightening a piece of the veil hanging over the wedding dress, whilst the bride, not flinching, holds her husband's arm. He hangs on to his top hat. The light from the skylight above is controlled by a grey blind and provides exactly as much as is needed. They are standing at the right level, and the staging is perfect. A portrait painter would not have done it differently. The final picture will create the illusion that the couple is standing in a comfortable drawing room, on a luxurious oriental carpet. Dagnan-Bouveret describes the scene with amused complicity, and as much precision as the photograph itself, with some added humour.

This moment captured by the lens has a unique value, at least for the protagonists in this scene. The solemnity of their expression, partly caused by the time they are forced to spend in that position, reflects the importance of the occasion, and of their commitment. The two young people gaze at the lens, perhaps thinking about something else entirely. They know too that this photo of 'the happiest day of their lives' will hang in the drawing room, where their children and grandchildren will admire it. Careful, one of them almost smiled at that thought. The picture would have been ruined. Don't move, and above all don't breathe . . .

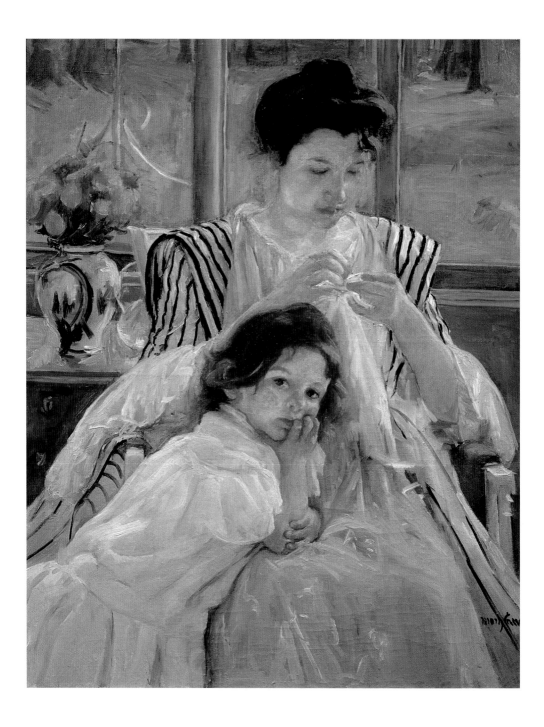

A sideways glance

Mary Cassatt (1844-1926)
Young Mother Sewing, 1900
Oil on canvas, 92 × 73 cm
Metropolitan Museum, New York

The young woman concentrates on her work, not taking any notice of the artist who has chosen her as a model. She could easily, and without changing her position, raise her eyes and exchange a quick glance, nothing more, just to re-establish contact and formalise the pose a little. It may be the case, of course, that they are engaged in one of those desultory conversations which ramble on, punctuating the course of a quiet day at home. Now she has had to stop what she was about to say – not that it was important – to concentrate on a stitch or delicate piece of darning that demands her complete attention. And now her daughter has decided to come and bury herself in her mother's lap. The child wriggles around a bit, makes herself comfortable, establishing her proprietorial rights. She can observe the world from this safe haven.

Although it is an indoor scene the light floods in as though we were outdoors. The windows, which make up the entire background, allow the garden to seem close to us. It is as though the whole house is made of glass, transparent, welcoming the landscape in; the domestic scene and the garden beyond are extensions of one another. The orange and blue tones of the bunch of flowers provide an invigorating contrast of complementary tones, and the light freshness of the painting is emphasised by the quick translucent brushstrokes. At a time when most indoor scenes were suffocated by their drapes, loose covers and heavy curtains blocking out the sun, Mary Cassatt depicts, not just a particular place, but a chance at last to breathe freely. Nobody here is restricted by the narrow confines of everyday life. In

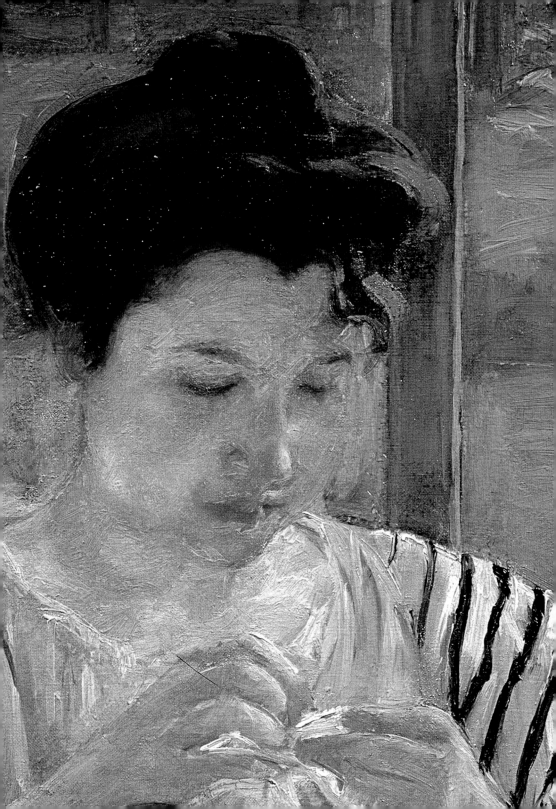

the past an artist would shelter the models from the hazards of nature. The early Impressionists went out to search for the purity of light in the open countryside, beside the water, in all weathers and at all times of day. Mary Cassatt, on the other hand, brought the light indoors, with large strokes of the paintbrush, throwing caution and all forms of parsimony aside: there was no question of diminishing or softening the brightness and radiance of the sun. The painting tears down the old sunscreens, and eliminates every hidden corner of shade.

The little girl gazes boldly at the painter. She knows that nothing is expected of her, as long as she can avoid disturbing her mother's work, or that of her aunt, who is the one painting a portrait of the two of them. Mary Cassatt painted her family without ever trying to disguise the simplicity of their connection. The poses remain genuine and intimate: a face bent down-wards, the material raised up to the eyes to examine the progress of the sewing. There is no affectation or artifice, no elaborate scene-setting or rewriting of everyday life. The painter is more interested in showing a real situation than in telling a complicated story. The substance of her work is the potentiality of a scene, what is promised and realised by the present moment, rather than any lengthily developed anecdote. And so she takes no account of the old traditional forms of representation, in which it would be expected that mother and daughter should be attentive towards one another, and display splendid tokens of affection and, implicitly, of shared virtue. The fact is that the image of the mother in painting had for a long time drawn on the tradition of depictions of the Virgin Mary, and in particular those of her being instructed by her mother, Saint Ann. Cassatt's image is certainly underpinned by a combination of the two themes, that of the Virgin and Child, and that of the education of the Virgin Mary.

The theme of this painting, and the more general one of needlework, sends us back to the idea of gentle domestic piety, such as that of Mary weaving the veil of the Temple. The sewing basket alone has a long history, encapsulating as it does, from Jacques-Louis David to Édouard Vuillard, the essence of feminine domesticity. But we must not imagine that the artist here is necessarily subject to such historical precedence. If she refers to them it is in order all the better to abandon them. The allusions are certainly there, right up to the structure of the window, which, behind the figure of the mother, echoes the layout of a triptych. Everything is in place, but there is a systematic shift and an alteration of the references, thus removing any religious or sacred significance in the image and investing the whole scene with a new freedom of movement.

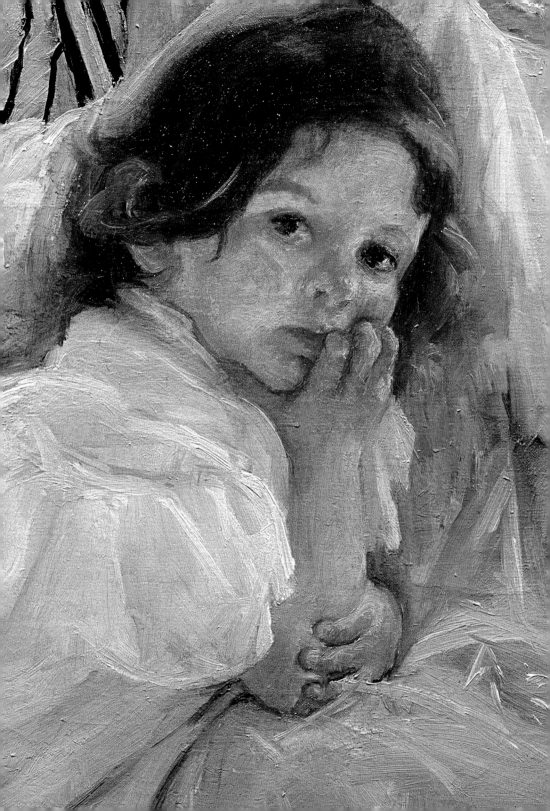

The mother is not passing on any knowledge, or even any new skill. She is no more trying to gain her child's attention than ours. We are not observing even the most casual of sewing lessons, and it is quite clear from the little girl's relaxed position that she is not the slightest bit interested in the refinements of embroidery. The image of maternal love here is one that is completely apart from the usual codes and conventions, which demand traditional instruction as well as the obligatory sentimental interaction.

The lively and innovative techniques used here to capture the vibrations in the atmosphere would in themselves be enough to indicate a new approach to painting, one freed from the accepted norms of respectability, which supposedly are needed to convey the gentle delicacy and vulnerable grace of female models. The child too is painted with large brushstrokes which bring her features to life. Cassatt succeeds in expressing a correlation between the natural light and the natural demeanour of the two figures: the reality of these two is depicted as much by their relationship with the light around them as by their gestures and the expressions on their faces.

The little girl, placed precisely between the two worlds, observes the artist at work with a thoughtful and searching stare of magnetic intensity. Two ways of living are brought together in this anodyne moment, that of the domestic hearth and that of the independent career, totally foreign to the norms of the time. Each of them knows the importance of what is being played out here, in this unspoken dialogue between the subtle silence of the needle and the striking power of the paintbrush. And so perhaps it is an educational scene after all, but of a very different type. The mother, her head bent down over her fragile handiwork, is allowing her daughter the freedom to explore, and to choose any space that attracts her – the world is opening up before her.

The painting is also, of course, dealing with the passing of time, and, as with other Impressionists, it is the awareness of the particular moment which dominates. There is none of the nostalgia for the past which often accompanies this thought; on the contrary it seems to speak of possibilities, of choices, of what might happen in the future. The bright reflections which enliven the surface of the canvas inform us above all of the dynamic in which the characters have engaged themselves. The mobility of the colours reflects the mobility of their thoughts. Future roles have not yet been decided and the work is built on the multiplicity of possible paths through life. It is a passing moment, one minute in a lifetime, suddenly caught by an intelligent and unprejudiced eye.

An American Impressionist

Mary Cassatt came from an upper class family and studied at the Pennsylvania Fine Arts Academy from 1861 to 1865. She travelled in Europe with her family from 1851 onwards, and lived in Pittsburgh, Philadelphia and Chicago. After spending time in Spain, Belgium and Holland, and above all in Italy, where she spent eight months studying at the Parma Academy in 1872, she settled in Paris, which she had already visited in 1866, and began to exhibit at the Salon in 1872. It was at that time that she advised her friend Louise Waldron Elder to buy a pastel by Degas, although she did not yet know the artist personally. Louise eventually married the industrialist Henry O. Havemeyer, and their art collection, one of the greatest in the world, which included both ancient and modern paintings, was eventually bequeathed to the Metropolitan Museum of Art in New York. This was the start of Cassatt's seminal role in spreading the word about French Impressionism amongst the great American collectors. (Durand-Ruel, the dealer, organised their first exhibition in New York in 1886.) Degas, who became a close friend, invited her to take part in the Impressionist exhibition of 1877. She then participated in all the subsequent shows, apart from that of 1882. One of the most interesting aspects of her oeuvre was her work as an engraver (using drypoint, etching and acquatint), which was heavily influenced by the Japanese prints.

Female artists

Apart from the great heroines of Impressionism, Berthe Morisot and Mary Cassatt, who both came from artistically minded bourgeois families, it is also worth mentioning Eva Gonzales and Marie Bracquemond: the former, a pupil of Manet, died in childbirth; whilst the latter had to bring to a halt a very promising career because her husband, the engraver Felix Bracquemond, had objections. At that time there were relatively few women who could devote themselves to painting, as Apollinaire bemoaned: 'Female artists have brought a new kind of sensibility to painting, which has nothing to do with any sort of fragility. It could be described thus: as a certain boldness in showing nature in its most childish forms. [. . .] What women bring to art is not new techniques, but more a kind of natural taste and instinct, like a new and joyful vision of the universe. There have been women painters during all periods in history, and it is most strange that there are none nowadays.'

Painting childhood

'Oh babies, my God! How disgusted I have so often been by pictures of them! A whole line of English and French daubers have portrayed them in such idiotic and pretentious poses! [. . .] Now, for the first time, thanks to Mlle Cassatt, I have seen images of delightful tots, in peaceful bourgeois family backgrounds, painted with a kind of delicate and delightful tenderness,' declared Joris-Karl Huysmans in 1881. And he continued: 'In the end, one must repeat again, only a woman is able to paint childhood. There is there a particular kind of feeling that a man is incapable of rendering; unless they are exceptionally sensitive and highly strung, their fingers are too fat not to leave clumsy and harsh markings. A woman can put a child down, dress it without letting the pins prick it; but unfortunately she often sinks into affection and tearfulness,' although he salutes the fact that Mary Cassatt is not one of those 'peinturlureuses' who exasperated him with their sentimentality.

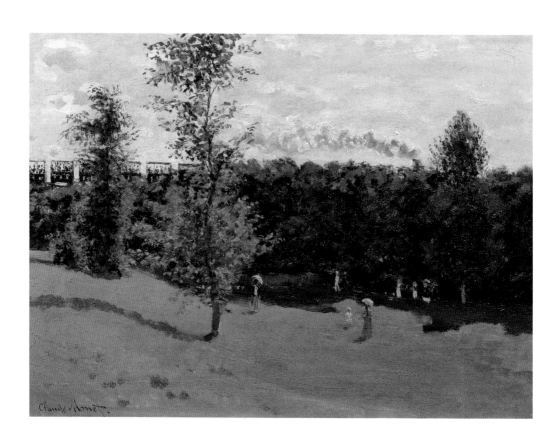

Hearing a distant sound

Claude Monet (1840–1926)
A Train in the Countryside, 1870
Oil on canvas, 50 × 65 cm
Musée d'Orsay, Paris

It seems strange at first. A muffled faraway rumbling, a steady hiss, growing louder, punctuated by irregular puffs, like the panting of an old animal. In the early days, they would look out for the passing train, but then they got used to it, and nowadays nobody regards it as an intruder any more. It comes by with clockwork regularity, telling the time, although some people still check their pocket watches as it goes by.

The gentle slope of the hill invites us to rest or to take a gentle stroll. We can glimpse a very small child, just a simple white patch in the midst of the green expanse, playing in the grass. The ladies have raised their parasols, and it is already so hot that some of them stay back in the deep band of shade that runs across the painting. In the pastoral peace and silence of the moment, which seems to hold the promise of an eternal spring, the railway heralds the opposite – the flight of time. The movement across the painting is more important than the image of the train itself. This movement, faster than it appears of course and broken up by the trees, is followed by a new sound that reaches the people down below. The straight line of the railway brings order to the curving folds of the landscape, waking them from their somnolent state, and dragging the countryside into the modern world.

The artist has retained just a general outline of the train and the carriages, painting them with large, rough strokes. He does not introduce any suggestion of the weight of metal and the power of the train — from this distance it looks more like a child's toy, with the carriages cheerfully wobbling along the track. This invasion of the countryside by the arrival of the steam engine begins to seem almost comforting.

The railway redefines the line of the horizon, which is carried along with it, making it stream past the eye. The absolute, which is what the ancient paintings were aiming for as a symbol of eternity, both desirable and impossible to attain, has changed its meaning. In classical landscapes, there was the expectation of a continuous movement towards another place, always aspired to by the viewer although they remained frozen in the foreground. In that way, the person looking at a painting by Claude Lorrain, for example, would always be at the point of leaving, condemned to wait and hope somewhere between departure and arrival. It was more an aspiration of the spirit than an actual journey, and the painting created a world where the mind could unfold; a place in which it could lose itself and dissolve into the probable magnificence of Revelation.

Here, though, the horizon is no longer a path to what is beyond. Certainly it draws the eye, but only then to pull it at a right angle in another direction. Gone is the old objective of landscape painting, which was to dig deeper and deeper into the darkness of panel or canvas in order to invent another world — a world which would also be another life, the afterlife. But infinity as defined by that imaginary point where parallel lines meet, moving further and further away from the viewer — that kind of infinity has no part to play here anymore. The ever-winding path, strewn with obstacles, with the reward of the bright light at the end, has now given way to a completely different arrangement: from here on, we will have to read the picture from left to right as though it was a line of writing. With the simple layout of his painting, Monet can suggest the idea of another place that is not reachable at all. The world he depicts is not one of epic deeds or transcendent moments, but it is nonetheless functional and efficient. In the contemporary world shown here, our relationship with distances is governed only by maps and railway timetables.

For a long time images were there to maintain the illusion that we could enter a space constructed around the promise of eternity. Each one of us, gazing at a classical landscape, would find ourselves drawn to travel through huge spaces, along the routes supplied by the artist, roads and bridges, paths and rivers, with rocks cracked open to allow the light in. All we had to do was to

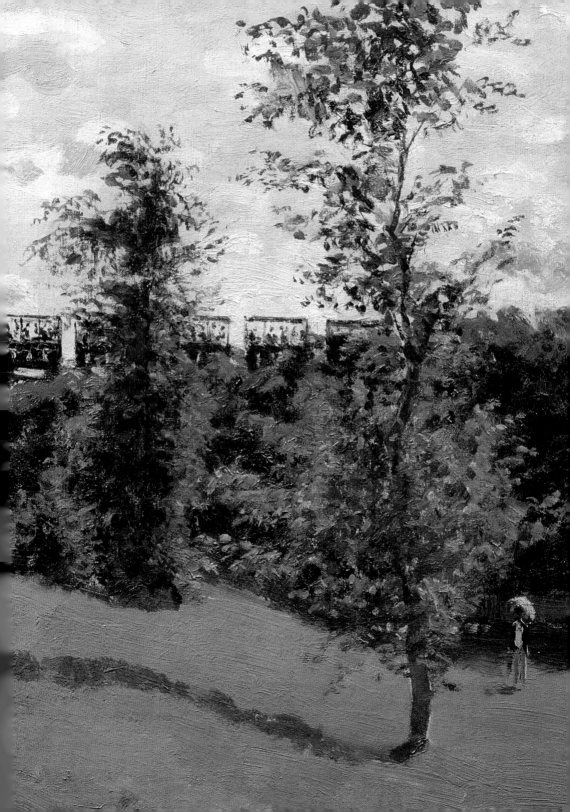

step inside the frame and the journey would begin, with all the approaches planned by the painter, right down to the last blade of grass. No doubt you sometimes needed an entire lifetime for this, as you realised that high mountains and deep rivers would require patience and courage, as well as obstinacy and caution. But this was the power of landscape painting — it accompanied you on your journey and at the same time interpreted it for you.

That train passing through Monet's painting is not ours. We can no longer regard ourselves as the chosen travellers we have been for centuries past, through paintings and within them. We could of course take another train, and reach our destination with much greater certainty than in that long-ago eternity. But we do not find ourselves on that particular train. We are here and faced with this landscape, where we have become, more often than not, the audience for other people's journeys. The artist is suggesting that the world from here on out is criss-crossed in all directions, and that these journeys controlled by the train and railways are no longer those of any individual. The small figures moving through the landscape remind us of how unimportant they are. They too just stay in their place.

The countryside is hardly disturbed by the soft outline of the train's passage. Monet seems to calm the whole scene by working the colour over large flat areas. The train's speed can only be imagined; it has not yet been experienced. A few years later the artist would add more identifiable, sometimes disorderly, touches which would convey the accelerated motion of the contemporary world. But for now the moment lingers on — the train chugging through the countryside is a symbol of time passing. Faster than before, maybe, but there is plenty of time for a calm eye to travel unhurriedly from one little carriage to another.

The prevailing harmony of the scene is in itself a sign that modern life has been accepted. The great trees place the landscape in its own time, a time when nature would absorb the railway into its own horizon. The engine disappears behind the bushy clumps of vegetation, the plume of steam forming a perfect parallel with the shadow of the trees, mingling eventually with the clouds without affecting the light. Monet could have shown the train as a spectacular product of the new industrial age, but he chooses instead to make it almost one of the elements of nature. The sound of its passage will very soon be no more than a discordant memory, which would melt back into the horizon.

The railway, a contemporary theme

The railway as a theme was already popular with several artists before Monet adopted it. Honoré Daumier, in several paintings and engravings, illustrated many of the new situations that might arise with the development of public transport, some negative, some comical. In 1843 he published a series of lithographs on the subject, called *The Railways*. J. M. W. Turner, in the same year and in a different vein, painted his famous *Rain, Steam and Speed*, a painting filled with semi-abstract energy and colour. Adolph Menzel depicted the desolation of *The Station by Moonlight* in 1845 as well as the almost frightening speed of a train travelling through the countryside in an 1847 painting entitled *The Berlin-Potsdam Railway*. In 1867, the American Theodore Kaufman painted a landscape in which one can see a train approaching in the distance entitled *Westward the Star of Empire*. All these examples contain a strong dramatic interest. Monet's originality lay not in seeking to depict social concerns or to create any spectacular or dramatic effect, but in integrating the railway into the serene image of the everyday landscape. A train is no longer the subject of epic grandeur and adventure, but simply one of ordinary life in the modern world.

La Bête Humaine

Émile Zola's novel, *La Bête Humaine*, was serialised in the weekly *La Vie populaire* from 1889 to 1890. The hero is a mechanic. The train itself, an essential component of the story, is depicted as both magnificent and menacing. This is in contrast to Monet's vision, which was from the beginning far removed from any symbolic intention: 'The train, which was going to Le Havre, was very crowded as there was an event the next day, Sunday, the launch of a ship. Despite the speed it was possible to see, through the lighted windows of the doors, the crammed compartments, the rows of heads, each in profile, squashed together. They flew past, disappearing. What a lot of people! Still the crowd, the unending crowd, in the midst of the rumbling carriages, the whistling engine, the bell of the telegraph, the ringing of bells! It was like a huge corpse, a giant lying across the earth, his head in Paris, his vertebrae all along the line, his limbs growing along the branch lines, his hands and feet in Le Havre and the other destinations. It rushed by, mechanical and triumphant, heading for the future with mathematical accuracy, wilfully disregarding what was left of man, on the edges, concealed but still alive and eternally capable of passion and crime.'

The traveller's gaze

The train was not simply a new theme enthusiastically embraced by artists. It would also transform people's perception of the countryside. Artists themselves used it to go and work in the country or by the sea, and they would discover new forms simply by observing the countryside through the train windows: large generalised masses rather than clearly delineated shapes, generalised colours rather than precise tones, an image rendered hazy by the very movement of the train. They noted this speeded up vision of the world, by which contemporary space was now defined, and consequently transformed their painting technique. Corot and the painters of the Barbizon school had already broken away from the scenography of classical painting, reinstating the aspects of nature that were more familiar to the passer-by. Now the Impressionists would make use of this new rapidity of perception which would glance, guess and would draw no conclusions, just brush against reality and pass beside it.

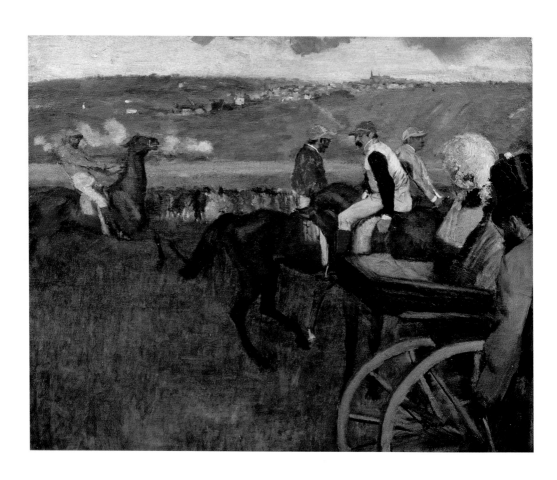

Just in time

Edgar Degas (1834–1917)
The Racecourse, Amateur Jockeys near a Carriage, 1886
Oil on canvas, 66 × 81cm
Musée d'Orsay, Paris

By the time he's pushed his way through the crowds, he's almost late. Almost? Is he late or not? Has he missed the start of something? We can't tell. The fact is that Degas has painted the precise moment at which one might or might not have missed an appointment, or the beginning of a race, or a meeting. It doesn't matter which, there is the sense here of having to hurry up, press on and catch up with life. Anyway, it's not necessarily too late. It may well be the case that this very uncertainty, rather than the safety of a solidly framed image, is what attracted the artist in the first place.

He has therefore chosen this point in time and this auspicious occasion to depict an eventuality which will from now on occupy the uneasy heart of this painting. The riders set off and pass by one another, trying to avoid each other, each looking for his starting post. It is like being in a theatre before the curtain goes up, but with no play to follow, no story. The painting defines itself as the space between brackets, a pause in the midst of a crowd of people going their own way, in the distant background of the picture.

The image only records fragments of what is happening, as though the frame could not quite hold the whole picture. Unless it is Degas himself who keeps changing his mind and in the end misses everything. But enough of what is essential remains for us to grasp what it is all about. To catch the whole thing would be a Utopian project, and to start again would be an aberration. In Degas' world doubt and hesitation do not exist. All that exists is a group of

people in a hurry. The problem here is not to identify what one sees but to select from the infinite demands of what is visible the single detail one wishes to retain. That detail should be informative, smart, witty, subtle, odd perhaps, dim or almost invisible, but above all suited to the economical nature of the painting. A carriage wheel, a hat, some shapes in the background at the outer edge of the field of vision along the side of the racecourse. It is a place of transit, a waiting room in which nobody lingers for long.

Soon there will be nobody left in the painting. The canvas could become completely empty, once the train in the distance has gone by and the steam has blown away. The train, the racehorses – Degas always follows the same idea: a succession of events, with everything there for a short term. The Romantics had invented the concept of suspense in a painting: Girodet's *Déluge* had not yet flooded the world, but it was only a matter of time – a few minutes would suffice.

Eugene Delacroix made a painting of *The Death of Sardanapalus*, but he did not depict the moment of death. Instead he showed the splendidly orchestrated preparations for the expected death. We know that what will follow will be quite terrible, but we do not actually see it. The impact of the painting lies in this imbalance forced on the breathless viewer, who is kept permanently on the edge of the unknown. This dramatic device is also used by Degas in his painting, but with the absence of two important elements: there will be no dramatic event or spectacular development; and there will be no human figure capable of prolonging the action we are witnessing at the moment. The fact is, the major part of the painting is already almost empty, and it looks as though everybody else is preparing to leave. And so there is, here too, a sense of imminence, but it is an imminent disappearance, an emptying out. The painting is predicting its own destruction.

The centrifugal structure of the image, based on the dispersal of the figures, lends the space a quality that is both feverish and detached. By gathering together a group of riders who are supposed to be elsewhere it attaches more importance to their movement than to anything else. The actions and ambitions of these individuals are here nothing more than pretexts for the staging of an ephemeral scene that is about to be dispersed. There is no narrative that can hang together.

One almost has the feeling that Degas' figures have no particular wish to appear in this picture at all. They are not interested in us, they do not wish to be observed, even surreptitiously. All the privileges of being a spectator

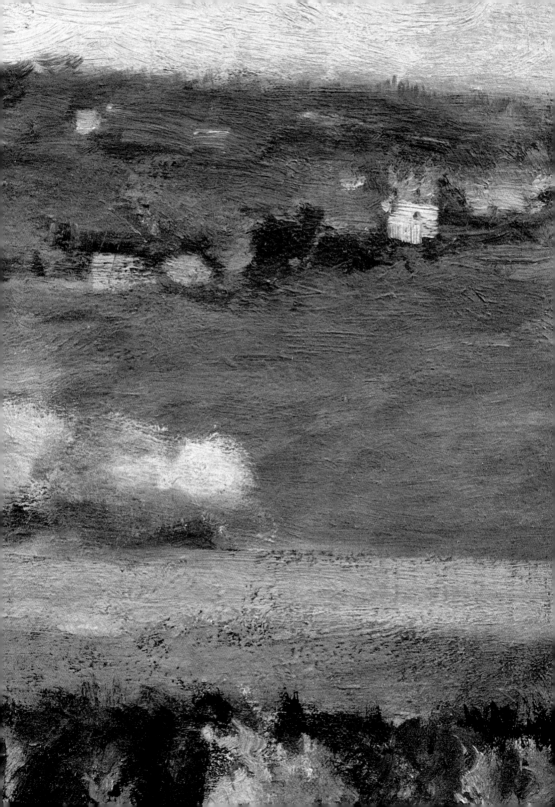

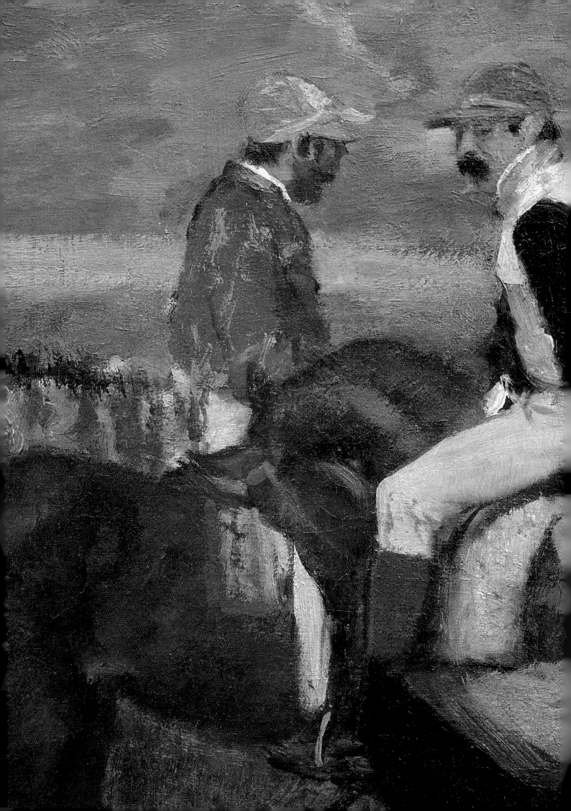

Choosing happiness

Pierre-Auguste Renoir (1841-1919)
The Luncheon of the Boating Party, 1881
Oil on canvas, 129 × 173 cm
The Phillips Collection, Washington DC

The moment could very easily have passed by unnoticed. It's a beautiful day, everybody is happy. In the light-hearted good cheer of the end of lunch, nobody is having any deep thoughts about life. Renoir is at home here. The owners of the restaurant love his paintings and prefer receiving them in payment to taking his money. Everybody is relaxed, the afternoon is young, let's linger awhile.

The painting glows with health. The canvas is illuminated by the full light of summer, despite, or perhaps because of, the awning that stretches over the terrace. The light penetrates and reaches into every part of the scene. The immaculate whiteness of the tablecloth is not enough — today there is an entire range of whites: a white dulled by mauve; a white spiked with pink; a white lit by yellow and green tinges; a white enlivened by blue; an attenuated white that loses itself in a shade of beige. And yet the sensation of pure white persists, like an idea that is so firmly lodged in the mind that it resists all immediate visual evidence. But the fact is that in this painting a true white can be found in just a few instances: on the shirt collar of the man leaning over his companions, on the right, and that of the man in the top hat at the back, as well as, not far away from him, on the sleeve of an elegant woman in black gloves. All the other whites are touched by their surroundings, reflecting in unequal parts the surrounding foliage and the awning stretched above the table. All these different elements were probably never quite the

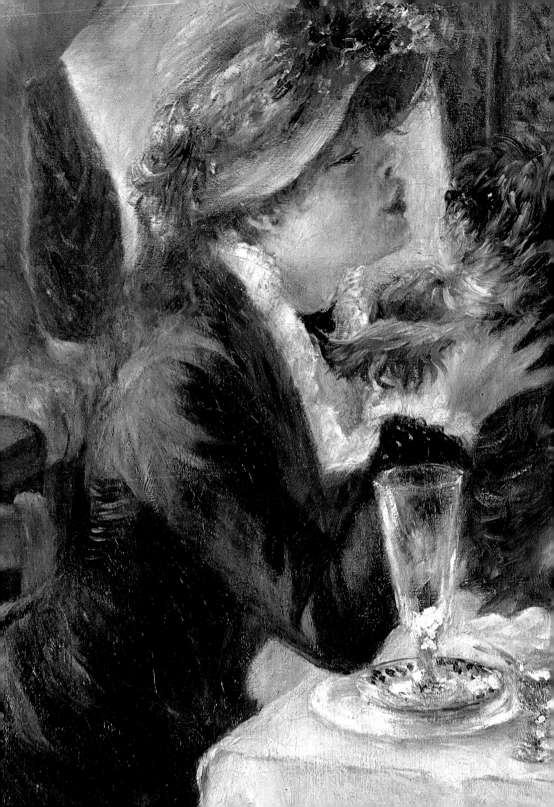

same shade from the outset. After all, the texture of the boatmen's vests is different to that of the tablecloth, which in turn does not resemble the jacket of the man on the right any more than the dress of the young woman who is looking towards us, casually leaning on the railing. Renoir does as he pleases with this white, which is never just itself. The painting drifts from one tone to the next, changing imperceptibly – as soon as you put a name to them they disappear.

In the end you get lost amongst these shades, and it doesn't matter in the least. Or rather it does – it's essential that you should get lost, and get rid of your old automatic responses. How much more time are we going to waste in trying to distinguish between these slightly differentiated tones and the materials they colour? Why draw up a pointless catalogue of things we can't quite grasp, things that seem impossible to grasp when it's such a beautiful day and we're all so happy. We are not obliged to think such ponderous thoughts, or to attempt to discover how the painting achieves such an illusion of nonchalance. This painting should be experienced, not understood. That is Renoir's great strength: he manages to achieve a universal dimension just through the portrayal of a boating party lunch in the 1880s. The flowery hats and the Chatou bridge in the background are not important, neither are the Sunday lunch and the rented boats. It could be any place – anywhere you've enjoyed a few idyllic hours. So much so that you feel able to share this moment with total strangers, to enter into the picture and become a part of it. You dream of being there, you almost share the memory of the event. The minute you see the image it enters into your own consciousness, mingling now with other completely personal memories.

Renoir's picture is the repository of the good life, and for him there was no greater aim for painting than this. Art, to him, was the antidote to everyday anxiety, the sleepless nights caused by suffering and the terrible sorrows of life. The only reality it will accept is that of simple well-being, happiness unaffected by conscience. He restores all those joyful moments that have disappeared over the course of our lives. Of course, it is not that simple – you need a strong will to invent your own version of Eden, always assumed by others to exist only in the pages of the Bible.

As his characters pose for him or choose not to, as they chat and pass before him, Renoir is always recalling, with a kind of greed, the paintings of the great masters of the past, who made light shimmer across the walls of palaces and churches in Venice and Antwerp. He thinks of the banquets given in Haarlem or Amsterdam – surely this little restaurant on the banks of the Seine

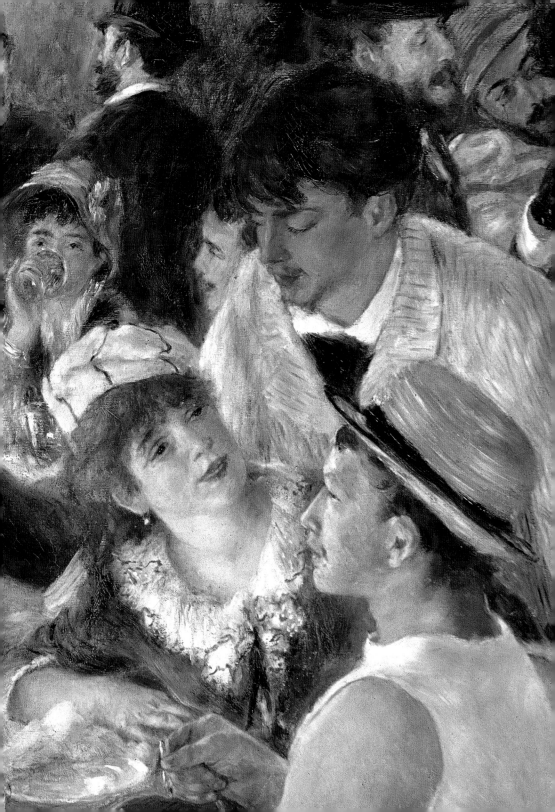

deserves a large canvas. And, as modern as Renoir is, he does love a splendid setting. The constantly moving group is controlled by the diagonal placement of the table. The metal frame of the blind stands in for structure, dividing the surface of the canvas into so many manageable spaces. The stripes and the railings are necessary to articulate a composition which in the past would have been balanced by some kind of arcade between two monumental columns. There is a still life, carefully placed at the centre of the picture, an evasive landscape beyond the terrace, the garden down below. The painting is bathed in a steady sunlight which does not alter the contours of the faces nor the appearance of the objects. The unity of the light wins over the apparent disorder spreading from one figure to the next: a back, a profile, one person chatting, another listening, a question, a pause . . . Blues come close to blacks, brown blends gently with white. There is very little red, just some in a small bunch of flowers on the hat of the young lady with the little dog. The figures become smaller towards the back, where darker clothes are juxtaposed with the mass of greenery. The composition pulls them closer to one another, and the whole scene is successfully held together.

The setting is so harmonious that it is impossible for reality to introduce any kind of tension. The guests come from all walks of life. Boatmen, a gentleman in a top hat, ladies in elegant gloves, cheerful young women, vests and dark suits: the painting encompasses an entire society. It may be that this kind of genre scene does not quite represent an everyday occurrence, and this could be a sort of historical tableau, displaying a range of ordinary people. Great men and great events do not play a part in Renoir's repertoire. This painting is simply informing us about a way of life, or rather about a way of feeling alive in another time.

Nobody will remember much about the lunch itself, if it even happened, or the taste of the wine or the flavour of the dessert. There is just this moment that no one can take away. Renoir has invented a space in which no important event is taking place, a space inhabited only by bright and echoing sounds. We can hear the glasses clinking, the loud voices, the muffled murmurs to which we need not pay attention. The hazy colours hardly disturb the image, over which there hovers a faint but controlled aura of intoxication. This is just one lovely sunny day, or even just one hour.

Maison Fournaise and the models for the painting

Renoir was an habitué of the Maison Fournaise, a restaurant which was not far from the station at the pont de Chatou. You could get there from Paris in twenty minutes, and it was easy for him to visit his mother who lived at Louveciennes, less than an hour away. It was an old shack that had been restored by a hotelier from Bougival, a very simple establishment which had eventually become a sort of sailing club, as the owner, who loved rowing, also rented boats out to visitors. *The Luncheon of the Boating Party* takes place on the terrace of the restaurant. The models, not all identifiable, are friends and acquaintances of Renoir's who posed at different stages: in the top hat is Charles Ephrussi, a banker and amateur art historian; stroking the little dog at the front on the left is Aline Charigot, Renoir's future wife; standing behind her is Alphonse, son of the owners; Baron Barbier, an ex cavalry officer and friend of Renoir's is talking to an anonymous young model leaning on the railing; Angèle, another model, is drinking. At the top and on the right are two friends, Lestringuez and Lhote (wearing a boater) who are chatting with the actress Jeanne Samary. On the right the journalist Maggiolo and Ellen André (who also posed for Degas' *The Absinthe Drinker*) appear, and at the bottom right is a 'much rejuvenated' Gustave Caillebotte.

In the studio or out of doors

This large painting took Renoir several months to complete. He began it in the summer of 1880, and completed it the following winter after several reworkings. His sessions painting outdoors were to be followed by corrections done in the studio. This allowed him to step back and gain the distance required to organise such a complex scene without losing any of the spontaneity of the outdoor study. He was also forced to take note of what light would be needed for the hanging of the painting: 'After all, a painting is made to be looked at in a closed house, with windows which often give on to artificial light. And so one must add work done in the studio to the work done out of doors. One must distance oneself from the intoxication of real light and absorb one's impressions in the twilight of an apartment. Then one must go out again for a blast of real sunlight. One comes, one goes, and in the end one starts to get somewhere!' During the 1880s the artist entered a period of self-doubt. He became uncertain of his ability to handle colour, and felt the need to concentrate on drawing and composition. He dealt with this crisis by studying the great masters of the past more closely than ever, from Raphael to Velázquez, passing by Titian and the frescoes of Pompei.

A memory of Veronese

It may be that one of the great works that Renoir studied in the Louvre, Paolo Veronese's *The Marriage Feast at Cana* (c. 1562–3), served as a model for the *mise en scène* of the *Luncheon*. The painting, which depicts Christ's first miracle, shows a large crowd of people, including the married couple and their guests, seated at a table. The reference is not such a surprising one when one considers Renoir's taste for scenes of cheerful conviviality, such as that in his earlier painting *The Dance at the Moulin de la Galette* of 1876. The subsequent *Luncheon* thus acts as a link to the most distinguished of sources. It should be noted that Renoir was not interested in Veronese's more important groupings, with Christ and the Virgin at the centre, and the cup-bearer pouring the water transformed into wine on the right, but only in the anonymous guests, the as yet ignorant witnesses to a miracle.

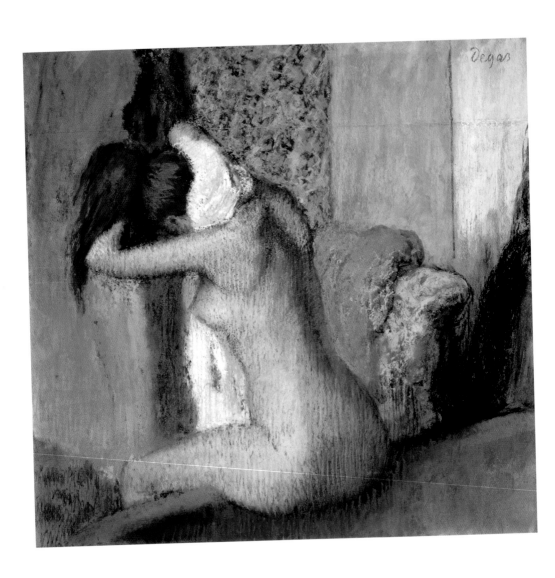

Daring to be bold

Edgar Degas (1834-1917)
After the Bath, Woman Drying Her Neck, 1898
Pastel, 65 × 62 cm
Musée d'Orsay, Paris

A faceless nude, sitting on the edge of a bathtub. The young woman has just got out of the bath. She turns her back and with a towel pressed against the back of her neck she rubs her damp skin, holding her hair up with one hand. It is an intimate scene, and the gesture is so rapid and spontaneous that we hardly have time to describe it. As soon as we enter the room we are struck by the image, and the abundance of colour that fills the whole space of the canvas, that it is almost impossible to retain any particular detail, even if we wanted to. The young woman's gesture only lasts for a few seconds, and our glance not much longer. We know that we are being intrusive; we glance down into the bathtub in which the water is already growing cold. Perhaps we will turn away in order not to prolong this intrusion. And so the actions of both the model and her unexpected observer tacitly coincide.

The pastels seem to glide over the surface, creating the illusion of a spontaneous image, the artist surprised at this unlikely sight, which he records the moment he sees it. The colours spread out, creating an almost hazy effect, correcting and softening our first impression. The perception of this image takes place in two stages: at first we are struck by the sudden appearance of the naked figure in the space; then almost immediately, the effect of the image is calmed down by the fine strokes of colour on the skin, or rather on the picture surface. It's the same thing of course: the contact between the towel and the body is no different from that between the artist's

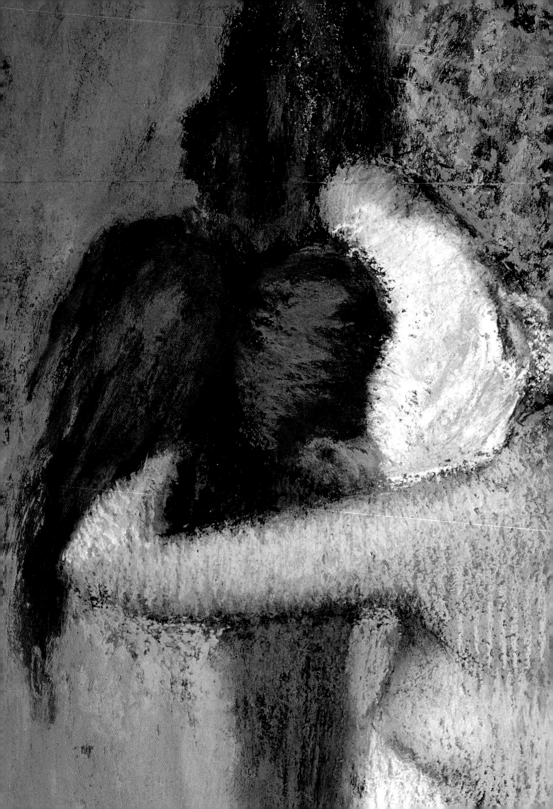

touch and the pigments, or the grain of the paper and the skin itself. The image corresponds directly to the skin thanks to this close attention to the quality of the different textures. Degas only has to reach out his hand to touch the young woman. The materials covering the armchair and the walls are softly emphasised with a wash of green and blue, and the metallic brightness of the grey is bathed in yellows. This almost surreptitious softening effect seems to take away from the abruptness of the gesture, and the body appears to relax as the skin begins to dry and become warm. The rubbing of the towel seems to displace the orange and indigo shades. The sections of colour diminish and melt together, as the pastel takes on the warmth of the body.

Although Degas gives the impression that he is secretly observing the young woman, almost fortuitously and at random, he is in fact creating a carefully constructed image. Despite the apparent naturalness of the pose, the model's body has been placed within a precise geometrical arrangement: with the elbow raised from the shoulder blade, and the straight line from the right hip to the left knee, straight below the elbow, the artist has created a virtual rectangle, all the more effective for the fact that it brings balance to the whole scene whilst remaining almost unnoticed. This mastery of a space, which portrays the sensual attraction of a young woman at her toilette, confers an almost abstract quality onto the scene. The furtive glance becomes frozen into a planned composition and the moment is caught and held by the image.

The simple alternation between the bands of colour does in fact remind one of regular patterns on drapery, or a doorway, or, perhaps, of the folds of a screen or the corner of a room. The arrangement of the lines which score the surface of the picture have the effect of proposing possible backgrounds. The general aim is more one of allusion, suggestion or summary than one of precise description. The artist is aiming to create a rhythm, something to act as a counterpoint to the suppleness of the woman's body, whose curves then seem all the more precious.

A great many drawings, studies and sketches were necessary to achieve the end result of this image. Degas gradually, with a sharper and sharper gaze, stripped away the elements that would encumber and weigh it down. He never quite comes to the end of it. It is never truly finished. It is, however, complete as an image of a precise moment of perfection, in which the senses seem to become numb without losing their strength and the picture still seems fresh from the artist's hand. Real life is still in there somewhere, made more mysterious perhaps now that it contains these erratic lines,

memories of unfinished gestures and poses that seemed too artificial or uncomfortable, the traces of what had to be changed in the course of its creation. The body is marked with these mistakes, differentiating it from the unreal classical ideals, but reflecting its true experience.

In traditional paintings, bathing women would strike detached poses. These goddesses, who had no existence in the real world, would be surrounded by obliging cupids and helpful nymphs. These Venuses, absentmindedly admiring themselves in mirrors which confirmed their beauty, would mime an anxiety about their appearance which they would never really feel. Degas' model, on the contrary, lives very much within the reality of her flesh and the weight of her gestures. She feels the cold and the edge of the bathtub digging into her thighs. The washed away colours seem to render her skin sensitive to the surrounding air. Those nudes worrying about their appearance, whether mythological or not, were putting on a performance, something Degas had always appreciated far less than what went on backstage, behind the scenes. Since he no longer believed in the authenticity of those figures from antiquity, or even in the artificial poses of studio models, he was left with the living and intimate space of the bathroom.

Only an incursion into such a private space could allow Degas to capture something that nobody was supposed to see: not so much the body itself, which was a commonplace sight after centuries of nude paintings, but more the real truth of the body, which had been hidden, reduced, almost erased by all the veils, high collars, petticoats, crinolines, corsets and finely laced boots . . . He was rediscovering the movement of the body, the way it bends and leans, how much it can twist, how far it can reach; the positions necessary to brush one's hair, dry oneself, reach one's back or feet, to straighten up. All these gestures would become an integral part of his repertoire, which would also constitute a deliberate challenge to society's conventional codes of respectable behaviour.

The young woman hides her face, concentrating on her bathing routine. She is not required to express any particular emotion. Degas has set the nude free from any of the psychological constrictions that persisted in the tradition of the genre; he has finished with codes of morality or seduction, those knowing glances and demonstrations of innocence and purity. The eloquence of this picture lies in its portrayal of the actual reality of the human body: henceforth the only language used will be that of the contour of the shoulder blade, the alignment of the arm, the gentle fall of the hair or the soft movement of the back of the neck.

Lessons from Ingres

With most of his nudes Degas avoids showing the model's face, following the example of the *The Bather* by Ingres from 1808. This was a favourite technique of the old master, used in his *The Turkish Bath*, the famous odalisque seen from behind, painted in 1862, and which was an inexhaustible source of inspiration for Degas. He must have often thought about the symbolic role played by the work, which was responsible for his first meeting with Ingres, when he was a very young man. Edouard de Valpinçon, the owner of the painting, had refused to lend it for the Great Exhibition of 1855, fearing that it might be damaged. Degas was a friend of Valpinçon's son and acted as a go-between, successfully persuading the collector to change his mind. When he brought the message, or possibly when he came to get the painting from Ingres' house, he timidly introduced himself to the great man he admired so much: 'I do a bit of painting; I have just begun, and my father, who is an art-lover and a man of taste, thinks that I may not be completely hopeless . . .'. Ingres replied: 'Draw lines, lots of lines, either from memory, or from nature.'

Freedom for the body

The traditional theme of bathing women descends both from Biblical representations (the story of David and Bathsheba or that of Susanna and the elders) and from the figures of classical goddesses, such as Venus or Diana, surrounded by their companions. In general the depiction of the nude involved a certain number of poses, connected since the Renaissance with settings drawn from mythology or literature, to which were added, during the Romantic period, the new attractions of Orientalism. In all cases the gestures and poses of these exemplary figures were designed to emphasise the perfection of their proportions and to formalise the beauty and dignity of the subjects. Degas departed from these traditions by showing ordinary women of his time getting on with their ablutions in a totally natural manner: 'They are simple decent women who are simply taking care of their physical needs,' he said. He kept a bathtub in the middle of his studio, around which his nude models would freely interact. Their bodies could then be observed in a variety of positions, some unflattering, some incongruous, some which would shock the public, who had no desire to see a reflection of their own intimate life. In addition, people would often assume that the women must be prostitutes, especially as they were considered the only people who needed to wash so frequently . . .

Pastels

Degas began to use pastels at the end of the 1850s, probably inspired by Gustave Moreau. At first he used them sporadically, for sketches and private works, and then for a series of landscapes on the Normandy coast in 1869. From 1875 until the end of his career, they became his favourite medium, as they responded both to his vision of a moving, transient world, and to his need to work fast, whilst always experimenting. The rich and layered colouration of the work is thus a result of the application of several layers of colour that do not quite overlay one another; he would fix them as he went along so that they would not mingle. In order to work the pastels, either neat or dissolved in solvents, Degas would use brushes, sticks and sponges; he would slice into the surface with knives or hot needles; sometimes he would place the work in progress on the ground and, first covering it with cardboard, stamp on it in order to make the pastel penetrate the backing and thus to obtain the effect he was seeking. Nobody ever found out the secret of the fixative he used, which was specially made up for him by his friend Luigi Chialiva.

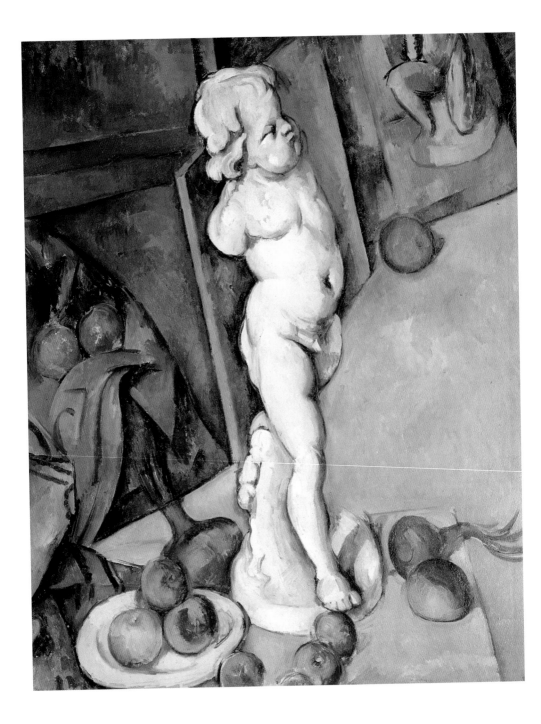

Uniting the present

Paul Cézanne (1839-1906)
Still Life with Plaster Cast, 1895
Oil on canvas, 70 × 57 cm
Courtauld Institute, London

One look should have been enough, you might have thought, for these simple objects placed on the corner of a table, or on the ground, not particularly susceptible to the passage of time whilst our gaze lingers.

A small statue of Cupid, a few apples unsteadily balanced on a plate, with others pushed between the folds of a piece of blue cloth, an onion – no, two. And then there is the haphazard nature of the canvases on the floor, propped up against the wall. There's another painting there, at the back, with the sketch of a sculpture taking shape. There is nothing more here than the unsurprising disorder of an artist's studio, full of disparate objects scattered around. Cézanne might have seen all this as we do, not paying much attention to it, as he arrived at his studio each day, with his mind elsewhere, already looking towards the waiting easel and canvas. He has surrounded himself with these objects, as if to form a sort of makeshift rampart, arranged according to his needs, across the canvas, in the corner of the room, filling gaps where the eye might start to wander and lose interest.

Away from the wind and the effects of sunlight, the fruit is threatened only by a slow patina of age and then of course comes the sweetish smell of decay as it continues to ripen on the plate. Soon the apples will be spoiled, speckled, fading between the folds of the cloth or shrivelled up on the edge of the table. It doesn't matter – he can paint them just as well from memory as from life. Cézanne was less attracted by the ephemeral manifestations of

nature than were the other Impressionists. Does he really count as an Impressionist at all, since he chooses to paint things that change as little as possible? But how could he not be, since he observes what is around him for hours, days, months, years, and it is the instability of his own vision that he records, and that becomes his subject. It is, for him as for the others, a matter of capturing movement, but here it is his own, that of his spirit and his eyes. Even if everything he saw was suddenly frozen, the painter would still be interpreting the fragility of what links him to the world around him.

And so the moment that he seizes is less a moment in the existence of that object as that of his own perception of it, which he grasps and transforms into a brushstroke of colour on the canvas, or sometimes a shape. He approaches, retreats, waits a while and then starts again. Nothing has moved but the artist's own breathing is enough to change the contours of the objects. His attention wanders, he looks inside himself, the paintbrush is motionless. The floor, covered in paint, rises up level to the painting. The artist looks up: what was real a few hours ago no longer exists. He discovers a shred of reality, then another, and the picture gathers together whatever it can. What it finally shows, and what seems quite obvious to us, is the result of an accumulation of different visions, combined, woven together in order to establish, if not some continuity, at least a coherent picture of something that one can identify with. Unsatisfactory, everyday, chaotic life, torn to pieces, is always seeking such coherence, but the artist will not settle for any fake harmony – the painting simply sews the pieces together.

The picture is built up piece by piece, with no attempt to mask the confusion that inhabits it. Part of the space is given over to this permanent state of doubt, which is also its raison d'être. The empty spaces provide almost as much material as the objects themselves. On either side of Cupid's head the contour of the canvas placed at a diagonal changes levels. An apple is suspended on the obtuse angle of a table that is not really a table. What else is recognisable? The everyday likenesses make the painting plausible, which was no doubt the artist's intention. On the left the deep blue cloth leads seamlessly from the table to a completed painting, without one being able to distinguish between the object and its image. The problem is how to separate the two. Each brushstroke expresses the reality of something experienced just then, or yesterday, or weeks before, or even months ago.

The image, which at first appears so simple, is undermined by these mysteries: how can one be sure of anything when the visible is constantly being redrawn by the urge to see things more clearly, or simply by weariness. A gaze that is so

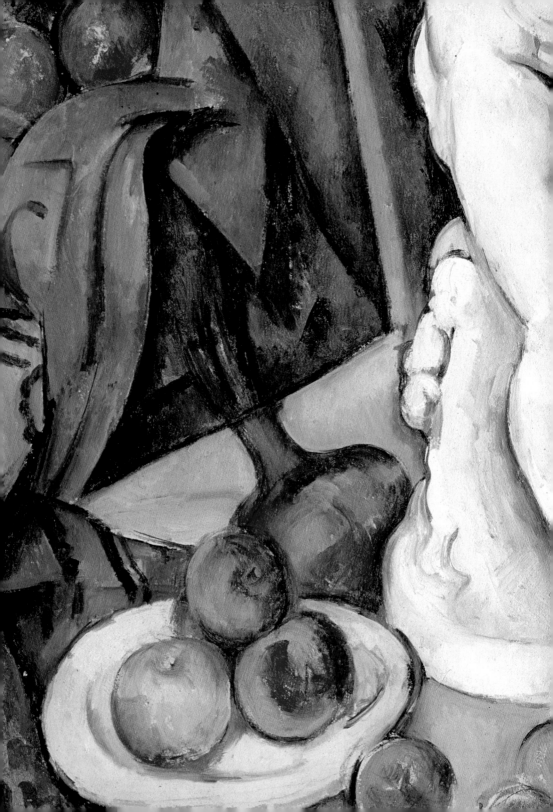

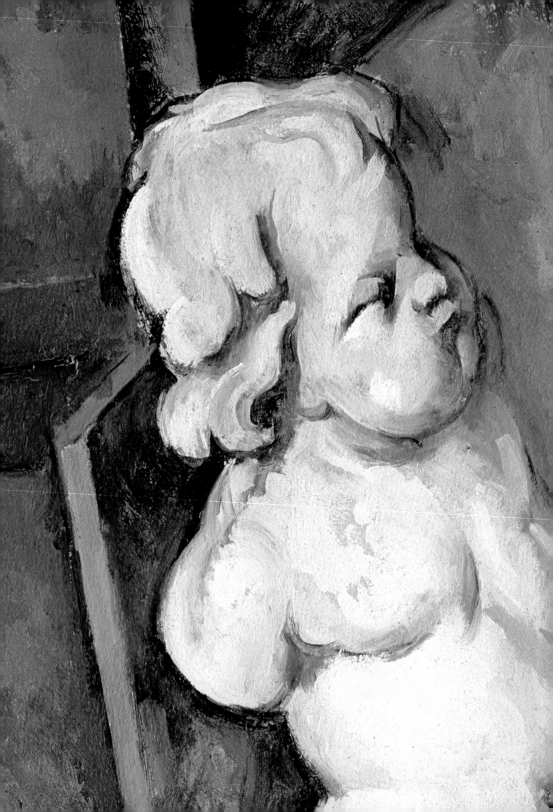

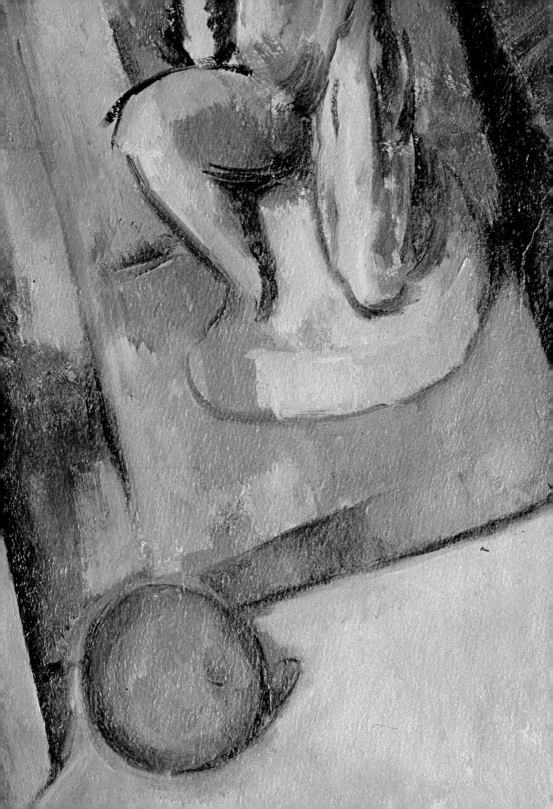

unsure of itself must rely on patience for a finished work to finally emerge from all these furtive, half-glimpsed scraps, which, laid end to end, never quite match up. But they do nonetheless result in a work of art, because, for the first time, they portray the intermittent nature of reason and emotion. He does not abandon the balance of the image, but treats it as a space in which time can be tamed and regained. The artist moves around the picture, at the margins of the space he tackles, in so many different ways depending on the day. I saw this, I was looking at that, do you remember, we were there . . . all are me, him, the other, reduced into so many different viewpoints, each one equally honest, valid and pertinent. They are equally lost but determined, each different point of view landing and finding its place on the canvas. All those forgotten moments and empty days – how can you leave out a single one in order to create a more realistic picture of the visible world? Cézanne was unable to lie in his painting, even if it meant putting his reputation at risk.

The armless Cupid, deprived of his bow and arrow, remains the pivotal figure of the painting. He is able to turn in all directions at once, but can no longer choose one. The divine troublemaker, who could inspire desire and, in all those stories, toyed with the sorrows of love, is here reduced to a mutilated plaster cast. Close to him, the apple that is about to fall gives off the aroma of past sins. There was a time when the young artist was driven by terrifying desires: he painted kidnappings, rapes and other bacchanalian scenes, he painted muddy Tragedy, made ugly by dirty tears, heavy with brown and blue washes. Cézanne's youthful work, which was dramatic and unsubtle, had revealed the tormented condition of a shy young man haunted by fears and silent hallucinations. Here, his troubles are no longer a hindrance to his work, they have become a part of it. Cézanne is no longer waiting for the day to come when things will be simpler and real life will begin. He knows now that the experienced world will always, and with complete grace, defeat any dream world, and that is exactly what he paints. Cupid can no longer flap his wings – they are eaten away and useless. He no longer needs them and here he is now, wiser and calmer, in the position in which the artist has placed him. He is just an antique amongst many others, a presence perhaps still conflicted on the inside by contradictions, but these oppositions become pivots around which all the rest can be arranged. He is now an artist's model, demonstrating to pupils the different brushtrokes, giving them a lesson about time and love, teaching them to draw. An unstable kind of reality perhaps, but peace has been achieved and true contemplation made possible at last.

Love and the anatomical model

The objects shown here, which Cézanne kept in his studio, appear in several other works, both drawings and paintings. It is not known who made this now lost eighteenth-century Cupid, of which Cézanne owned a cast: the names Pierre Puget, François Du Quesnoy and Coustou have all been suggested. The painting in the background shows the bottom half of another cast, from a sculpture once attributed to Michaelangelo, and which was extremely important to Cézanne, if one is to believe the account of his friend Joachim Gasquet: 'Right up until his final hour, he would, as a priest reads his breviary, draw and paint the Michaelangelo cast from all aspects.' The juxtaposition of Cupid, the figure of Love, whose sexual organ is at the exact centre of the painting, with that of the cast in the background might suggest some tension between reason and the erotic impulse, the separation between the desire, always contained, for pleasure and the appetite for knowledge.

'The modern condition of neurosis'

During the last years of the nineteenth century, a great many writers began to consider the question of 'neurosis', in view of the great changes that had taken place in the concept of the painted image. The word did not yet have the connotations later introduced by the works of Freud. Then all it meant was some inner trouble, some hypersensitivity to the spirit of the time, which would explain the softened contours, the unfinished nature of the paintings and the feverish style of the drawings, all of which were the characteristic attributes of Impressionist painting, and, at another level, of Cézanne's destructuring of space. 'Our epoch is unsubstantial, its certainties constantly shifting, its decisions unstable; it goes by in a constant haste. This hurried diversity of existence causes the nerves to become fragile and oversensitive, and induces anxiety of thought and insatiable desires, which ruin the weak and inflame the strong: this modern condition, neurosis, has affected many of us; some have been exalted, lit up as it were, by shafts of bright light, while others have been defeated by it.' (Étienne Bricon, *Psychologie d'art*, 1900)

Zola's lack of understanding

In 1886, Émile Zola published *L'Oeuvre*, the fourteenth volume in the saga of the Rougon-Macquarts. Twenty years earlier he had been a great supporter of the work of Cèzanne, and subsequently that of Manet and the Impressionists. By the time of his novel, however, he considered their work to be a failure and his hero, mainly based on Cézanne, is a failed painter. The publication of the novel brought to an end a friendship that went back to the two men's childhood: 'After several weeks of happy work, everything was ruined, and he could not complete his great female figure. He was killing his model with exhaustion, driving himself for days on end, and then he would drop the whole thing for a month. Ten times the figure was started, abandoned, and then begun all over again. A year went by, then another, and the painting was still not finished; sometimes it was almost complete and then he would scratch it out, and everything had to begin again. [...] It would take another generation, perhaps two, before it would be possible to paint and write logically, with the pure and lofty simplicity of truth ... Only truth and nature can be the proper basis, the necessary discipline, outside them lies madness. [...] No, he has not been the man to carry out his own ideas. I mean that his genius was not powerful enough to stand them up and create with them some definitive work.' (Émile Zola, *L'Oeuvre*, 1886)

Seduced by appearances

Impressionist artists no longer believed in the prevalence of one single image in a painting. How could they, when they watched the changing light transforming everything it touched from moment to moment: colours would melt into one another, boundaries between forms would shift, silhouettes would dissolve. To them reality was indefinable, and, instead of avoiding the problem they sought to embody it, by showing a plurality of more or less indistinct images, none of which convey a clear statement about the nature of things.

Their painting had no purpose other than to reveal that which everybody could see. They had no intention of crossing this barrier, beyond which lay eternal certainties – indeed they delighted in the idea of a multitude of possibilities.

They were in effect choosing to convey a different kind of truth, no less tyrannical in a sense, than that of the moralists of the past. Theirs was the truth of accurate perception, shown within the discipline of what could actually be seen by any onlooker. It was a matter of showing another kind of accuracy, one which would very often upset an audience accustomed to seeing things more clearly defined in a painting than in real life: they used to be able to count the buttons on a pair of boots, or the leaves on a tree, and now they could hardly even see the edges of their own fence.

By placing the emphasis on the immediately visible, Impressionism brought to the fore all the elements that come between the viewer and what they are trying to see: a sheet of snow, a curtain of trees, a blinding light, an atmosphere built up in half-tones. The painting technique itself became all important, with the materials presented centre-stage and the brushstrokes highly visible, which ran counter to both standard practice and to the ancient rules of the illusionist's art.

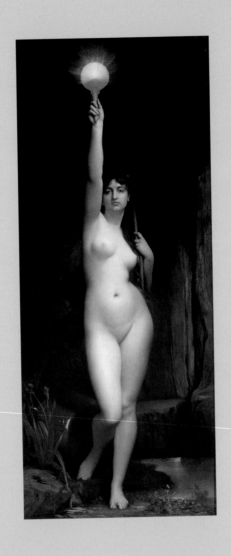

Finding another truth
Jules Lefebvre (1836–1911), *La Vérité*, 1870
Oil on canvas, 264 × 111 cm, Musée d'Orsay, Paris
.
.
.
.
.

Truth does not feel the cold: virtue can rise above natural difficulties – nothing can affect the purity of her colouring, a blend of marble and ivory. She who sees everything holds up a mirror in which every man can see into the depths of his own nature. She appears out of the darkness beside a bubbling spring, and lights up the world with her absolute authority. All she knows of time is that it will always allow her to triumph.

This is not really the body of a woman, but more that of an idea, a dream of the essence of womanhood. It is a timeless image, but one with enough photographic accuracy to be truly seductive. But of course it is a purely intellectual form of seduction. This is a serious painting. This severe creature will certainly call to order anyone who starts becoming excited by her chilly attraction: she isn't really naked, as she has never had to remove any clothes.

Allegory already had a long history in painting, but it continued to inspire the academic painters, who were fervent defenders of the beautiful and the good in art. This is more than just a subject, it is a metaphor about what painting is supposed to offer: a perfect accord between content and form and the correct expression of an inalienable principle.

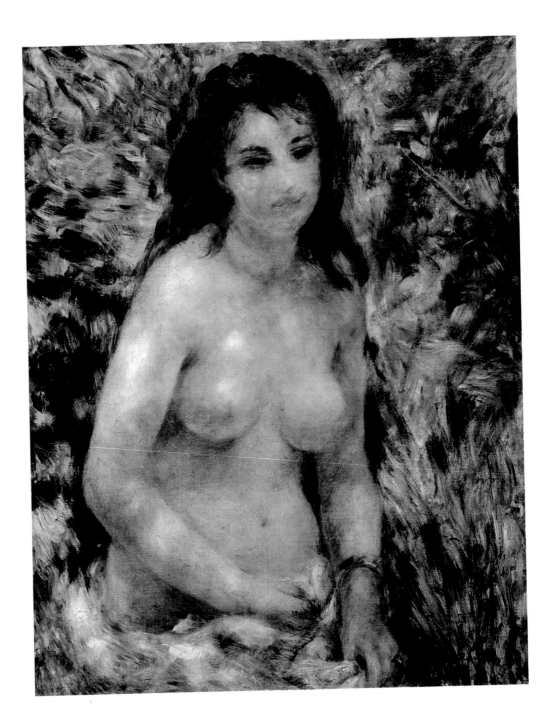

In love with youth

Pierre-Auguste Renoir (1841–1919)
Study. Torso, the Effect of Sunlight, 1875–6
Oil on canvas, 81 × 65 cm
Musée d'Orsay, Paris

She has the timid and almost awkward manner of a new model. She holds a cloth around her hips. She appears to be listening to the artist's instructions. Her hesitant gestures seem to blur her outline and the painting has ruffled her hair. She has kept just a bracelet on her wrist. The sun filters through the leaves, colouring her naked flesh.

Her gesture recalls the pose of a modestly draped Venus and the greenery that surrounds her seems to make her in some way a sister to those nymphs dancing in the forests of antiquity, happily bathing together, believing themselves unwatched, whilst a faun waits, poised, about to emerge from his hiding place. All those furtive and elusive creatures of woods and fields, leaving delicious memories in their wake. But we digress, carried away by the weight of outdated tradition. All we have here is a young woman with an already well-developed body, half undressed for the purpose of this painting. The bracelet she is wearing, more a trinket than the ornament of a goddess, brings her firmly back into the present. It is impossible to connect her with any allegory or random divinities, with their certainties about their purpose and mission, all well-protected by the contours of perfect draughtsmanship. This girl belongs to a time in which fables are no longer necessary. Or perhaps they have not yet been invented. Renoir has turned his back on the

old classical models, and gives one the impression that mythology could very well begin here, at this precise moment in time, with a pure image of a figure that is both radiant and yet completely lacking in self-assurance.

The division between darkness and light has almost disappeared and instead what we have is simply a dialogue between the light and the girl's skin. It replaces the distribution of shade which in the past always defined the contours of the body. The result is an abundance of homogeneous and volatile colour. The flesh tints of the body are overlaid by streaks of blue, patches of violet and shades of mauve, and a light yellow. Thus the painting endows the model with another dimension of existence, a deceptive and fleeting image, entirely subject to the passing moment. One image follows another, always changing with the constant redistribution of the light. Nothing remains still and there is an illusion of red, a suggestion of warm ochre, dashes of blue. None of it is part of the girl herself, or tells us anything of her thoughts, or where she lives, or what she would be like if she were removed from this play of the light.

Just as the coloured reflections end up masking the reality of the girl's flesh, so each brushstroke both shapes and destroys her. The two actions can no longer be separated: the blue paint stroking her breast is also bruising it. A particularly strong ray of sunshine threatens to completely distort the figure, and to efface its true shape, whilst her face is weighed down by red paint. Her whole body seems to sigh heavily beneath the feverish activity of the paintbrush, or perhaps she is simply affected by the heat. All this starts out as no more than a vague feeling, a kind of ambivalence that increases as we study the painting and its apparently anodyne subject matter. At first sight we have a pleasant image, with no emotional hinterland, nothing which could trouble the spirit of the viewer, except perhaps the very lack of even the most tenuous of narrative contexts.

Renoir has painted a vulnerable body, unprotected by any history. There is nothing to fix it in the eternity of mythology. Traditional nudes, with their ageless marmoreal purity, were assured of an entirely abstract existence into which no suffering could penetrate. They existed outside time, ignorant of both the beauty of youth and the decrepitude of old age. Renoir's model, exposed as she is to the sweet torment of these variations of the light, is, on the contrary, engaged with her own future. A breeze blows over her soft skin. Youth has never been so clearly perceptible as it is here. And because it is so evident it starts to worry us – this picture suddenly seems to be telling us something about the possibility of growing old.

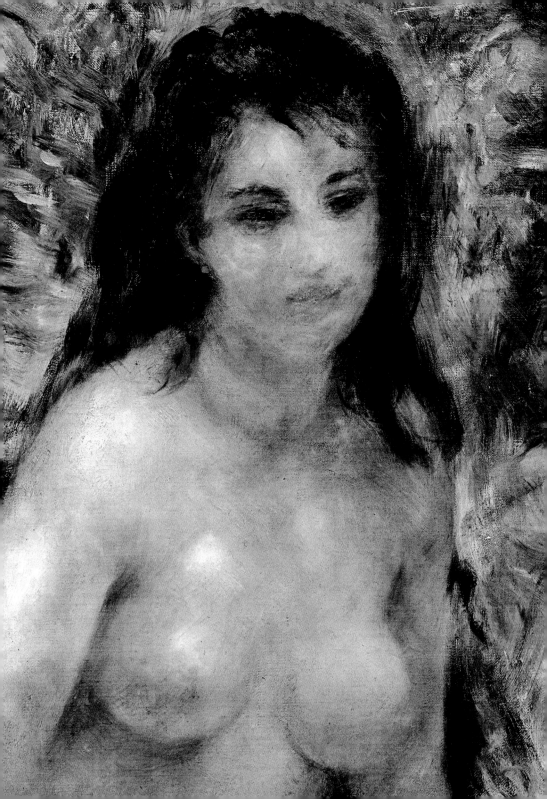

As sometimes happens, an artwork can open an unexpected door and spring a whole new meaning and another kind of relevance on us. The mind is drawn further than it might have expected, to the edge of an abyss. This deflection is quite possible – a painting is not always aware of its consequences, and this indifference allows meaning into what is missing. An image lingers, superimposing itself on another. The bluish lines remain on the skin. Instead of fading, diluting or disappearing to enliven another part of the picture, they seem to sink into the flesh and corrupt it. And so it appears that the colours of a glorious summer's day are not so different from those of death itself. Just one bright and unforgiving moment can bring a living body to an end and transform it into a frozen corpse. The painting suddenly becomes frightening and unrecognisable. The skin seems to have turned to ash, and we no longer know what we are looking at. The image has paid the price for its frivolity.

But the picture also speaks, in another way, about the future. It seems to marvel at that which appears, which charms us and then disappears in a few seconds, not waiting for brutal reality and its harsh lessons. The light plays before our eyes, amusing itself with the young model, selecting from its prism the most becoming colours, as one might choose a jewel or a ribbon. Time, observing her at this turbulent moment will also attempt to transform her, but will not prevail. She is not ready, not yet. Renoir keeps her back, in that undefined space of sketches, studies, and images which are nowhere near completion. And so this painting remains as a promise – not a stage amongst others, which should, like all creative endeavour, result in a finished work, but as an essential phase of his art, fundamentally imperfect and eternally youthful.

The colour of flesh

The nude was one of Renoir's favourite subjects. His figures, which were very different to those of classical tradition, were above all affirmations of the bloom and abundance of flesh, which towards the end of his life would take on mythical proportions: *The Large Bathers* were the direct descendants of the paleolithic divinities of Mother Earth. The young woman portrayed here differs from classical models, not just because of her natural pose, but also because of the colours of her skin. Renoir had no time for the evocations of enamel, marble or alabaster that one could see hanging in the official Salons. He followed other examples, particularly that of Rubens, who had already used touches of green, mauve, blue or yellow to bring flesh to life. All Renoir needed to do was to study his portraits of Hélène Fourment in the Louvre, or the great canvases of the *Life of Marie de Medici*, abounding with voluptuous nude naiads and other nymphs. Eugène Delacroix, recognised by the Impressionists as one of their greatest influences, had worked in the same manner, giving his *Liberty Leading the People* of 1830 such violently coloured flesh that the public, unable to recognise the allegory, was confused and horrified.

A 'decomposing' body

Green or blue tones were normally used for representations of dead bodies. Renoir, using them to show coloured reflections on the skin, was reacting against a visual convention that had been established on a sound observation of reality. Although to us the very notion of decay or mould in the context of such a picture seems incongruous, we can nonetheless understand what the more reactionary criticism was getting at, when expressed by an outraged Albert Wolff: 'Try and explain to M. Renoir that a woman's torso is not a heap of decomposing flesh covered in green and purple patches indicative of a corpse in a state of extreme putrefaction.' There are two conflicting approaches here: that of the artist, who is simply trying to describe what he sees, and that of the spectator, who is looking for a heightened reality and insists on searching for it in the painting. The quarrel is based on a misunderstanding and illustrates the prickly choice between the reality of objects and the way they appear.

A fear of reflections

Nineteenth-century painting manuals repeatedly put painters on guard against 'foreign reflections', which could disrupt their work. They explain how they can be avoided with the help of blinds and curtains. But work carried out in the open was more problematic, with all its attendant inconveniences such as draughts and dust. These could be avoided by painting canvases inside the studio, where one could imitate the atmosphere in nature. All this was possible, as one of the artists recalled 'unless one exposed one's models to the rays of the sun, which would be insupportable to anyone other than peasants.' But in the end the main attack on the notion of reflection came from the fear it engendered, expressed unequivocally by the critic Jules Lecomte: 'When it is a question of painting a portrait, whether in the sun or the shade, out of doors or in the studio, by daylight or candlelight, we cannot allow the figure to become merely a sort of lantern on which lands a forced combination of the reflections of the thousand and one objects surrounding the subject: reflections of people, of things, of the atmosphere. One would be applying to painting the old platonic theory which saw us only as reflections of others.'

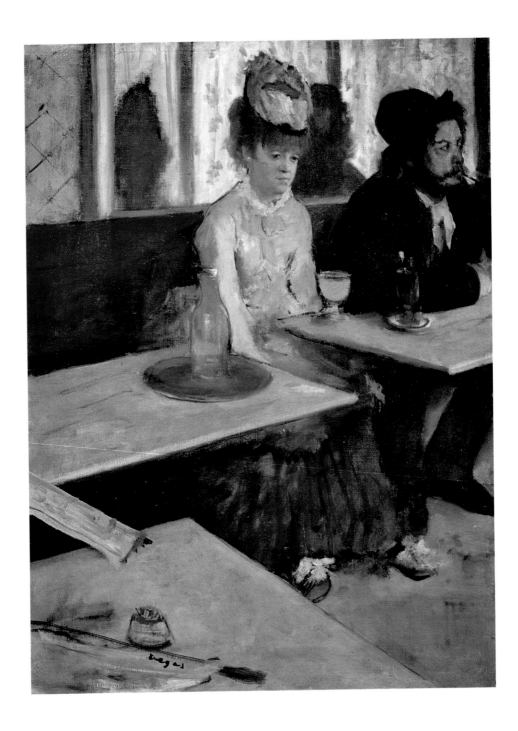

Forgetting decorum

Edgar Degas (1834–1917)
In a Café or *The Absinthe Drinker*, 1875–6
Oil on canvas, 92 × 68 cm
Musée d'Orsay, Paris

.
.
.
.
.
.
.
.

She stares vaguely, lost in her thoughts, leaving untouched, for the moment, the glass of absinthe which draws the eye like a lamp. He, on the other hand, is more alert and seems to take an interest in what is going on around them. Perhaps that's an exaggeration. He just sits with his arm resting on the table, happy to look elsewhere. The grey tones of the painting bathe the café in a subdued afternoon light, imbuing it with an atmosphere of boredom. The canvas, with its washed out colours, seems as soft as an old piece of blotting paper.

We can immediately imagine some simple story, inspired by the woman's air of resignation, her arms hanging down at her side as though she has forgotten that they belong to her. Degas, in any case, hardly bothers to paint them – they're useless so there's no point focusing on them. And so he leaves the painting unfinished. The glass of absinthe has become the focal point of the picture, so much so that it became part of the title of the work. It takes over from the rest of the scene, as it is both the cause and the effect of the everyday drama that is being played out. It explains the sort of emptiness that gives the image its sense of exhaustion, and the gloomy attitude of this woman who has nothing to look forward to, except, at most, a staggering exit from the café. Her companion, who may be no more than a chance encounter, appears to play a subordinate role. He probably won't stay there as long – his legs look strong enough to carry him elsewhere. His position in

the picture, at the edge of the canvas, denotes his importance: she either does not know him, or she knows him only too well. Anyway, she is the one we are watching, and she is the one who will end up alone. It is almost as though she is a symbol of absinthe itself; the poor woman of the streets is acting as the poignantly updated version of a classical allegory. It is certainly the case that she is the main character, at the centre of the picture, a slightly unsteady axis for the whole image, a perfect example of deplorable morals, or, worse, of the vices of an entire era. It's a punishing part to have to play.

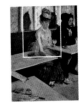

There is a repertoire for the representation of drunkenness in art, in which it is presented as equivalent to greed and the other deadly sins. As they so often do, artists treat the subject in an ambivalent manner, showing us both the pleasures of the sin and its dire consequences. The characters portrayed by Brueghel or Rubens, to mention only two, roll on the ground in joyful embraces, get into meaningless fist fights, or just gaze beatifically at the world around them. The children seated around family tables in the paintings of Jan Steen or Jacob Jordaens seem prepared to follow cheerfully in their footsteps, and everybody is happy because the evils of a bad upbringing are thus exposed in the most entertaining manner possible. It was a way of educating people through warning and bad example.

This could have placed Degas in the very respectable tradition of moralising artists and other lesson-givers. It is certainly the case that everything about the appearance of this figure points against her: a woman sitting in a café in a slumped position, her feet sticking out to the side like those of a collapsed puppet, her body literally in a state of confusion. It is a genre scene portraying a side of life most displeasing to the censors. But their problem with this painting is that it is difficult to find any moral judgement on the part of the artist. And so they immediately come to suspect Degas of being provocative: only some kind of perverted pleasure could explain this betrayal of the simple rules of good conduct.

In fact it does not matter to Degas whether these two are drunk or not; he neither conceals the fact nor does he revel in it. He is not drawn to fiction, and, as is always the case in his work, it is the body itself that speaks, not the morals of bourgeois society. He observes this woman leaning slightly forwards, with drooping shoulders and empty hands, because she supplies him with new possibilities of form. In the same way he would paint dancers or women ironing, all moving in their own way, or jockeys and horses, each with their own set of characteristic gestures and poses. Here, in this particular space of the café, which is neither drawing room nor theatre,

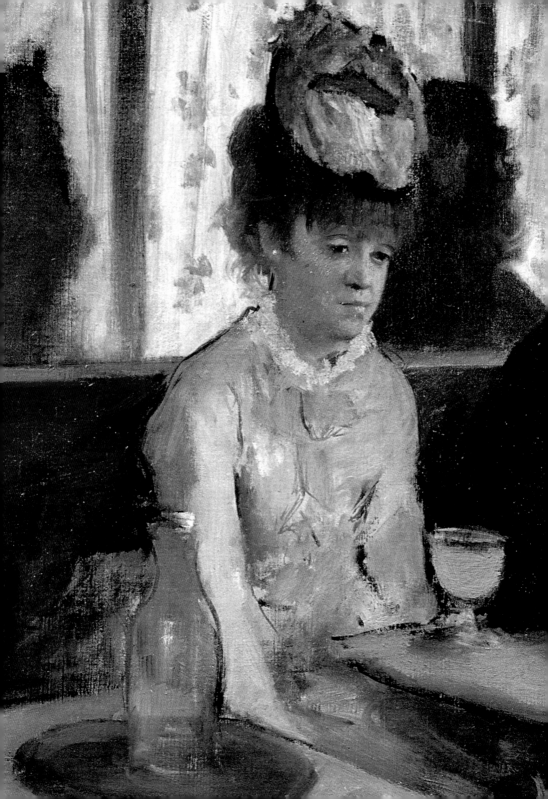

another language prevails – one might even say a whole other vocabulary: that of the loneliness of the discarded rag doll, of a body that has been used up and that has no words left, and no reason to find any.

The two figures, who are ignoring one another, or maybe not, are enveloped by the softness of the different tones. It is enough that they are there, at the same place, at the same moment. They have abandoned themselves to the lethargic atmosphere of this melancholy moment, perhaps finding in it some sort of respite. Her hat is a little crooked. There have been better days, brightened by the soft yellow ribbons on her corsage, which even now provide a shimmer of light in the grey evening.

The café, hardly described by Degas, provides him with an alternative space, a sort of retreat from real life. Here he finds what cannot be shown elsewhere, that which we are not supposed to see. Things are abandoned, and life drifts on aimlessly in this silence and amongst these subdued half-tones. One can imagine the faded sounds in the background, half-heard sentences, blurred by the comings and goings in the room. Here the artist has discovered much more than just a new background to paint, it is a completely new way of accessing the nature of man. None of the rest matters. The mirror does not tell us much and simply shows us a coarse reflection of the two figures and some light from outside. There isn't even the reflection of a waiter.

The woman is seated almost between two tables, as though she couldn't find a free space, or one that suited her better. And yet the rest of the café appears to be empty. Perhaps, after all, she did want to get closer to this man who doesn't seem to have seen her, to be closer to someone, anyone. Around her Degas has composed a staggered arrangement of space, the sketch of a labyrinth leading from one table to the next. And so there she is on the edge of nothingness, on the margins of her own little world, which is as complicated as it is unstable. Indeed it is so complicated that she is lost in it, even though she doesn't move. But it is so simple that she is impoverished by it. The viewer remains entrenched behind their own table, the first one they bump into. In the end each one is in their own way, imprisoned. The image, without appearing to, is showing us the unbearable.

Degas, as usual, does not linger. A few casual brushstrokes are enough to fill up the foreground of the canvas, where a few newspapers are lying around, no longer useful except as a place for the artist to put his signature. They've read the news. Out there the world continues in its constant commotion.

A scandalous subject

The work, originally entitled *In a café* by Degas became *The Absinthe Drinker* in 1893. When it was shown at the Grafton Gallery in London it was immediately perceived by the majority of the public as a detached, and all the more shocking for that, portrayal of the depravity of the working classes wallowing in drink. The picture caused a great scandal, fuelled by the press. The reactionary die-hards found the attack on the accepted dignity of artistic subject matter quite intolerable and saw it more as a sociological study or a piece of temperance propaganda – the consumption of absinthe, the 'green fairy' was eventually forbidden in 1915 – whilst other critics, who read it simply as an anecdotal painting, praised the genius of the artist. George Moore stated, 'My God – what a hussy! A whole lifetime of idleness and low vice is written on her face. It is not an agreeable story, but it teaches a lesson.' He concluded with evident admiration: 'The beautiful, dissonant rhythm of this composition is like a page of Wagner.'

Between literature and music

A London critic, W. B. Richmond in the *Westminster Gazette* of 16 March 1893, reproached Degas for using the painting as a 'literary spectacle', whilst another, Charles W. Furse, retorted two days later in the same paper that 'the delicacy, charm and beauty' of the work overwhelms the spirit in the same manner as 'a great symphony'. Like Degas, all the most innovative artists of the time tended to abandon description and attempted to depict suggestive equivalences, thereby mirroring the effect of music. In its extreme form, this would lead to abstract art. Gustave Flaubert had in 1861 described this approach: 'The story, the plot of a novel does not matter to me. My idea, when I write a novel is to create a colour, a tone. [...] In *Madame Bovary* all I wanted to do was to render a certain shade of grey, the colour of the decayed lives of concierges. The story I planned to place within this mattered so little to me that a few days before I started I had planned Madame Bovary completely differently.'

Two friends in the Nouvelle-Athènes

Degas' painting was created from a *mise en scène* in which he had placed his friends, the engraver Marcellin Desboutins and the actress Ellen André, who described it thus: 'I am sitting in front of a glass of absinthe, with Desboutins in front of some harmless beverage, the world turned upside down, eh! And we look like two idiots.' They were in the Nouvelle-Athènes café in Place Pigalle, one of the centres of artistic life since before 1870. Degas could be found there, as well as Monet, Renoir, Pissarro, Gauguin, Lautrec, then Seurat and Signac, as well as Manet, who may have had Ellen André pose there for *Plum Brandy* (1877) and celebrated his Légion d'honneur there in 1882. One significant detail can be seen in the foreground of the painting: 'The waiters in the bar were themselves interested in the artist's discussions, and would obtain newspapers carrying criticism that concerned them as soon as they appeared.' (Sophie Monneret, *L'Impressionisme et son époque*, 1979)

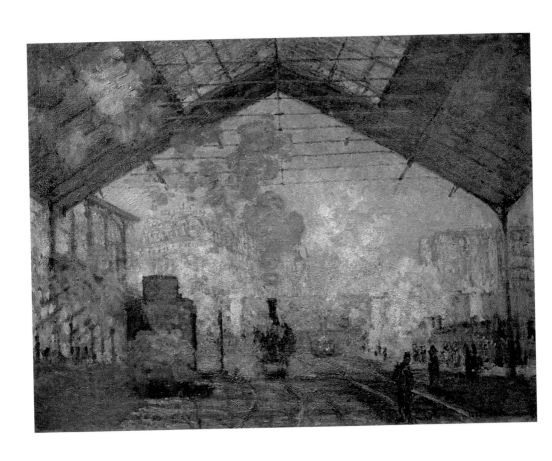

● ● ●

Neglecting the machine

Claude Monet (1840–1926)
Gare Saint-Lazare, 1877
Oil on canvas, 75 × 104 cm
Musée d'Orsay, Paris

.
.
.
.
.
.
.

A train pulls into the station. One can guess at another following behind. Monet knows that he will not be satisfied with just this one point of view. On another day he will have to place himself nearer, go forwards, and then back again in an effort to capture the essence of the scene. Maybe a cloudier sky would be a more effective rival to the steam escaping from the engine. People coming and going perhaps . . .

Everything is still so new; these narrow steel pillars, the huge panes of glass, the platforms leading out into the open. The city never stops changing, and painting is changing with it. The station attracts visitors, as curious as the travellers are confident: people just passing through the capital, architects intrigued about these new techniques, blasé city-dwellers, lovers of the machine, and also artists keen to develop a personal repertoire that is relevant to the contemporary city.

Monet's tendency to create multiple images, which differ from the usual progressive and cautious approach to a painting, demonstrate a wish to cover the whole subject, with more and more detail, using the different points of view to build a portrait of modern life. Moving from surprise to peaceful

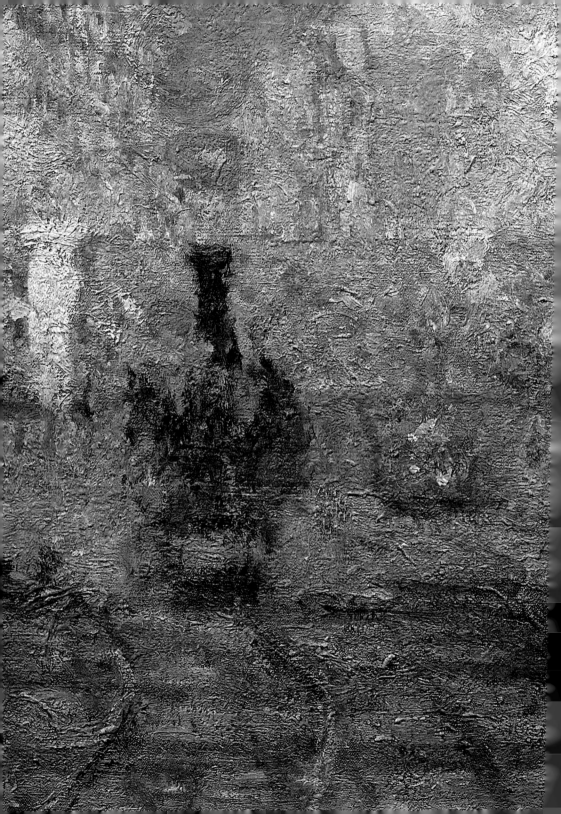

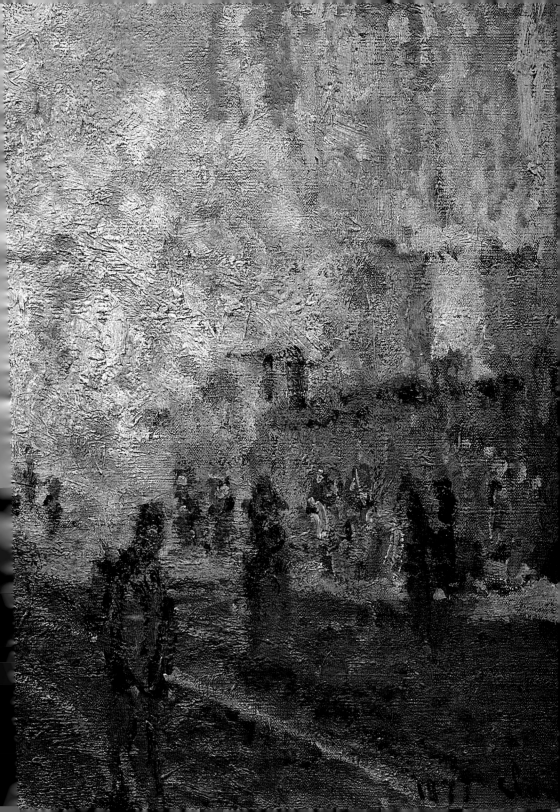

familiarity, from planes that are sometimes tightly controlled to sometimes fleeting and oblique, the whole subject can be explored with no fear of repetition. The time of responses made to a set of cautious variables is now over. There is no question of reproducing a successful painting in order to please the paying customers; now the artist must always consider to what extent the visible remains partial and fragmented. Each painting will therefore remain unique, since it can only deliver the clear perception of one particular moment, from one subjective point of view. Each passenger alters the space in the railway station as he or she moves through it, at their own particular pace, with all the planning and exhaustion involved in that particular journey, paying more or less attention to their surroundings, and mainly preoccupied with luggage, or the timetable, or the onward journey which now awaits.

We know little or nothing about the train itself. The painting is the opposite of any document of record – Monet was not interested in the machines themselves. He wished to embrace all the living and complex reality of the station itself, without slipping into any over-confident description. The bustling atmosphere and the particular colour of the circulating air are for him more important than small details. All that is necessary is for everyone to be able to recognise the truth of the sensations that are peculiar to the place and so the steam engine, despite its great prestige, is here just suggested as part of a vast *mise en scène* in which light and geometry play the other principal roles.

Monet could have painted either a general picture of the station and its architecture, or he could have concentrated on the trains themselves. Instead he chose a balanced scene and centred the whole composition so that they all had equal parts to play. In this way the observation of the departure results in an astonishingly theatrical scene. The station at Saint-Lazare, seen like this from the interior, becomes a sort of temple conferring new majesty on the surrounding city. It is not merely a question of the new railways, their speed, the purely practical changes which will affect everyday life in all sorts of ways; it is also a kind of holy spectacle, which transforms the achievements of industry into a glorious apparition. The arrival of the train in the heart of the city takes on something of a modern theophany.

The clouds of steam everywhere in the painting remind us irresistibly of the quivering vapours that alchemists sought in their distillations, as well as the smooth trompe l'oeil skies produced by the skills of the eighteenth-century fresco painters. Nothing here of course connects with theology or even the

halting first steps of the early scientists, but the history of images speaks for itself. Monet takes ancient forms and uses them to convey entirely new phenomena in a recognisable manner. He makes baroque clouds rise above Paris and confers unexpected gentleness on the proud construction of steel and glass. The station appears to be a place of purity and freshness, somewhere between the laboratory and the celestial heavens, and where all that is missing is the odd garland of little angels. How can one imagine the soot and greasy dust, or the clatter of machinery, when faced with all this blue light and translucent colour? The artist allowed himself to be carried away by the long spans of metal, which fade and then reappear through the smoke. The warm browns of the foreground are softened with purple as they fade into the distance. A few human figures wander between the rails, to remind us of the proportions of the place. On either side, the buildings in the neighbourhood seem like huge vessels drowning in the fog, quivering with a dull and imperceptible movement.

The painting seems indifferent to the weight and material nature of subjects; it creates a kind of poetic fiction, which seems to us more true than what we have actually experienced. The station, crisscrossed with energy and conflicting forces, offers the artist a space rich in subtlety and variety in which he can recreate the art of landscape painting. It really is a kind of rebirth. It may seem like chance, but he is following in a tradition that goes back, before Turner, to the works of Claude Lorrain, painted in the middle of the seventeenth century, which were to act as such an inspiration to the British artist. Those golden galleons and huge caravels have long since sailed into the mists of time. But Monet's composition offers us a direct descendant of those sumptuous images of ports bathed in light, those scenes of eternal departures and long-awaited arrivals.

Impressionist painting always maintains a fascinated but reticent relationship with objects. It observes them but does not define them, looks and then loses its bearings, always mingling the demands of what we see with the awareness of the limitations preventing us from properly grasping the visible and the real. The opaque steam produced by the engine is thus much more significant to Monet than the train itself. It is linked to the transparent architecture, and it exposes the fundamental choices faced by the artist, which are finely balanced in this work: on the one hand there is the visual uncertainty, which is an excuse for the unfurling of all the colours; and on the other, the presence of structures which provide stability. What is in play depends finally on the economy of the image, which in turn can convey a vision of the world.

The Gare Saint-Lazare

The Gare Saint-Lazare, as painted here by Monet, had been inaugurated with great pomp and ceremony by Napoleon III, accompanied by the Tsar of Russia and the Emperor of Austria, on 2 June 1867, during the Great Exhibition. Thirty years after the opening of the railway line linking Paris to Saint-Germain, a line since then extended as far as Rouen and Le Havre, this, the first Parisian station for the Compagnie des Chemins de Fer de l'Ouest, had already undergone considerable transformations and embellishments. Others would follow, linked to the Great Exhibition of 1889. Built by the architect Alfred Armand and the engineer Eugène Flachat between 1842 and 1853, the station was a remarkable example of the new architecture of steel, most notably the huge 40-metre beams conceived by Camille Polonceau to arch over the platforms. Around 1845 construction techniques perfected the use of rolled iron, a successor to the cast iron used from the end of the eighteenth century in England. It also engendered a whole new aesthetic, with the emphasis on discipline and transparency, which would characterise the new industrial age and transform the appearance of the whole city. And so the oldest railway station in Paris lies chronologically between the Halles, built in 1853, by Victor Baltard and Felix Callet, and the Eiffel tower, erected between 1887 and 1889 by Gustave Eiffel.

The fascination with steam engines

Before the eleven studies of railways painted by Monet in 1877, Manet painted *The Railway* in 1872, in which railway tracks and the steam from an engine are seen behind a young woman (Victorine Meurent, the model for *Olympia* and *Le Déjeuner sur l'herbe (The Luncheon on the Grass)* and a little girl. Manet, also fascinated by these machines, would consider painting a steam engine, but in a different manner to Monet. In 1882, he wrote to his friend Jeanniot: 'One day, on my way back from Versailles, I climbed on to a steam engine, next to the mechanic and the driver. Those two men were a magnificent spectacle – their sang-froid, their stamina! It's a dog's life! Those people are the heroes of today! When I am better I am going to paint them.' And indeed he did write to the Compagnie des chemins de fer de l'Ouest in October that same year to request the authorisation to paint, in one of the depots, 'a locomotive machine and its mechanic and driver'. But Manet was already very ill, and he died without having been able to fulfil this project.

Monet at the station

Renoir related the circumstances, no doubt somewhat exaggerated, in which Monet came to paint the station: 'He put on his finest clothes, puffed up the lace around his wrists, and casually swinging a gold-tipped walking stick, handed his card to the director of the Chemins de fer de l'Ouest at the Gare Saint-Lazare. The doorman, taken aback, showed him in at once. The director asked the visitor to take a seat, and he introduced himself quite simply: "I am the painter Claude Monet." The director knew nothing about painting, but did not like to admit it. Monet allowed him to flounder for a few minutes and then deigned to give him the good news: "I have decided to paint your station. I hesitated for a long time between yours and the Gare du Nord, but I think in the end that yours has the most character." He got everything he wanted. They stopped the trains, they evacuated the platforms, they stuffed the engines with coal in order to produce the kind of steam Monet was looking for. He settled into the station like a tyrant, painted in the midst of general worship for days on end, and finally left with a good half-dozen paintings, with the whole staff, led by the director, bowing down before him.'

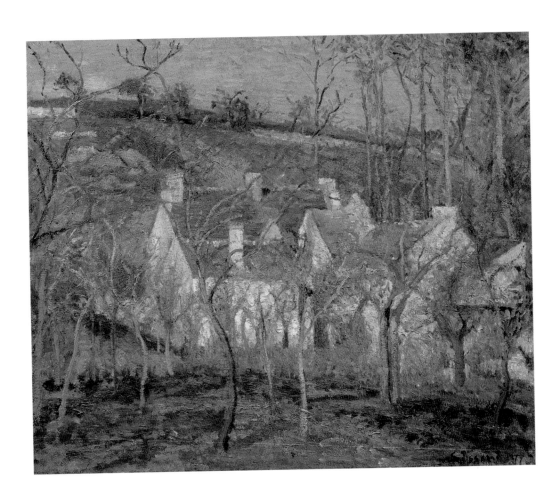

No need for a path

Camille Pissarro (1830–1903)
The Red Roofs, Corner of a Village, Winter, 1877
Oil on canvas, 54 × 65 cm
Musée d'Orsay, Paris

.
.
.
.
.
.

The colours in this slightly hazy landscape are scattered over the canvas, slipping underneath the trees and the bare branches. The lines and shapes superimposed by nature partly mask the houses that are huddled together. A green path curves slowly around, beginning beyond the edge of the painting, and bending round to avoid the hamlet.

It is not much of a walk. You might even feel a little disappointed not to have gone a bit further, unless you rather enjoy an easy stroll. The artists of the preceding generation had also regarded familiar, nearby places as worthy subject matter for their art, and the communes of Fontainebleau and Barbizon had supplied them with plenty of material. A leafy wood, a group of houses – none of this was new in the 1870s and so it became quite natural to find yourself a part of a painting, stopping at the entrance to a village, or beside a river after a short walk. Pissarro's landscape affirms as much as ever his relationship to the here and now, and the lowly point of view is no longer particularly surprising, although the determination to stop the walker in their tracks is perhaps more so.

A few leaves here and there form an irregular screen, through which you can glimpse the houses. The red roofs, although they give the picture its title, are hardly visible, partly concealed behind the slender branches. It's not much, and of course it doesn't prevent you from grasping the subject of the painting, but it's enough to irritate the eye and make you doubt its

capacities. Everything here is achieved 'despite' or 'after' or in other ways, creating obstacles in the way of reaching a proper understanding of the painting. You will have to get through this clump of trees, push aside the branches that are in the way and then try to find some sort of space where you can decide which direction to take next. You might knock on a blue door, find your way around a white wall, scratching yourself on some imaginary brambles – which seems more and more likely as you study the painting. Any artist trained in the classical tradition would soon have got rid of this curtain of trees, changing their angle, or just disposing of them without any regrets, since they are, after all, blocking the view.

In the past, when one studied the details of a landscape, from a wood to a river, between a ravine or a forest, the eye would only lose its way occasionally, and would regain it by looking into the distance. From a bird's eye view, or from the point of view of a lifetime, such delays and detours did not matter. Such a vast perspective would very quickly make you forget how hard it had been to cross the river on that shaky bridge, or how long it had taken to climb that hill. That would now seem charming, almost laughable, when seen from so far away. What would have been a passing inconvenience in a landscape of the sixteenth or seventeenth century has now become the main subject of Pissarro's painting. And, seen from such close quarters, the smallest of obstacles now seems insurmountable, and almost shocking in its intention. Getting to those houses with the red roofs demands an effort, with no reward in sight other than a steep climb up to the fields which block the back of the picture. Could you not avoid this complicated network of bushes about to blossom, and get there more quickly and more directly? If those bright tiles that have been laid on the roofs of these old houses are so interesting to the artist why doesn't he give them greater importance?

Unless, of course, it is now the case that the subject of the painting no longer stands out with this new approach to capturing what is visible. And perhaps for Pissarro, the whole interest of the landscape lies precisely in this way of looking at things in which nothing is clearly perceived: in these conditions, the difficulty of seeing is as important as the actual thing we are observing. As in many other paintings, what we actually see is concealed by the way in which we can or cannot see it. The artist here is a kind of pioneer, cutting through the wood, dragging the viewer with him through the bushes. Too bad if it all appears blurry, if his pride is scratched, or he trips up on an all too strong brushstroke. Still, painting never causes any long-term injury, and he'll get used to it in time.

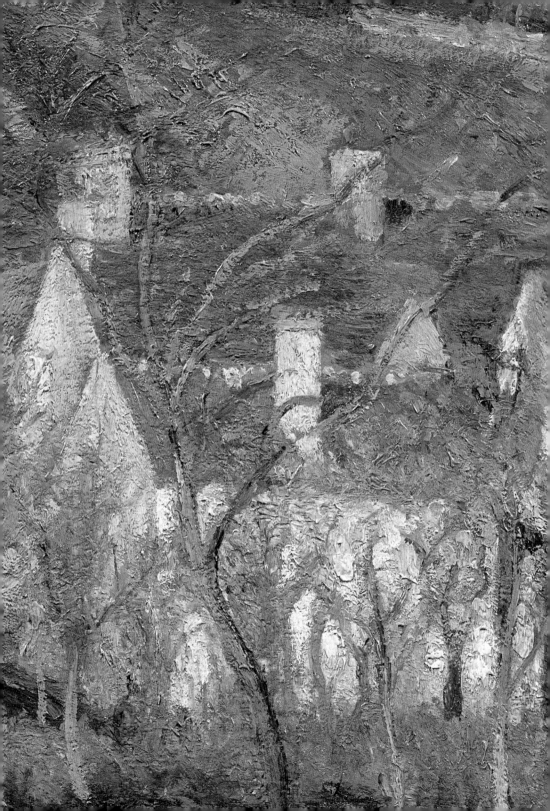

The artist is not actually seeking to place the viewer in difficulty by making access to the subject too difficult. But he has to be honest and take account of that which constantly intervenes between him and what he is looking at, an intricate maze of obstacles and delays. Most of the time we see very little, and what we see is not very clear. Unimproved nature obstructs the most innocent of expeditions. You try to see, to distinguish one house from another – it's an arduous task.

Pissarro has no desire to create an accessible landscape, open to all comers. He does what he can with what nature offers him. But there is certainly no need to suspect any underlying symbolic, moral or spiritual message. This imprecision dispenses with Romanticism, for which landscape painting was a favoured vehicle. Corot had developed the taste for ethereal landscapes, in which one still looked for the shadows of nymphs behind trees, if not the nymphs themselves. The woods rustled as they went by and the whole of the nature became part of a dream. These hazy memories enveloped the woods and the fields, blew dead leaves through the seductive melancholy of late afternoon. But Pissarro's chosen theme doesn't encourage any of that kind of reverie, although there are, without doubt, reminders of Corot's vaporous images. Pissarro is happy to do without any supposedly ineffable poetical creatures. To see things clearly and simply is difficult enough.

There is no time for any literary fantasy anyway. The artist has to hurry, narrowing his eyes perhaps to see those deep red tiles between the branches. There is a purple haze, a gift for a painter alert to the slightest change in the landscape. Because time is flying. It is already the end of winter and the wheat in the fields is beginning to colour. Soon the fruit trees will blossom. And, behind the branches, heavy with leaves, the last touches of red will disappear from the landscape.

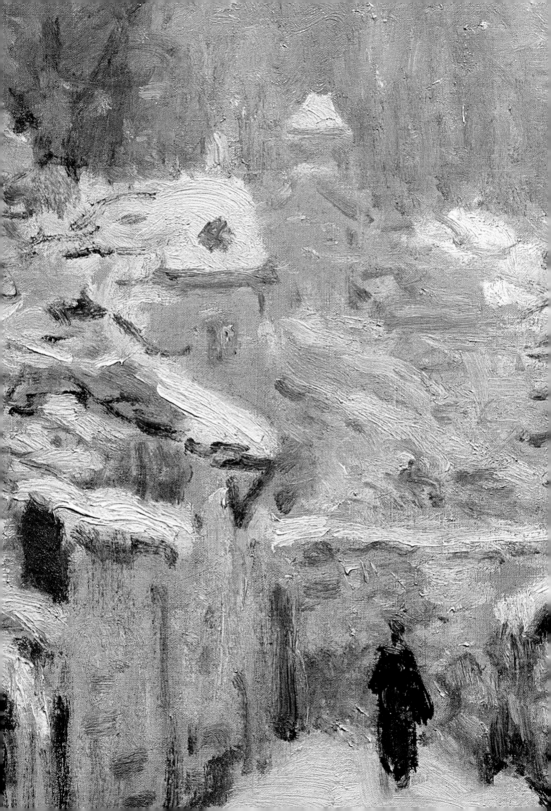

snow. The image thus supplies us with the least information possible, nothing is precise. It is Louveciennes, we know that. It had often been painted by the artist, who knew its every nook and cranny. But this particular street between these two walls? We have to refer to the title of the painting if we want to place it anywhere other than in our own childhood memories.

Sisley's painting muddles our perception of time, and in particular the idea of a steady succession of years; it removes the whole concept of chronology, encapsulating in one image the piercing shouts of children and the shivering of the old. Snow is a highly effective trigger for emotional memory and the games it can play. It certainly buries things more attractively than dust, leaving just a few imprints, rewriting history. The image forces the awakening of memories, and with that a freeing of the imagination; weightless thoughts, as insubstantial as the snowflakes which we never saw falling. It is one of those denuded works of art which draws the viewer in with a sigh, back to our own private moments. The picture sits quietly, offering no theory.

It is likely then that we could end up imagining and creating memories rather than actually recalling them. We have probably never been down this narrow street, or seen these slightly decrepit walls, or that barrier at the end, but there are many other places like this. We may never have been inside this church, whose name we do not know. Perhaps we suddenly remember it . . . Did we, in fact, ever play in the snow that much, throwing snowballs and building snowmen with carrots for noses? Perhaps it is just one of those readymade images of the joy of winter and carefree childhoods, an illustration from a children's book, some alphabet of the seasons. Perhaps, it's hard to tell. The fact is that Sisley's painting, more than anyone else's, can bring unexpected depth to the present by implying an imaginary past. It creates another form of history, which is unique even if, at the final moment, all that is left is the loneliness of that winter street lying in the particular silence of an advancing evening.

Sisley at Louveciennes

From 1871 to 1875, Sisley lived in furnished rooms in rue de la Princesse in Louveciennes. The chemin de L'Etarché, pictured here, linked his street to the rue Président-Doumer, and Sisley had painted it several times, in both 1873 and 1874. The expression 'pictorial cartography' has been used about him to describe his method of studying one particular place in several different paintings. They are not exactly a series, since the images were not constructed around any particular theme, such as the changes of the seasons, or variations in light according to the time of day. His attitude is more reminiscent of the aesthetic choices of some of his great predecessors, such as Courbet or Constable, who only wished to paint places familiar to themselves, each canvas offering a veritable portrait of their own surroundings. The result is a kind of auto-biographical landscape, which contrasts with the tradition of classical landscape and its pursuit of universal truths. All the same, this supposed statement of subjectivity by the painter is not so much an anecdotal image as the suggestion of a space that has been truly inhabited.

Winter landscapes

The representation of snow in painting had already been well mastered in the fifteenth century, in the engravings, for example, of the Limbourg brothers. At the time the aim was to depict not just the winter months in the year's cycle, but also the jobs that had to be done in those months. All through the year, one was forced to relive the effects of the divine curse placed on Adam and Eve, chased out of Paradise and forced to earn their subsistence through labour. The image of men toiling out in the cold, and the idea of imagined comfort indoors, that had to be earned, reappears in the sixteenth century in Breughel the Elder's work, in particular his *Hunters in the Snow*. The innumerable characters populating the winter landscapes of the seventeenth century could also be regarded as symbols for man himself; playing, falling, rising up again, collapsing and always endeavouring as best he can to struggle on through life. Francisco Goya turned a deeply compassionate gaze on the misery of poor people caught in snowstorms, but by the nineteenth century the use of the theme as a tool for moralising had completely disappeared, and henceforth painters concentrated on a detached observation of its effects on light and colour.

Impressionists and snow

All the Impressionists, to differing extents, painted snow scenes, as the texture and light produced provided a unique opportunity to study reflection. Monet, with *The Magpie* painted in 1868, exploited the possibilities of the subject by introducing powerful contrasts and using a rainbow of colours to convey the mass of white. In other paintings he emphasised the relationship of colours that came and went between the snow and the landscape, with the vast expanses of his Norwegian paintings. Renoir, although he had several times tackled the subject, hated snow and confided to Vuillard: 'I have never been able to bear the cold . . . And anyway, even if one doesn't mind the cold, why paint snow, that outcast of nature? The two artists most attracted by the familiar yet poetic atmosphere of the rigours of winter were Pissarro and Sisley. Thus George Lecomte wrote, about Sisley: 'He feels the heavy grandeur of the snowy masses which, spread over the undulations of the earth, both ennoble and cast a gloom over the forms of nature. He demonstrates – and with what skill! – the depth of the slowly built up layers, as well the weight of the snowflakes on branches and light constructions.'

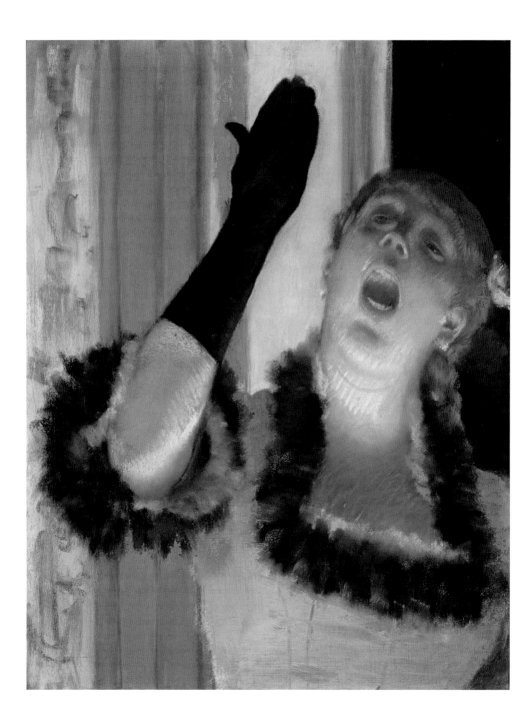

Burned by the limelight

Edgar Degas (1834–1917)
La Chanteuse de café (*Café Singer* or *Singer with a Glove*), 1878
Pastel on canvas, 53 × 41 cm
Fogg Art Museum, Cambridge, Massachusetts

.
.
.
.
.
.

Her mouth gapes dark and open, she seems to swallow up the shadows of the hall. She is leading the performance, on a little stage transformed by some minimal lighting. The green, gold and orange shades strengthen the backdrop, like an orchestra behind the singer.

The show has already begun. We find ourselves placed right up close to this singer that the whole of Paris has come to hear. Perhaps a bit too close, truth be told – we prefer her voice to her face. And yet that voice has never seemed quite so powerfully substantial as it does now. Her whole body is acting and singing as well, and her gestures echo the words of the song, providing another dimension. There is a strong sense of drama, of heavy scent that mingles with the smell of her sweat. Her black-gloved arm indicates with an unstoppable gesture what she is throwing in the face of the public. It catches the notes in mid-air, freezes them in space, giving them time to resonate in the audience's mind. That is what will leave them shaking at the end, after she has stopped singing. After she has left the stage it will be the memory of that arm sheathed in silk that will remain like a flourish in front of their eyes. Degas takes possession of the gesture – he of all people appreciates the elegance and above all the effectiveness of such a movement, with its capacity to transform the most banal of settings into a pure and thrilling space.

Nothing here is real – not the emotions of the subject and her nocturnal power, nor the mysterious beauty of the decor which will quite certainly look shabby in the cruel light of morning. But the artist revels in the creation of such a spectacle. For some time now his paintings have not been concerned with immediate reality. They are spaces dedicated to the artificial and he seeks out worlds that correspond with them: in the line of the make-up which sculpts and highlights the features, the colour of her lipstick, the eye-shadow darkening her eyes or that thick powder that gives her complexion such a chalky texture.

The footlights shining up at her invade her whole body and appear every-where. She becomes another sort of woman, painted not once, not twice, but three times: by the artist's chalky pastels which impart a mask-like stage appearance, by the bright light which eliminates any half-shades, and by the shadows which stick to her lips and penetrate her nostrils. She is the repository of an accumulation of images, each one contradictory. The darkness whirls through the quivering feathers, skims along the edge of her corsage and weighs her eyes down with all the exhaustion of a sleepless night.

This might have been at most the image of a passing expression, a snapshot of a gesture intended as a small detail in the general action of song and *mise en scène*. Just one theatrical gesture, part of a whole sequence. But Degas takes it further: the singer's expression is transformed by what she is performing, and for one very short moment she becomes unrecognisable, for the sake of the show. This expression is superimposed on to her normal features in repose, and one forgets the shape of her mouth, the position of her head, the arch of her eyebrows. The picture corrupts the truth and leaves a smell of sulphur.

At every moment reality collapses and fades away, cancelled out by one of these multiple additions. It is just these images – showing only a partial, in many ways false, certainly deceptive, picture of the reality of this woman – that Degas chooses to show us. This woman with the distended nostrils, the dark mouth, the sooty eyes could not exist anywhere except in front of these lights. Who is she really, what is she like without the voice and the borrowed feathers, when she returns to her ordinary everyday life, in the filtered light of her own home or in the comings and goings out in the streets? Does she look the least bit like this creature?

The lamps in the rehearsal rooms, the coloured spotlights which sweep over the stage – what difference do they make when what is visible can no longer

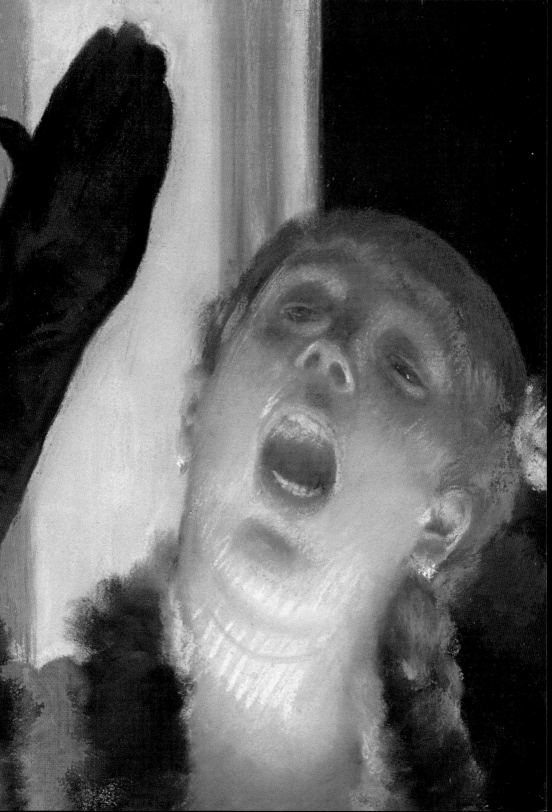

be properly defined? Degas did not share his contemporaries' enthusiasm for the light found out in the open, and he liked to concentrate on the expressive effects of artificial light. He had, in his time, completed studies of skies that verged on the abstract, landscapes of cloud and wind, but he greatly preferred those effects of the light which could be manipulated and directed, and eventually forced in such a direction as to definitively contradict the substance of reality.

As a man of the theatre, Degas liked to overlay appearance on to appearance, with brushstrokes learnt from the make-believe effect of the light. He seemed to be asking whether the search for an intimate expression should win over the extravagance of the reinvented face. Sincerity without make-up would be appallingly clumsy. There was as much truth in the performance of a singer or an actress as in that of a painter, or at least a kind of secondary truth of the same sort as his – that of elaborating, recomposing and re-creating to produce something no one could have envisaged in ordinary life. But the performer must project beyond the footlights if she is to survive. And so the painter comes up close to her, cuts her back, puts his mark on her and builds a structure around her. Even those at the back of the concert hall, caught by this striking form and direct language, will undergo the same seduction as the lucky people in the front row.

Everything is calculated, on the canvas as on the stage: the lines and colours must carry as far as the singer's voice, further perhaps. Degas makes the performance last until the picture has shown us everything. The lights and the shaded areas accentuate the high notes and deepen the low ones. The tight framing of the painting makes all the different values of black, which could have drowned the image, resonate: the imperious black of the glove, the soft black of the dress, the black of the backdrop behind the singer, the black smoke in the corners of the café. One more beat and the arm raised at the passionate climax of the song disappears, erased by all this darkness that acts like a whiplash. The spectator, glued to the spot, waits for the final note, still attached in the darkness to this voice that we can now no longer hear.

'The civilised flesh tint'

Huysmans willingly rebelled against the conventional techniques used by academic painters when painting flesh. They had, according to him 'invented inflated painting, puffed-up works [. . .] It is not even like porcelain any more, it is just flaccid and over-polished: it is, I don't know what, something like the limp flesh of a squid.' Very early on he saluted Degas for the way in which he conveyed the truth of his subject, with *La Chanteuse de café* as a prime example: 'He was one of the first to tackle feminine elegance and vulgarity; one of the first to tackle artificial light, the glare of spotlights before which low class music hall singers would bawl in décolleté dresses, or where dancers dressed in gauze would leap and pirouette. Here there were no creamy smooth complexions, no fake skin made of watered silk, but real skin powdered with velvet, flesh made up for the theatre and the cubicle, just as it is, grainy and rough seen close to, and, seen from afar, bright and sickly. M. Degas is a past master at what I would call the civilised flesh tint.'

The café concert singer

Degas painted a great many scenes at the café concert around 1875 to 1877, at a time when he used to frequent the outdoor musical cafés in the Champs-Elysées, such as les Ambassadeurs or the summer Alcazar, preferring them to the tiny smoky theatres into which the public crowded during the winter. This painting, which is not the portrait of a real singer, is a reminder of what one of the most famous singers of her day, Theresa, born Emma Valadon, wrote in 1865: 'You had to sing as loud as possible to be heard over the noise of all the carriages heading for the Bois de Boulogne.' Degas was a great admirer of the singer, who had become a Parisian institution within a few years: 'She opens her great mouth and out comes the most grossly delicate, spiritual and gentle voice you have ever heard. And her spirit, her taste – where could one find anything more beautiful? She is admirable.' Huysmans, in his novel, *The Vatard Sisters*, which appeared in 1879, describes a singer who shares much with Degas' creation: 'Her chin cast a shadow over the bottom of her neck. The raucous sound from her gullet was accompanied by four gestures: one hand on her heart and the other stuck down the side of her leg – the right hand forward, the left hand back, the same on opposite sides – two hands stretching together towards the audience [. . .] Her mouth would be wide open, gaping like a great black hole as she belted out the final verse of the song.'

In praise of make-up

Baudelaire, in praise of make-up, wrote: 'A woman is well within her rights, indeed she is fulfilling a kind of duty by attempting to appear magical and unreal; [. . .] It does not matter in the least if the ruse and artificiality are obvious to all, as long as it is a success and as long as the effect is always irresistible. [. . .] As for the artificial black line around the eye, and the red at the top of the cheek, the aim is to achieve the same result, that of surpassing nature, although the effect is to satisfy a quite different requirement. The red and the black signal an unnatural and excessive way of life; the black frames the eye, making the gaze deeper and more singular; it gives the eye the air of a window open into infinity; the red emphasises the cheek bones, further increases the brightness of the eye and lends the mysterious passion of a priestess to the beauty of the female face.'

Simplifying painting

Impressionism marked the death of the subject as it had thus far been defined. The religious repertoire had run out of steam decades earlier and artists were now closing their manuals of mythology and their history books. They showed their enthusiasm for nature by placing great importance on landscape painting, and cast aside the necessity for figures to play any kind of key role. Moral questions, romantic outpourings, any sense of the tragic – all were swept aside. However, the luminous atmosphere in which the remaining figures evolved would be at least as eloquent as the stories of the past.

The introduction of modernity to these images was not the end of the story: it was not a question of replacing the ancient subjects with new ones and preserving the same narrative techniques. What happened, and what could sometimes be so disconcerting, and so disappointing for their contemporaries, was simply that the subject itself was more and more reduced, sometimes to the point of almost disappearing altogether. Just as the naturalist writers now drew their material from everyday life, so artists increasingly moved away from fiction. Writers and artists often shared the same aims and interests, without confusing them. Painting now began to avoid anything that would seem too much like conversation; it became dumb, or almost dumb.

A kind of fragmentation of space, in which life was conveyed in short bursts now took the place of the traditional expression of a painting by some kind of narrative tale. A more or less rapid sequence of gestures and shapes would appear on softly coloured surfaces. The painting, absorbed by its consciousness of the present, no longer had the time or the inclination to tell any kind of story. It was only by going from one painting to another, following the repetition of a particular theme, that one could begin to reconstruct a feeling of continuity, albeit an often fragile and uncertain one.

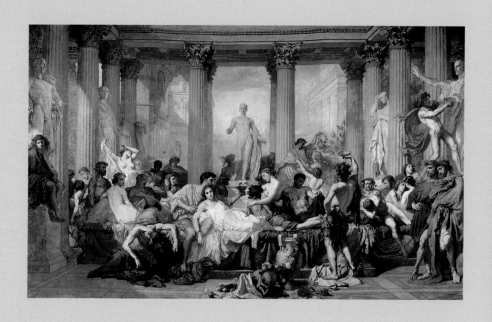

Abandoning the stories

Thomas Couture (1815-79), *The Romans of the Decadence*, 1847
Oil on canvas, 472 × 772 cm, Musée d'Orsay, Paris

.
.
.
.
.

This enormous canvas represents a lament for its times: there are no great men any more, other than those frozen in marble. This corrupted society offers itself a spectacle of its own decadence. The search for pleasure has replaced any sense of duty. The grey shadow of the morning after gradually envelops the carefully worked tones of the painting and plunges it into despairing apathy.

Thomas Couture has arranged a vast and tumultuous scene, in which each character, each face, is an elegant illustration of degrees of decadence: blind drunkenness, careless nudity – each gesture in turn suggests a last surge of desire and consciousness before the final slide into nothingness. The image is replete with contrasts and references; everybody the artist has ever admired is summoned up with no discrimination between styles and periods. The architecture of the surroundings is reminiscent of the Venetian Renaissance, sixteenth-century Italy cohabits with Diego Velázquez's Spain, and the dramatic eloquence of Théodore Géricault and Eugène Delacroix lies alongside the eroticism of Jean-Auguste-Dominique Ingres. The work, which uses every single resource of historical painting, was to bring considerable success and fame to the artist.

A few deep red flowers are scattered in the foreground. Couture has sketched them in with a few brushstrokes, with a freedom that he has only secretly allowed himself, a freedom which his pupil Manet would make full use of in the future.

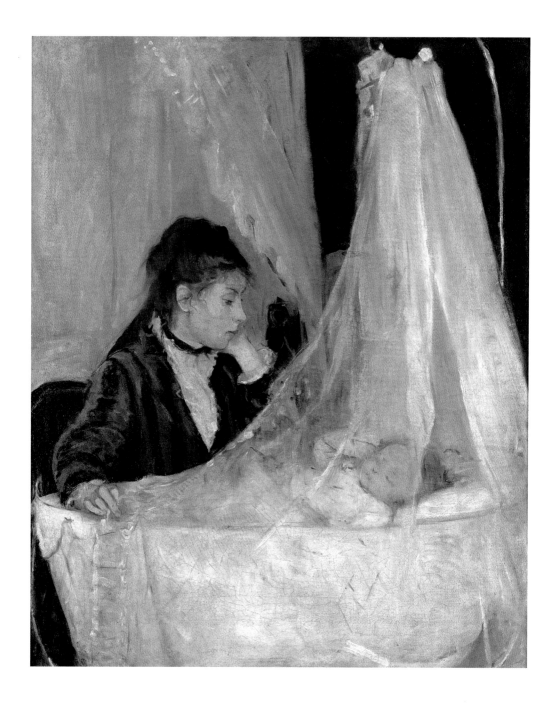

Opting for discretion

Berthe Morisot (1841-95)
The Cradle, 1872
Oil on canvas, 56 × 46 cm
Musée d'Orsay, Paris

She could just get up and quietly leave the room so as not to disturb the baby's sleep; but she lingers a little longer, absorbed in contemplation, holding back the veil over the cradle with an almost automatic gesture.

The light muslin is enough to blur the baby's features, which we can hardly distinguish. Her face appears a little hazy, sheltered from all eyes other than those of her mother, as though it is only right that she alone should be the one to see her baby clearly. It is as if Morisot, by choosing this point of view, intended to demonstrate the basic difference, not of degree but of nature, between her position and ours. This scene also differs from the usual sentimental tone in that it does not solicit admiration from the visitor for the newborn child, when we would peer into the cradle looking for some resemblance, however slight. Here, we are brought into an extremely private space, but kept at a distance, on the other side of the veil.

The relaxed baby sleeps with her arm raised, lying against her head. Her mother, with her face resting on her hand, watches her child without perhaps realising that their gestures mirror one another. These gestures are in fact quite different, they only appear similar to the viewer. There is a perfect harmony between the two figures, which reduces, almost to nothing, the world that surrounds them. The artist herself is excluded from this

private space. Morisot paints the image of a fundamental unity, more deeply expressed by this detail than by all the conventional descriptions of tender maternal love to be found in traditional images.

The fall of the veil, which divides the picture, gives a structure to the complements of light and shade. The entire painting rests on this dialogue between different levels of reality. At the back of the room another curtain, no doubt that around the parents' bed, reflects the one around the cradle and completes the effect of a space that is simultaneously enclosed and transparent. The figure of the mother, between these two luminous planes, gives stability to the picture and in turn is echoed by the dark wall of the room. We have here a very simple game of alternation, like the suggested rhythm of day and night, or more accurately of wakefulness and sleep, constructed and supported in a minor key by the notes of blue and pink which float through the materials. Morisot is in her own way also exploring the sense of time passing which is omnipresent in the work of the Impressionists, but she lends it a slightly different dimension, based on dividing time into short sequences rather than dwelling on the transitory nature of things. This succession of short moments of wakefulness and sleep corresponds to the reality of her subject, that of life with a newborn baby.

Sitting next to her daughter, the mother seems to be meditating as she gazes down at the sleeping child. Perhaps she is able, at last, in this moment of silence and rest, to let her thoughts run freely, without relaxing her gaze. We can imagine a stream of unimportant ideas and practical considerations, possibly alongside the occasional deeper and weightier thought. She sits up straight, but with her head slightly tilted, almost like a traditional figure of Melancholy. In truth, it is difficult for the viewer, who can only see her profile, to really describe her in such detail – it is all a presumption, a vague suspicion that crosses the mind when we observe her demeanour, natural though it is. It seems as though a moment of solemnity is passing through the mother's spirit, just as the memory of that ancient symbol came to mind, only to be summarily dismissed, as if we were almost embarrassed to even have considered it. All Morisot ever does is suggest the most transparent of feelings, demonstrating the delicacy of her approach.

The image defies proper description: such a subject would normally include an interior scene, with furniture and accessories playing a leading role, even if only to supply a few more accentuated colours. But this space is free of any extraneous anecdote, and above all expresses a silent relation-ship. The intimate vantage point allows the artist to avoid the cliché and

stick to the essential: the adult's gaze at the child rather than the child itself. Her presence, which is real but hazy and almost unsubstantial, seems more like an image in the making, a promise for the future. The scene, thanks to its simplicity, clearly reminds us of what we would experience in the same situation, with such a sharp perception of the reality of life that all the rest disappears. It is the perception not just of a person in front of us, as confounding as that is, but of the pure and absolute fact of life itself.

The light shining through the veil is another presence. Held back by the sheer material, it dissolves into pearly shades, so pale as to be almost imperceptible, like air, only made visible by the fluid lines of the paintbrush. The atmosphere is weightless, just floating, hardly a breath of air. Morisot seems to be listening for the sounds in this scene as intensely as she studies the mother's gaze. The child's soft, barely audible breathing, so vulnerable — a sound that a parent is always listening for, with its regular rhythm, occasionally interrupted by a passing dream. The tiny face suddenly crumples, the mouth opens, a hiccup shakes the layers of the veil. There is a touch of mauve and yellow in the shadows. Peace returns. The colours return to normal.

Throughout the history of painting the veil has been connected with the idea of revelation, what would one day finally be visible, but which remained, for the time being, partially hidden. From the veil of the Temple which separated the profane from the Holy of Holies to the veil of the Virgin Mary lying across her forehead like a kind of celestial halo, it represented the hidden essence of being, the surface of reality. Berthe Morisot's painting, which avoids all sacred references, does however have a natural link to the ancient symbol, and serves to remind us without any pathos or exaggeration of how all of life is woven through with this blurred vision.

In her later work, which was light, subtle and playful, she could evoke, better than anyone, the sound of a peal of laughter that weighed no more than a feather. There was always a little breeze in her paintings, like little splashes creating a magnificent disorderly crush of adjoining tones, pressing against one another, as though trying to recreate the beautiful serenity of a rainbow. But here, and at this moment, all that we sense is the air itself, the intangible air that surrounds the baby, and, passing through the veil covering the cradle, seems to pervade the canvas itself.

The Morisot sisters

The three Morisot sisters, Berthe, the eldest, Yves and Edma, came from a bourgeois family – their father was a councillor at the audit office. They studied, from 1857, with Geoffrey Alphonse Chocarne, an academic artist. Berthe and Edma then continued their studies under Joseph Benoît Guichard and finally Jean-Baptiste-Camille Corot, between 1862 and 1864. Corot taught them the importance of freedom of technique and working out of doors, which became essential components of their artistic vision, and the first works they showed at the Salon were landscapes. In 1868, Berthe met Manet, who influenced her for some time, and for whom she posed several times, notably in *The Balcony*. Edma, having exhibited her paintings between 1864 and 1867, married a naval officer called Adolphe Pontillon, an old friend of Manet's, and went to live in Cherbourg and stopped painting. Berthe on the other hand pursued an independent career, which was never hindered by her marriage in 1874 to Manet's brother Eugène. In 1878 she gave birth to a daughter, Julie, whom she frequently painted. Little Blanche, painted here, was Edma's second daughter. She wrote a little earlier to Berthe: 'When I think of all those artists, I tell myself that just a quarter of an hour of their conversation is worth quite a lot of more substantial pleasures. [. . .] To chat with Monsieur Degas whilst watching him paint, to laugh with Manet, philosophise with Puvis – all these are things I envy.'

Morisot and Impressionism

Although Berthe Morisot had been favourably received by the Salon, she nonetheless took the advice of her friend Degas who had invited her in 1874 to join the future Impressionists' exhibition. Although Manet, who was determined to differentiate himself from the group, had refused to join, she showed nine paintings, one of which was *The Cradle*, which was eventually acquired by the Louvre in 1930. Her former teacher, Guichard, when consulted by her mother, did not conceal his disapproval: 'My heart sank when I saw your daughter's works in that company; I said to myself "one does not live amongst madmen with impunity. Manet was right to refuse to exhibit with them. Of course when one looks at them in good faith, one finds excellent pieces here and there, but they are all more or less off-beam. [. . .] Here is my advice to her, as a painter and as a friend: go to the Louvre twice a week and spend three hours standing in front of Correggio begging his forgiveness for having tried to make oil perform what should be the exclusive function of watercolour.'

A south-facing studio

In 1862 Edmond de Goncourt attacked traditional customs, denouncing 'the idiotic habit all our painters have of making their models pose in north-facing studios. When you are facing north all you get, so to speak, is the cadaver of daylight, and none of its radiance and light.' Naturally, Berthe Morisot, who wanted above all to paint light in both its diffuse and radiant forms, made a different choice, noted by the artist and writer Jacques-Émile Blanche: 'She wanted her studio-drawing room in the rue de Villejust to face not north but due south, with white Louis XVI panelling; the light was evened out by cream coloured blinds, which would explain the chalky quality of her paintings, which are never supported by any solid shade; there is not a single dark corner; narcissi, tulips and peonies in vases stand out against the light background; skin appears transparent with the flat modelling and smooth tones of faces and objects that face a window. Such lighting acts as a "discolourant". I do not believe that any artist before Berthe Morisot had ever deliberately painted "when there was no effect of the light"; that is to say she eliminated all contrast of shade and half-tone, and instead used a same "light value" to detach one figure against its background.'

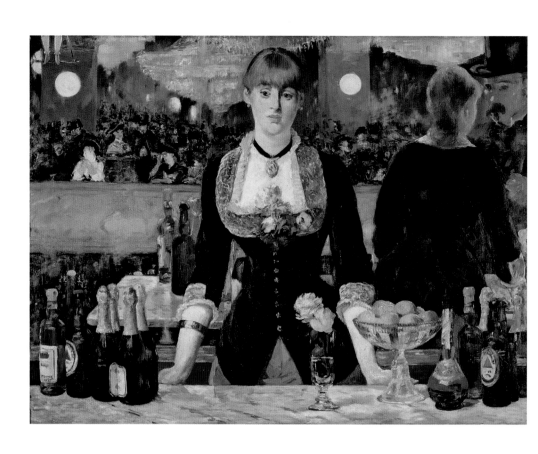

Being there

Édouard Manet (1832–83)
Bar at the Folies-Bergère, 1882
Oil on canvas, 96 × 130 cm
Courtauld Institute, London

There she stands, as accessible as the painting itself. She waits, her hands on the edge of the marble counter, for nothing in particular. It is not real though: she is not here to live her own life, all she is doing is playing a part. She will do her best to respond to the needs of the customers. A glass of champagne, and another? Yes, thank you, you're welcome. We can imagine her saying anything, and we can guess at her thoughts, if she has any. Manet has not placed her here for any other purpose. We can invent an entire dialogue if we feel like it; the artist will neither help nor hinder us.

She says nothing. It is the customer who does the talking. We can see him leaning forwards, reflected in the mirror behind her. The reflection is a distortion of the optical truth, and makes them look closer together, in a manner that suits their surroundings. The artist has found a way of implying a presence whilst retaining an element of doubt: if this man in the top hat is really there, leaning towards the young woman, already holding a glass, why isn't she paying him more attention and why does the painting convey such a powerful feeling of indifference? It is soon clear to us that the reflection must be a false one, off-centre, and no more than the suggestion of an impossible image. Yes, that must be it: the mirror is suggesting a hypothesis, showing us something that is not really there, something that could happen, and that sometimes, at certain times of the evening, actually does happen. Or has happened before, an insignificant event, a drinks

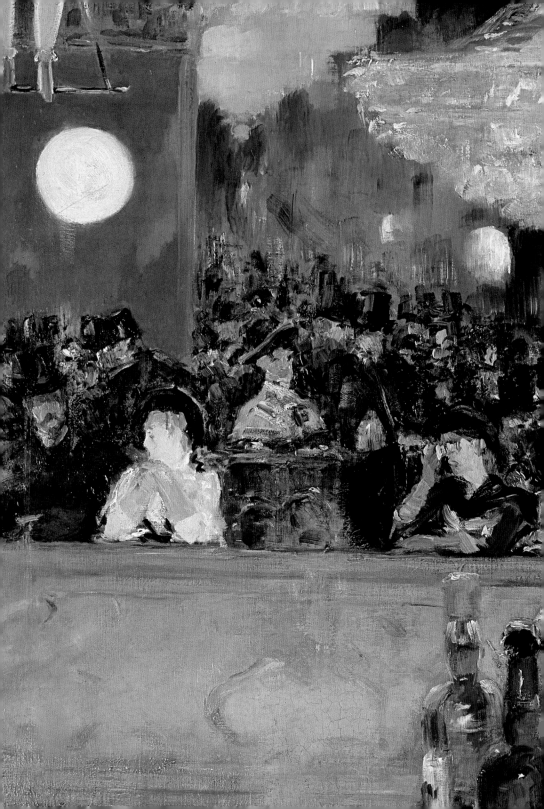

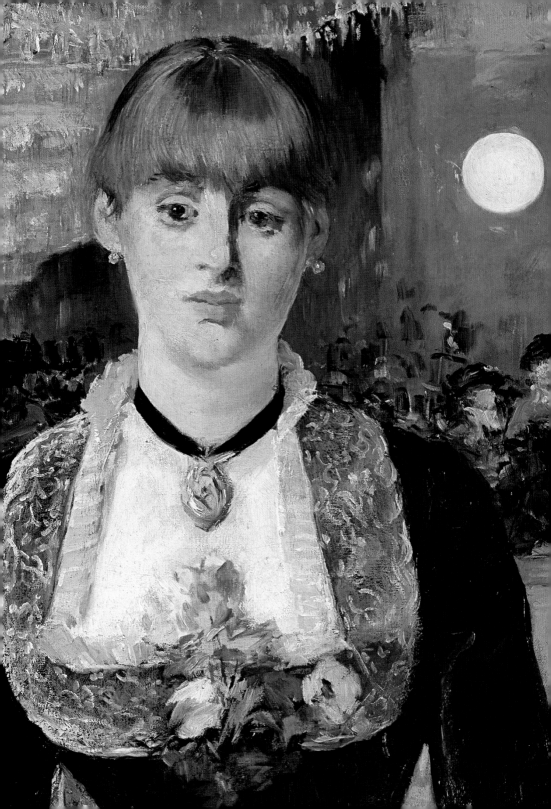

order given to the waitress at the bar. Manet gives us no other details. We are not told whether the waitress is helpful, the customer satisfied; we are shown none of the gestures involved in the exchange which has happened, or will happen. Neither figure shows any change of expression, none whatsoever. The story has not begun. The mirror here is the receptacle for an anecdote that Manet refuses to share. He simply contains it and does not allow it to invade the space of the canvas. The reflected image of the young woman refers to a secondary scenario, one which the artist is not ready to completely engage with.

Let us continue. We might just have seen, quite simply, a scene in a bar: a young woman serving a customer in front of her. In theory, the viewer witnesses this exchange, shown from behind in the large mirror at her back. But the scene immediately contradicts this reading by failing to establish a proper relationship between the figures and the reflections. The artist certainly shows them twice, but without any attempt at verisimilitude. He is setting up two parallel discourses and dividing the space on the canvas. At its centre is this young woman with no history, whose life takes place elsewhere.

By concentrating on the impact of this presence, which dominates the image, Manet once again emphasises the woman's indifference to the rowdy clamour of the room — in which we are of course standing. Her intent, or possibly vacant, stare simply ignores us, but not in an insulting manner. Still we can have no illusions about her — we are never going to get any closer.

The mirror behind her reflects a sparkling image of the crowd on the balcony, which serves only to emphasise her withdrawn demeanour. Manet scatters tiny light touches of black along the rows of seats, beneath the cold light of the heavy glass globes. A light coloured dress cuts into all this black, standing out, immediately visible, from the crowd of spectators, and we see a small but important contrast between light and shade. It's another person, her opposite, living the life that the barmaid is certainly not able to at that moment. Right up at the top left of the painting, just under the frame, an acrobat is twirling under the roof. Manet catches her little green boots just at the moment when she places her feet on the trapeze. This is the vocabulary of unruly seductiveness. The agility of the acrobat draws the eye up to the edge of the canvas, and for a second we forget the solemnity of the barmaid. We are drawn into those deep pearly greys which the artist uses to such effect: the lawful pleasures of a night out on the town are displayed here with the brilliant elegance of black and white, accentuated by the bright colour of a few candied oranges and a bottle of green liqueur.

Renouncing drama

Alfred Sisley (1839–99)
The Flood at Port-Marly, 1876
Oil on canvas, 60 × 81 cm
Musée d'Orsay, Paris

·
·
·
·
·
·
·

Port-Marly has taken on a Venetian character: we can easily imagine ourselves in a gondola, and without even having left the suburbs of Paris. The town surrounded by water offers a paradox that delights the imagination. It is simultaneously an impossibility and a reality, its existence making us believe that anything can happen, and that contradictions can in fact bring about harmony. The artist's dreams of lakes have been realised by this disastrous flood.

It is a kind of waking dream, sensitive to the slightest breeze, owing nothing to fantasy and everything, pleasingly, to an ordinary news item. Despite the evidence of a catastrophe, Sisley has succeeded in producing an image of total serenity. Clouds float just above the water. A few boats offer a ferrying service. People seem to have adjusted to the situation, as though the pleasures of boating have quite naturally replaced the journeys of passers-by in the street. It is an unusual way of life, and a change important enough to be recorded in a painting, although not enough for any dramatic recital.

The painting portrays a simple fact: the change that has taken place at Port-Marly, transforming it into a floating city. At first we might think that no commentary is necessary, and all that is needed is an unadorned and austere description of what has happened. But the fact that the artist sticks to the wider landscape, without showing anything else concerning the life of the inhabitants, is in itself a significant aesthetic choice. The people here play a

minor role, hardly even walk-on parts. The artist is clearly not particularly interested in their activities or gestures, or in any of the practical consequences of the flood, even though we are shown the landing stage and the boats surrounding it. It seems that his attention is entirely absorbed by the novelty of the colours which flutter over the water and cause it to ripple.

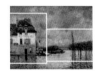

Sisley, from the middle of the flooded river, carefully records the variations of the peach and grey reflections. He refines his touch, remains patient and starts again between the gusts of wind. We can imagine the scene, the quiet calm, the enterprise of the artist who has placed himself at the centre of the event, like an impassive counterpoint to the drama. He produces an image which seems to disregard the most dramatic elements of his surroundings. As we look, we become surprised that we were not struck sooner by the sobriety of the picture. It presents such a curiously normal, acceptable situation that we automatically accepted it as such. Sisley envelops the viewer in such charm that we are unable to argue with it. The faded peach of the façade, interrupted by the sharp black of the door, the creamy white of the gently glowing wall above, all fill the eye with such visual satisfaction that the subject of the painting becomes relegated to a secondary rank, a mere detail. We no longer pay much attention to it. What does the flooding matter so long as the deep reddish brown of the roof tiles continues to interact with the purple blues of the sky? The satisfaction induced by this, albeit subtle, accord between the soft greys and the ochres make us forget the documentary reality of the scene.

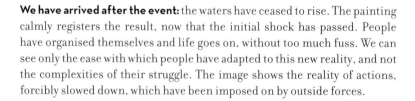

We have arrived after the event: the waters have ceased to rise. The painting calmly registers the result, now that the initial shock has passed. People have organised themselves and life goes on, without too much fuss. We can see only the ease with which people have adapted to this new reality, and not the complexities of their struggle. The image shows the reality of actions, forcibly slowed down, which have been imposed on by outside forces.

It is a state of mind as much as a phase in the sequence of events. It is important to note that the psychological speculation which normally accompanies any natural disaster, is notably absent from this work. It is perhaps this absence of tension placed alongside the depiction of extreme circumstances which best defines the particular nature of Sisley's work, which is always controlled by a sense of restraint.

And yet, like other artists of his generation, he retains some element of romanticism in his work, even though he is not drawn to spectacular

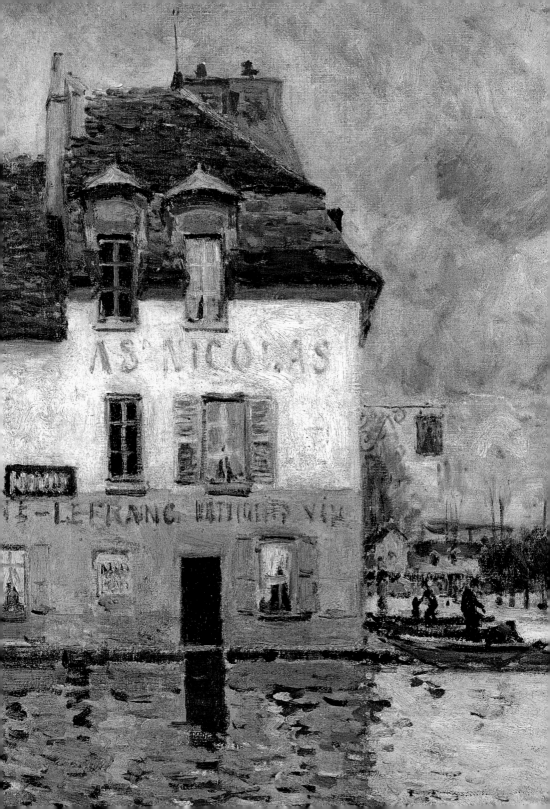

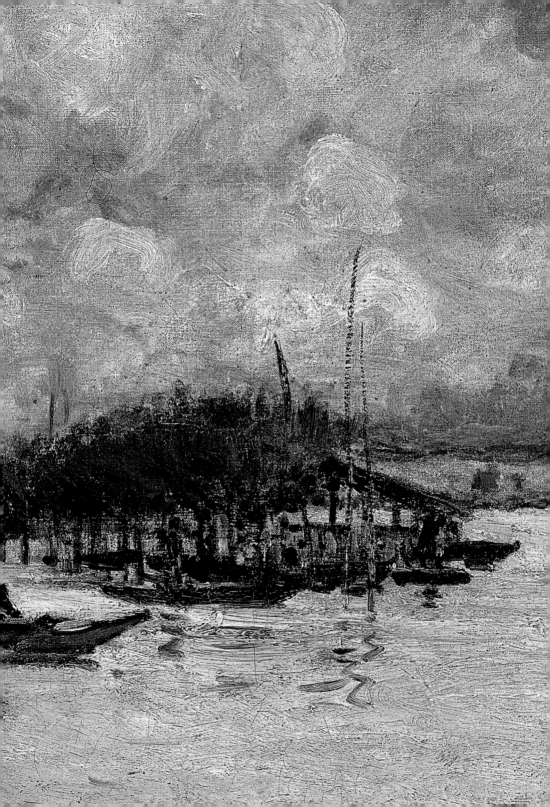

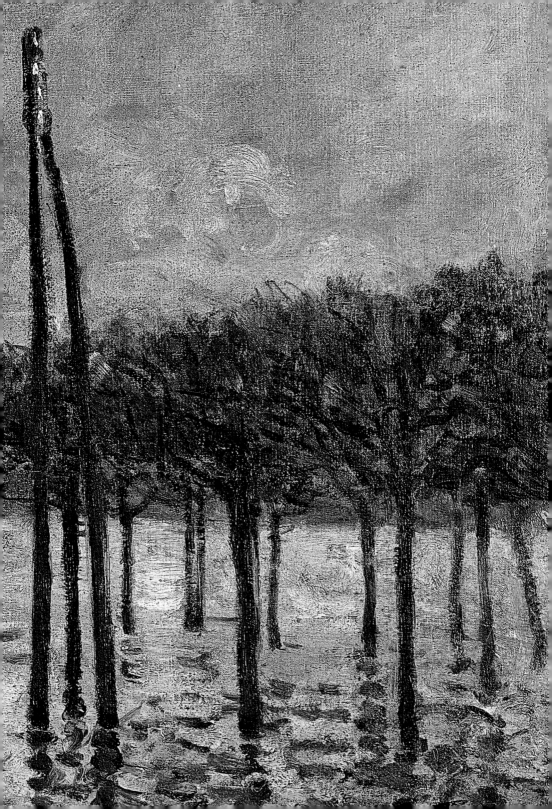

subjects: if there is a link between the movements of nature and the state of the human mind, it is an internal one. In the past, the confrontation between man and nature in shipwrecks and storms had provided excitement and delight to artists and poets alike. The viewer, lost amongst the elements, would find themselves heading towards a fatal end where only an extra-ordinary stroke of destiny could save them from certain death. Everywhere a ship was about to go under, a dagger was being held above its victim, and the gods waited for the bleak outcome from the wings, wreaking chaos with nature for as long as it took to punish mankind.

Now there is nothing left to fear. The only part of the thunderstorm depicted by the painter of Port-Marly is the subtlety of its greys, and these are merely the memories of tumultuous weather contained in the purple and blue clouds still heavy with rain. It is up in the air, rather than in the lapping waters below, where the artist shows us, from a safe distance, the power of these ever-changing shapes. The exuberance of the brushstrokes is therefore welcome, controlled by the painter and consigned to a particular area of the painting. But it is temporary, that is clear, and it soon dissolves, exhausted, into scraps of darkness which grow smaller and then disappear.

Time slows down. We are asked to appreciate the perfection of the moment, particularly considering its unusualness. But for all that, Sisley does not need us to recognise the marvel of an incomparable moment, as Renoir does so powerfully. The thrill of the present is unknown to him, and perhaps he does not need it.

The reality that we discover in his painting arises from a sort of calm emptiness devoid of any sense of the exceptional. It is sometimes a slightly troubled reality, no doubt put to the test, but never to the point of causing an imbalance. In Sisley's world modern life, in all its forms, is absorbed, but with a little distance, a sense of wisdom or resignation. That is why he expresses a particular notion of time, time drawn out and slowed down, which we accept without anxiety and allow ourselves to sink into. Whether we experience cold, a ray of sunshine, a gust of wind or the flooding of a river, the only outcome possible in Sisley's work is an eventual return to peace and calm. The landscape will, sooner or later, return to its normal restful state, and life will continue as though nothing had happened.

One of Sisley's favourite themes

In the spring of 1876, the Seine burst its banks and flooded Port-Marly. The event inspired Sisley to paint half a dozen pictures; he lived close by at Marly-le-Roi, where he had moved in 1874. This method of working was typical of the Impressionists, who liked to make several studies of the same subject with some variation in the point of view or time of day. This painting in the Musée d'Orsay (who own two of the works in the series) shows the wine merchant's at the corner of the rue Jean-Jaurès and the rue de Paris. We can partly decipher the inscription on the side wall: 'A St Nicolas, Cagne le Franc ... [perhaps the name of the proprietor] Vin.' This painting was shown at the second Impressionist exhibition in April 1876. The subject of a river in flood was one of Sisley's favourites. He first depicted it in 1872, also at Port-Marly, and would later reprise it at Moret-sur-Loing.

From deluge to flood

The theme of the flood has been extensively explored in painting, and it takes us back to the Bible: 'For behold, I will bring a flood of waters upon the earth, to destroy all flesh in which is the breath of life under heaven. Everything that is on the earth shall die. [...] For in seven days I will send rain on the earth for forty days and forty nights, and every living thing that I have made I will blot out from the face of the ground.' (Genesis 6: 17–18, and 7: 4) There is a similar account in Mesopotamian literature and in classical mythology with the myth of Deucalion and Pyrrha. In all cases, the anger of God strikes at humanity and threatens to destroy it, sparing only a few of the chosen who will have the task of repopulating the earth. Even when a painting contained no direct reference to the sacred, these iconographic echoes would remain. All confrontation with the elements was symbolic of man guilty in the eyes of his God. Poussin, Girodet and Géricault had all tackled the theme in the most dramatic manner. During the Romantic period, scenes of shipwrecks and storms portrayed the heroism of man struggling against nature and facing imminent death. The theatrical nature of a flood still pervades the scene in Paul Huet's *The Flood at Saint-Cloud*, painted in 1855. By the time the Impressionists came along, a flood was nothing more than a news item.

The opinion of contemporaries

There were more than forty articles written at the time of the second Impressionist exhibition, which was attended by crowds of curious Parisians, following the upheavals that had been caused by the group's first exhibition in 1874. The eight works shown by Sisley, which were more low key in temperament than the others, were well received on the whole, especially those which depicted the floods, which drew all the more attention for having been in the news. 'This may be the best picture in this exhibition of diehards,' wrote a certain Bigot. E. Blémont, stating that it was 'a painting of great value [...] with its pretty St Nicolas café, its half-submerged trees, its wide horizon, and its pale blue cloudy sky.' And G. d'Olby added that 'one would willingly go to this auberge and eat some fried fish caught beneath the window'. This showed to what extent the public approach to painting had, with the advent of Impressionism, passed from any intellectual judgement to a reaction to the atmosphere of a picture.

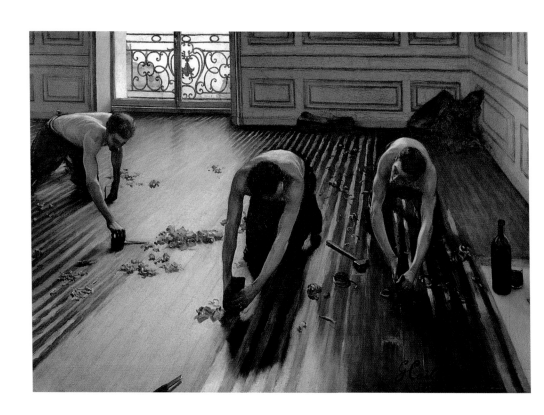

Getting into a rhythm

Gustave Caillebotte (1848–94)
The Floor Planers, 1875
Oil on canvas, 102 × 146 cm
Musée d'Orsay, Paris

The artist might disturb them. He has come into this place where these men are working, and is both too close and too far away. Too close, because they'll need the space he is occupying, which they have not yet reached with their planes. Too far away, because he is not working with them. Standing, he sees them from a different point of view to their own. One aspect of the painting does however link the sanders and the intruder: thanks to the edge of the floor which has been taken close to the top of the picture, the shape of the canvas is almost identical to that of the floor. And so we are simultaneously in the picture and in the room.

Our eye is drawn deep into this variation on brown and black, and we almost lose our balance. There is nothing to hold on to in the foreground, or rather at the edge of the frame. We feel we might step clumsily on that tool lying there, only part of which is included in the picture. The way it lies there reminds us, in a way, of the placement of knives in old still lifes, lying diagonally on a laid table, ready to be picked up and used. Caillebotte takes up this idea, but leaves the tool on the ground, amidst a calculated disorder. By catching our attention, he enables us to enter the picture at the best angle possible: all we need to do is lean down, bend our knees a little and place a hand on the ground to find ourselves in the same position as the men working on the floorboards. The most important element is, after all, these gleaming planks of wood which are gradually being returned to their original naked state.

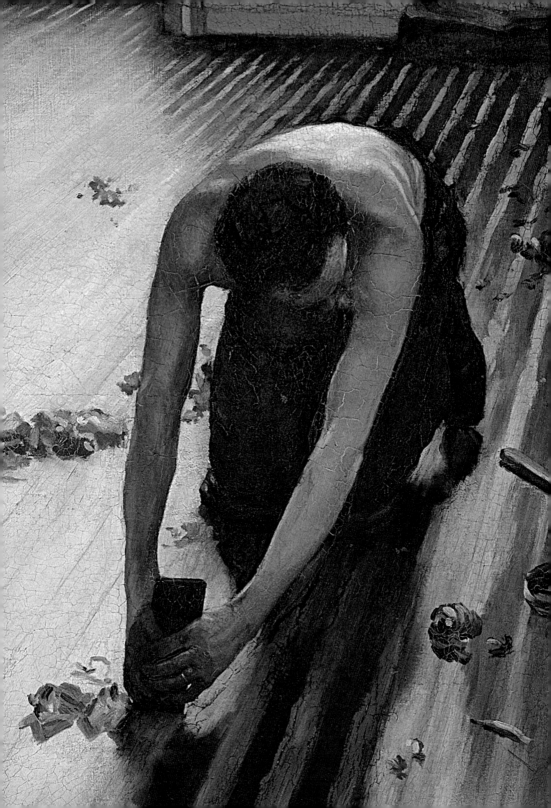

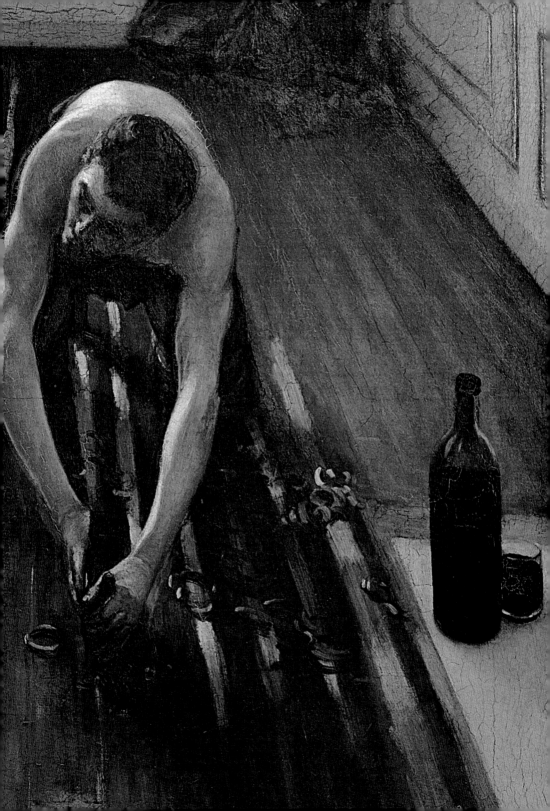

We are then struck by the precision of their movements. Perhaps we are forced to be a little more attentive by the precarious position we find ourselves in, but suddenly the mastery of their movements and the skilled nature of their work seems all the more striking. The two principal figures, with their faces slightly turned towards one another, seem to be exchanging a word or two, just muttering something, or making some brief remark, without ever stopping their work, or, worse, making the line crooked. The effectiveness of the work depends on this combination of strength and restraint, concentration and relaxation. The artist, who is, like them, an artisan, uses the same materials and techniques as them – canvas, wood, plane, brush and scraper, ancient varnish and layers of translucent colour. This painting is a celebration of companionship: the bottle of wine at the right of the picture is just waiting for the break.

The artist selects only a few significant aspects of these working men, mainly engaging with their bodies and the relationship they have with the space around them. And so their faces are left vague, as they are not relevant to the subject. As we can't distinguish their features, there is no temptation to regard them as individuals and endow them with different characters, features and names. Caillebotte could have just have left it at that, but he takes it further: he emphasises what makes them identical, providing them with the noble anonymity of ballet dancers who have learnt to erase all their individual peculiarities for the sake of the ensemble. The more alike they are, the more powerful their presence. The painting works like a stage, following a secular tradition that goes back at least as far as the Renaissance. It is not a performance, but it is a show; it is only the register that has changed.

Caillebotte places one worker in the centre, a second one next to him, and a third a little further away. This figure acts as a counterpoint to the first two, who are in a fixed parallel position with one another. The artist articulates the composition in such a way that the first thing we are aware of is the physical force of the subject: the eye is drawn towards the two main figures, it moves from one to the other, and then to and fro, centimetre by centimetre, towards the back of the room. It imitates the movement of the plane. The third figure breaks this movement as well as interrupting the symmetry between his friends. The successive rhythm is started, repeated and then corrected by each figure in turn. In the same way, the geometric structure of the parquet floor, rigorously established by the artist, is contrasted with the curls of wood shaving, which introduce soft curves, echoed in the iron balcony outside the window.

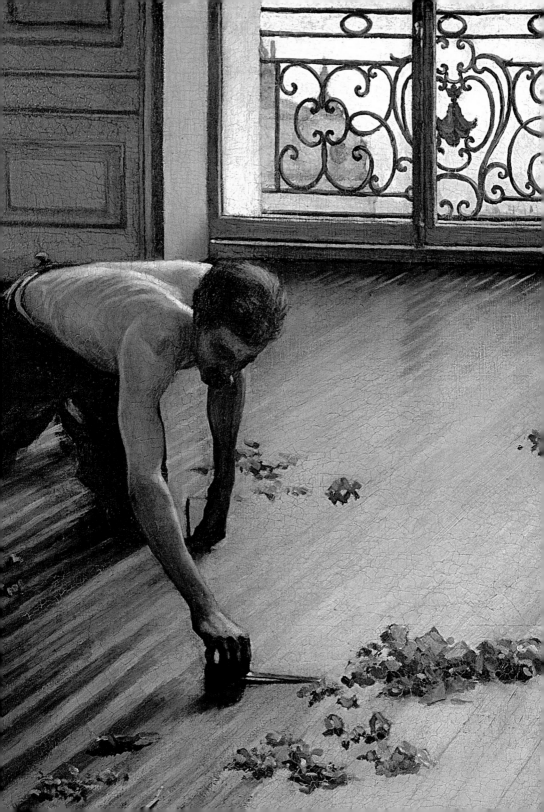

With their lack of individual identity the planers remind us in some ways of the human figures that were studied in the past in the academic studios. But instead of striking classical poses symbolising glory or compassion, exalted or wounded pride, all these figures are doing is carrying out useful work, prompted by material need. The painting deals above all with the existence of real bodies, whose presence and positions are completely legitimised by the necessities of everyday life. They are not athletes or martyrs, or executioners going about their business, and they are certainly not damned souls in Hell: these planers have taken the place of all the conventional male nudes of traditional art. And, more importantly, although Caillebotte draws on the resources of a theatrical space, his actors remain completely devoid of any theatrical significance. A body, with no underlying message, does not need to express what was known in the seventeenth century as 'the passions of the soul'. They are not here to raise their arms to the skies, lower their heads, or bend their knees to demonstrate their feelings and emotions. All that is needed is their strength. The viewer is easily able to identify their own movements with those of the figures in the painting.

Caillebotte's economical use of colour encourages the onlooker to pay attention to the effects of the texture of the painting. Reduced to an austere play of browns and blacks, the image forces the eye to notice the materials used and to identify the evidence of a classical training that carefully reproduces the exact appearance of reality. One of the essential aspects of the work, which at first appears so spare and uncompromising, is the subtle play of light on the surfaces, illuminating them but never making them seem unnatural. On the contrary, the light reveals and displays all the different textures of metal, wood or skin. But Caillebotte does not allow himself to be seduced by illusion as an end in itself: he just retains the motifs he needs to render his almost abstract view of his subject, and he includes no gratuitous elements. The grain of the wood beneath the workings of the plane takes on the softness of flesh; the varnish captures the light and adopts its transparency. Between the planks of wood, stripped or varnished, the icy harshness of the tools, and the heat of the bodies in motion, the artist achieves not just a fine balance between forms, but also a harmony of sensations.

An emblematic painting

In 1894, Renoir, who was his friend Caillebotte's executor, decided to pay homage to him by including one of his paintings in his own legacy to the state. He chose *The Floor Planers*, which, as part of the collection, would become the most well known of Caillebotte's works. It is the case that to this day there are very few of his paintings in public collections. The artist, who came from a well-off family, and would often help his friends by buying their work, had no need to sell his own paintings which, even during his lifetime, were not seen by many people. He stopped exhibiting when he was only thirty-four years old, and after his early death twelve years later, his work was definitively relegated to the private sphere. It was only much later, in 1960, when the Art Institute of Chicago bought his painting Paris Street, that there was a revival of interest in the artist. Even so, he was only represented by a single painting during the Impressionist centenary in 1974. It took several more years for people to begin to properly re-evaluate the originality of his work, with a new historical perspective that gave consideration to the social and economic context over any strict pictorial vocabulary.

Deconstructing movement

The technique of showing several figures performing the different stages of execution of the same movement can be seen as much in the work of Caillebotte as in that of Degas. They were both passionate observers of movement and equally interested in photographic images. They worked on a whole range of subjects: Degas' dancers, his women doing their hair; Caillebotte's manual workers and boatmen wielding their oars. Although this was clearly linked to the Impressionist preoccupation with conveying the passing of time, a subject intensely studied at the time, such techniques had been tackled in the past: one thinks of Millet's *The Gleaners* from 1857 or even, further back in time, the famous *Battle of San Romano* by Paolo Uccello from around 1455.

A 'vulgar' subject

The journalist and writer Louis Enault articulated a commonly held view when commenting on Caillebotte's painting at the 1876 exhibition: 'The subject is vulgar, no doubt, but we can understand why a painter is drawn to it [...] These sturdy lads, who have readily tossed aside any inconvenient clothing [...] present the artist, who wants to paint a nude, with torsos that other trades do not exhibit so freely. M. Caillebotte's planers are certainly not badly painted, and the effects of the perspective have been well studied and with an accurate eye. I am only sorry that the artist did not choose better specimens, or when he had to accept what he was offered, that he did not allow himself the freedom, which no-one would have begrudged him, to interpret them more freely. His workers' arms are too thin, and their chests too narrow. By all means, gentlemen, paint nudes if nudes are what you're after. [...] But make your nudes beautiful, or don't do it at all.'

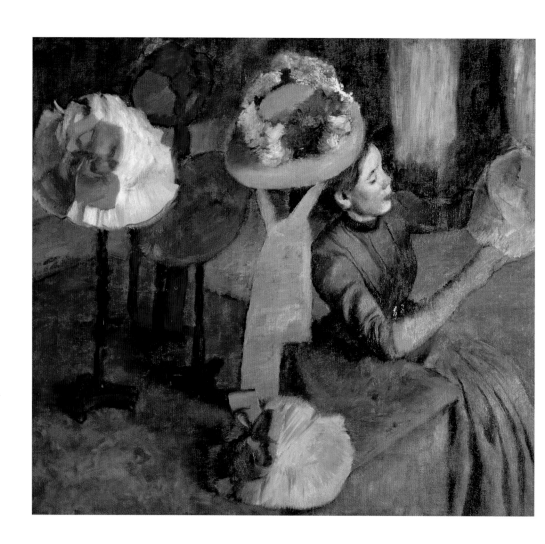

Allowing a shortcut

Edgar Degas (1834-1917)
The Millinery Shop, 1882-6
Oil on canvas, 100 × 110 cm
Art Institute, Chicago

She uses the tips of her fingers first, her eyes too of course, but mainly her sense of touch. She is immediately rewarded for her boldness. The soft touch of silk, the tangled ribbons, the deep velvet – what more could some elaborate story full of pointless events tell us about this scene? Why would we need the complication of some unimportant anecdote when we can plunge straight into the peace and fluidity of the soft blue, the watery green and that thrilling foaming white? The image tips beneath the eye of the artist, who is carried away by his passion for exquisite materials and fine trimmings. We tip over with him, and fall briefly, landing almost immediately in the rustling muslin – a delicious moment.

The hats on display bend forward, like faces, falsely attentive, prepared to adopt the most flattering pose they can. Perched on their stands they already seem to have a life of their own. The milliner, with her sleeves rolled up, sharpens a curve and straightens a turn-up. Without realising it, or perhaps without showing that she realises it, she leans at exactly the right angle: it looks as though a flowery hat is about to settle on her head. It would suit her just as well as any of the others – it's tempting. But it is not for her, although those green ribbons are a perfect match for the rather dull shade of her dress. It is all there, in the uncertainty caused by the choice of materials – how can one be sure? The soft brushstrokes encourage this hovering indecision. You pick one, you put it down, this one, or perhaps the one beside it. It's softer, more discreet. Really, you think so?

The wide ribbons fall listlessly, exactly on the axis of the painting. That's the beauty of the image, this spinal column which supports the whole picture without seeming to – a well-planned framework indeed. The milliner, like the artist, creates by using guesswork, decides the measurements, uses taffetas to achieve a slightly jaunty allure, imagines a feather there that would quiver in the slightest breeze. Or perhaps a ribbon would be wiser, dark red preferably. And with the eyes hidden beneath the brim . . .

There would be no point in creeping in on tiptoe, hugging the walls, or hiding yourself in a corner to watch people coming and going or to describe the shop. You must aim for pleasure first, instant gratification. Others would choose the same freedom to paint flowers in a field or a happy arrangement in a vase. Degas is doing the same thing here, but today he's painting a bouquet of hats, with no build up. Any visual redundancy would dilute your interest in the subject. The artist would clearly have no time for the long preambles of Balzac, who minutely describes, stone by stone, the slightest wall in the slightest street just to provide a background for one of his characters. To hell with fictional inventories – this place we have entered will remain undefined. The decor does not exist unless it is to be given a leading role, which is not the case here. As for other figures, they would just produce a lot of gossip – walk-on parts, idle onlookers. Of course this young woman working on the bonnet is a necessary part of the painting – she animates the image, which otherwise would be no more than a simple still life. However she must remain in her place. She will not become the heroine of the piece, nor will she have anything to say.

Many of Degas' contemporaries, as well as the general public, still delighted in suggesting links and developments between characters in paintings, turning painting into a branch of literature. The milliner's shop could easily have lent itself to such an interpretation. But just the thought of any kind of intrigue is too much. The picture will definitely not tell a story, not even the most subtle allusion: nothing of lovers' meetings between purchases, hurried fittings and secret bills, delayed deliveries or confidences imparted over the counter – all lost with the sigh of a dying rose, beneath a tiny ribbon. Or better still before a hardened mirror that can never repeat any of the whispered sighs or complaints that it hears.

Degas, always the professional, right up to the secrets of the back of the shop, is a master of the indistinct background in which murmurs remain suspended in the air. Nobody is better than him at letting them dissolve into the rarefied atmosphere of a painting. Once all that has been sorted

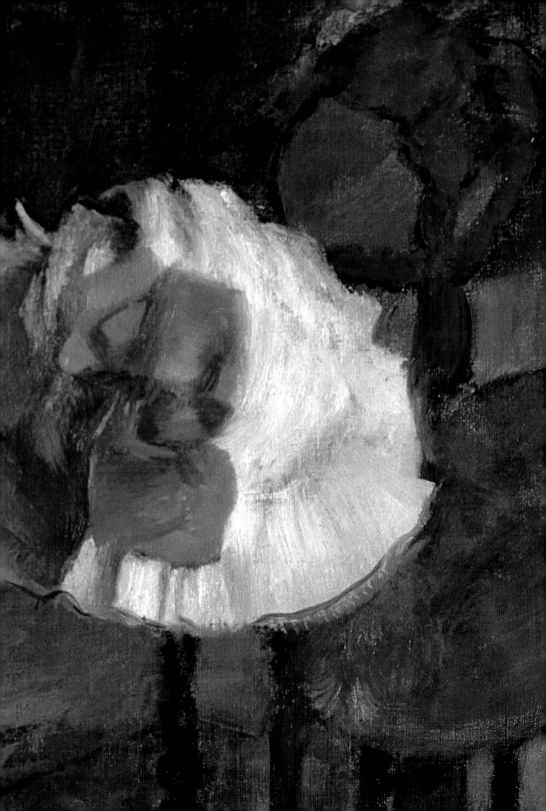

out, and old sentiments have been set aside along with last season's fashions, the hats themselves become dominant, suddenly at the heart of the painting, a vibrant heart crammed with coloured presences and gentle rustlings of longing for the smoothness of satin.

Degas found the transition from one milieu to another quite simple, and did not feel the need to show any of the details of his travels through Paris. What he wanted to capture was the atmosphere of his subjects' everyday life: he worked within a kind of mimesis, in which he admired the elegance and precision of the way people composed and controlled themselves. Laundry workers and milliners, jockeys, dancers and cabaret artistes, all his models to some degree worked at eliciting what was important in human nature. And his art is a record of their skills. An athlete in training, a voice in practice, a ribbon being cut; the special quality of each gesture, the light that is needed, the dust on the boards and the damp in the air, the exhaustion and temporary absences – Degas absorbs all of this as well as the exact colour of a wall hung with silk. By watching them hour after hour he gathers together everything about them, the truths they cannot admit to, their secret problems. And what he finally produces shows that in the end there is no subject here other than art itself, whether it is that of the milliner or his own. He is showing us talent, the ardour of creativity, the passion and the greed for what can be made, learnt and improved upon, the manipulation of textures and the secret effects of colour.

For some time, painting seemed to become impatient, no longer tolerating the portrayal of a succession of episodes, or a series of chapters. Hasty brushstrokes softened the contours, colour no longer remained within the outlines. Instead, it spreads and becomes diluted, like a tear or perhaps a kind of erosion. There is a need to skip the slow bits, the heavy descriptions. It is a picture that is wary of the novel but still has something of its atmosphere, a kind of slightly flushed nervous energy, which comes across as the last quiver of the artist's brush. He is trying to get down to basic essentials, taking short cuts and not giving in to old conventional forms of expression. Not, in particular, giving in to anything that can come between the image and the viewer – to reach out directly, to offer the pleasure of pure sensation.

The milliner and client

This painting marks the end of a series of works produced between 1882 and 1886 of the millinery shop. In the early 1880s and after 1890, Degas would also explore the subject with pastels. In many cases, he introduced other figures, looking at themselves in a mirror or trying on a hat. Research carried out by the Art Institute of Chicago has revealed that beneath what is now visible in the painting, the artist had originally depicted a customer wearing gloves and a hat. He decided against using this figure, but did not, however, change its position, instead including the figure of a humble milliner at work. This was a method frequently used by Degas, like a transparency overlaid on to a position or gesture, which did not change anything essential of the silhouette. In this case the superimposition, even though it is invisible, contributes to the ambiguity of the image, giving it a particular kind of depth and making one sense the relationship between the two different figures.

The importancce of the object

Traditionally in paintings, objects and accessories in particular are used to signify particular characteristics of the figures: a skull held by a meditating saint, or a fan in the hand of an elegant woman, are both part of a well-established code that enables the onlooker to understand the message of the painting. In all cases the object itself remains no more than a prop, no matter what its symbolic power may be. The originality of Degas' work comes from the fact that it reverses this usual hierarchy and makes the object itself the principal player, dwhilst at the same time gradually reducing the importance of the figure which supposedly justifies the presence of the object: the viewer is now expected to take on that role. The way the image seems to tip forward in the space is echoed in some passages of Émile Zola's *The Ladies' Delight* (*Bonheur des dames*) (1883) in which he describes the bewildering seductiveness of a large department store. The pictorial equivalent of this falls halfway between a genre scene and a still life, and reminds us to a certain extent of the market stalls, groaning with food, that one sees in Flemish paintings of the sixteenth century.

Japonism

'It's a curious thing this revolution brought by Japanese art to a people until now enslaved, in the world of art, to Greek symmetry: now everybody is thrilled by a plate in which the flower is not quite at the centre, or by a piece of material in which harmony is not achieved by half-tints but rather by a skilled colourist's juxtaposition of clear colours . . .' (*Journal*, Goncourts, 18 February 1877). 'Japonism' was the word used to describe the extraordinary craze that grew up amongst artists for Japanese art after Commodore Matthew Perry's assertive opening up of the country to the outside world in 1853. At first it was the objects that aroused people's interest, the porcelains and bronzes, but it was the engravings that caused a real visual revolution. They were a vital element in the Impressionist movement, displaying as they did large, flat coloured surfaces and plunging perspectives, as in the 'Ukiyo-e', and images of 'the floating world'. The Great Exhibition in London in 1862 and in Paris in 1867 revealed to the public what had already caught the attention of Manet, Monet, Whistler, Tissot, Baudelaire and the Goncourt brothers. Shops were opened, and articles along with many other works on the subject were written, resulting in a deeper knowledge of Japanese art by the end of the 1870s. Degas, along with Monet, being adept at close-ups and unusual framings was, without doubt, the artist who most deeply appreciated and responded to this new aesthetic.

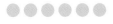

Sticking to a theme

Claude Monet (1840–1926)
Haystacks, End of Summer, Giverny (Les Meules, fin de l'été à Giverny), 1891
Oil on canvas, 60 × 100 cm
Musée d'Orsay, Paris

Nobody is going to stop here. The workers' day ended a few hours ago, and walkers generally take a different route. In any case, few of them would imagine that there was anything of the slightest interest to look at here, right in front of them, only a step away. Just two haystacks carefully aligned, one close by, the other some distance away, forming a backdrop. Two haystacks in the middle of a field and in the middle of a canvas. There is so little there in the way of landscape that the painting could be passed off as a detail, a fragment from a larger image. The viewer, disconcerted in the face of this unrewarding scene, looks instead at the band of violet blue that cuts across the summer sky.

It is not a common subject for a painting. Or rather it is such an ordinary sight in real life that it seems quite out of sync in a painting. Haystacks in general only ever act as a background, at the very most, to images of farm labour, sometimes as allusions to the wealth of property owners in socially motivated paintings; but nothing prepares us for this presentation which is both sparse and monumental, quite unsuited to the anodyne nature of the subject. In the past, this level of importance had occasionally been granted to a group of trees, or sometimes one isolated tree, but that theme, although bold, did reflect a certain tradition of nobility: the vertical nature of the tree could be associated with the potency of willpower, or often it could represent a meditation on the passing of time.

A frail young tree could draw the spirit towards the future, whilst an ancient one would be the witness to events in the distant past. A tree, with a life so much longer than that of man, could easily be seen as a symbol of wisdom and eternity. The wind in its branches, its proximity to the sky – even the most ordinary of trees, as a distant descendant of the trees of paradise, has some connection with the spiritual world.

A haystack on the other hand might find some difficulty in claiming such importance. It is thickset, dense and pot-bellied and has no connection with the sacred – it just sits there like a block, which is perhaps its main virtue, since it must resist the threat of scattering or collapse. It forms a natural bastion. The artist is not attempting any rural narrative; he just works on a geometrical volume, a conical mass with opaque colours that become iridescent in the sun. The entire value of the painting lies in the simplicity of the theme and the brevity of its message. Monet avoids all forms of painterly eloquence; he selects from nature the least seductive, the least expressive of subjects, but at the same time, the most well-built and well-integrated of shapes. A shape devoid of emotional content or symbolic history – a new theme, and his very own.

The artist has thus eliminated everything that could link the object to any context or other significant element. The connections aroused by the shapes could have led to other ideas, from a haystack to a house or to a figure, from a silhouette to a tree, from a hedge to a haystack; all those routes had been extensively explored. The picture would have turned into a genre painting, a country story. But all he wanted was a haystack, and another to mark the correct distance, maybe a few others, just suggested, in the background, to introduce some rhythm, nothing more.

The image does move, so much so that Monet finds it hard to let it breathe fully. The sunlight envelops it in such a way that the colours are changing all the time, mingling with one another, creating patches of translucent pinks, blues and yellows. The heat of the day has entered into the thickness of the stack, of corn or wheat – it does not matter to the artist as long as the rough surface responds to the passage of these last rays of sunshine. Nothing comes between him and his theme, other than the passing hours. He wants to capture it all, and yet nothing is happening apart from these stunning changes of colour. The canvas is just a receptacle for amber and violet shades. It seems impossible for Monet to ever stop. He will be driven away by the falling of the night, but he will return. And he will for some time to come continue to produce these paintings as the days and seasons pass.

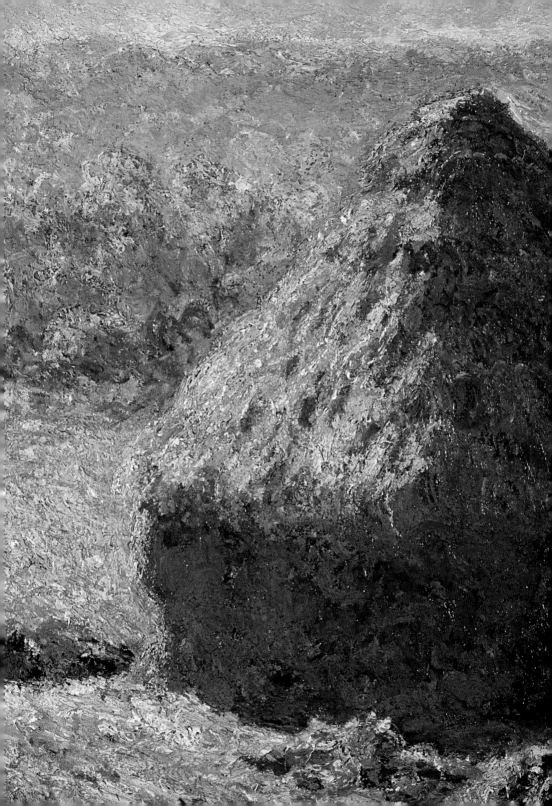

Bathed in this sunlight that wraps itself around the haystack in big patches of yellow and purple, Monet must have been reminded of another painting, many years earlier, of a group of young girls in flower in a garden, playing around a tree, their dresses lit up by the sun. They had disappeared long ago, and yet the artist still pursues the same goal, which would always fascinate him, and would never end, trying to conjure up that all-consuming moment in time. The images slide past, linking with one another through the decades of work, like half-remembered phrases from a counting rhyme. The young girls turning around the tree, the light turning around them, one day . . . and then they scattered and the shadows began to turn around a haystack, and then another.

The artist asks nothing more of the viewer than that we should follow this solemn and light melody of passing time. Time tells its own story by taking over this painting, and all paintings. It continues with its eternal circular trajectory – the haystack is also a sundial, and its shadow, as it has always done, marks the passing hours on the ground. Monet follows in its path, to find out how much time he has left, and to understand where to place his easel in order to try and reassure himself, as he used to, that these vanished moments will return.

The painting offers nothing more than that which can be retained and supported by memory. It demonstrates to us the modesty of our disparate memories and the obstinacy of a spirit determined not to give anything up, especially those little things that in the end were what mattered most: the extraordinary intensity of the moment, the blinding sun and then the return of the soft light. All reasons to paint.

Monet painted this haystack, or another, fifteen times, a synthesis of fifteen different days, from the darkest to the brightest, from hot to cold, beneath snow and sun. Fifteen paintings to compose a narrative that has no story but without which life is not possible, beginning each time from the same empty space in the middle of a field. One day in the summer mist, another in the morning when the sun was too pale.

One painting would lead to another: he would start again, paint the scene, but it would never be the same. Every gesture is unique and irreplaceable like every nuance of this cycle of light, and nothing, ever, repeats itself.

The first series

The 'Exhibition of the Recent Works of Claude Monet' opened on 4 May 1891 at the Durand-Ruel gallery. Out of the twenty-two canvases shown, fifteen were of the same subject, one or two haystacks seen at different times of the day. Although he had in the past made several studies of the same subject – the Gare Saint-Lazare for example – this was the first time he conceived the whole series as an ensemble. Its immediate success was unprecedented in the history of Impressionism, and the critics unanimously praised both the decorative and the poetic nature of the works. Camille Pissarro, although critical at first of an enterprise that he regarded as basely commercial, changed his mind once he had seen the exhibition and wrote the very next day to his son Lucien: 'I found it very masterly and luminous, that is uncontestable ... The colours are pretty rather than powerful, the drawing is beautiful but fluid, especially in the backgrounds. It doesn't matter, he is really a great artist! No honestly I am not surprised. These canvases breathe contentment.'

The ensemble and the fragment

On 7 October 1890, Monet wrote to his friend and future biographer Gustave Geffroy: 'I am slogging away at a series of different effects (on haystacks) but at this time of year the sun sinks so fast that I can't keep up with it ... I am getting so slow at working that I despair, but the further I go the more I realise how hard I must work to be able to convey what I am looking for: "instantaneousness", above all the envelopment of the same light spreading everywhere – more than ever I find myself disgusted by things that come easily at the first attempt. And finally I am more and more obsessed with the need to convey what I am feeling, and I pray that I retain my powers a little longer, because I feel that I can make progress.' This venture marked a definitive landmark in the history of images. Monet continued with other series (the *Poplars*, *Rouen Cathedral*, and the *Waterlilies*) launching an artistic technique that would become common practice in the twentieth century. The open unlimited nature of the work eventually meant that it came to be regarded as just one work, in which each individual painting was no more than a fragment. And so whilst the Haystack series represented something complete, the notion of the fragment would eventually lead Monet into a frantic race. Around 1900 he produced no less than forty-eight canvases of waterlilies. He was only restrained in this constant pursuit of the fleeting moment by the space available in the Orangerie rooms at the Tuileries.

Unfinished moments

'We make little use of our experience, we leave unfulfilled on long summer evenings or premature winter nights the hours in which it had seemed to us that there might nevertheless be contained some element of peace or pleasure. But those hours are not altogether wasted. When new moments of pleasure call to us in their turn, moments which would pass by in the same way, equally bare and one-dimensional, the others recur, bringing them the groundwork, the solid consistency of a rich orchestration.' (Marcel Proust, *In Search of Lost Time*, 1913-27)

Immersing yourself in nature

In the midst of the seventeenth century, Nicolas Poussin painted a particularly significant episode in the life of Diogenes: the ancient philosopher, who has given up all his worldly goods, sees a young boy, who knows nothing of philosophy, drinking water from his hands. The old man then understands that he must give up the one object that he has kept, his drinking cup, as it has prevented him from coming into complete contact with nature.

The Impressionists had begun to identify the space of the canvas with the philosopher's journey, following it to its ultimate logical conclusion. In a symbolic manner they too would throw away their drinking cup and it was clearly no coincidence that Cézanne professed such great admiration for Poussin, whose vast landscapes had in their time defined the connection between nature and human reason. The theme of nudes and bathers in the open air, which was so popular at the end of the nineteenth century and the beginning of the twentieth, was itself a demonstration of this need for a fusion with the elements, and the desire for a return to basic principles. They wanted to restore painting to a living relationship with the surrounding world, to rid it of all its affectations, and to raise it to its true level, and consider it as, above all, a space that relates to life itself.

Turner, during the Romantic period, initiated the concept of conscious abandonment to the forces of nature when he had himself tied to the deck of a ship in a storm in order to achieve greater realism. His images, in which the world appears to dissolve into colour, had reached the frontiers of abstraction. By 1870 Monet and Pissarro had seen and admired the works of the English artist in London, and the memory remained alive within them as that of a discovery that could not fail to encourage their own bold experiments. But they followed their own individual path, building on observation, working on the spot and on immediate impressions, in a play of perpetual transparency that would gradually include the concept of time itself.

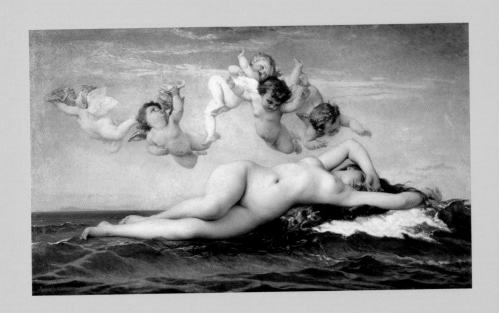

The end of boudoir painting

Alexandre Cabanel (1823–89), *The Birth of Venus*, 1863
Oil on canvas, 130 × 225 cm, Musée d'Orsay, Paris

.

.

.

.

.

Lying back on a wave as comfortable as a bed, the goddess born from the sea is resting, wearily languishing. With one arm folded over her face, her eyes half-shut as though she was just waking, she observes the onlooker with an affectation of shyness. Her body is naked, but her modesty is safe, first because she is a mythological figure, therefore wise, and secondly because, by partly covering her face she appears unaware of her own sensuality. The codes of good behaviour have been observed.

Under Cabanel's watchful eye, this embodiment of love and civilisation becomes, in the words of Émile Zola 'a delicious whore, not made of flesh and bone – that would be indecent – but of a kind of pink and white almond paste'. The artist excels at creating a pleasing image of a simplified world, where nothing requires any thought: an appealing work for a public that is happy to be distracted and even sometimes to become harmlessly excited. And if there are a few echoes of the pinks and blues of the splendid decors of the eighteenth century, it is all the more appreciated – it's just a matter of re-using the old formulas.

The artist triumphed with this painting at the official Salon of 1863, while Manet was causing laughter and scandal at the Salon des Refusés with his *Le Déjeuner sur l'herbe (The Luncheon on the Grass)*, which was judged to be badly painted and indecent, showing as it did a naked woman in a scene of contemporary vice.

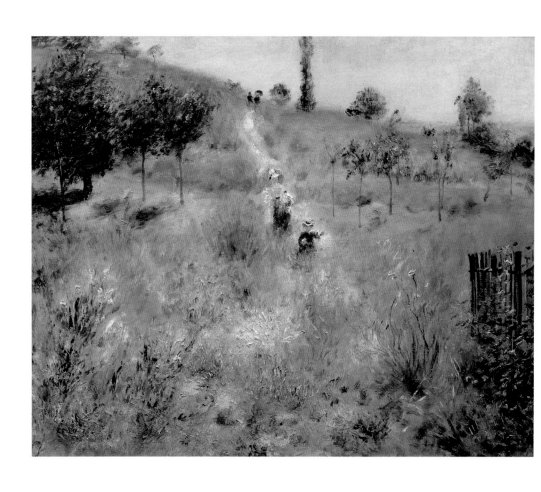

Drunk with colour

Pierre-Auguste Renoir (1841–1919)
The Path through the Long Grass, 1875
Oil on canvas, 60 × 74 cm
Musée d'Orsay, Paris

It would be best to wait till they get here, to stay planted in front of the fields watching their progression. You could easily go to meet them, walk through the long grass, trying to follow the path that has become overgrown with the arrival of spring; but it would be best to just concentrate on this image, watching as the tiny patches of colour grow larger until they develop into properly defined human shapes. To be able to perceive the exact moment when they become recognisable. When they were further away, the shapes were so indistinct that the red of the umbrella mingled with that of the flowers, just one more poppy, one slightly deeper blue shadow. And then, they became detached from the landscape, just enough to make you certain of having seen them. After that, it all happens too quickly – they are nearly here, the picture will be lost, melting into the chattering activity of the return from a walk.

The artist plays the scene back to himself over and over again. The moving image begins again from the beginning. They walk but do not advance. They advance but do not arrive. The present is being perpetually replayed. He will keep the image in his mind, the image of a moment that never ends, and that will never end. It shows time itself set against a background of endlessly renewed nature. It floats in a space we thought was reserved for mirages, a space for promises, with a dusting of fresh air and sweet horizons.

The picture gradually fills up, in an astonishing flurry of mixed colours. Of course the image remains faithful to what we see in nature on a radiant summer's day, or rather what we do not see: all those details that are only half-noticed, from a distance and fleetingly, without quite realising it, occupied as we are, looking at someone elsewhere, a face perhaps, or the signs of a change in the weather. No doubt the artist initially intended to capture, even just a little, the reality of these shapes and figures: the line of a tree trunk; the wooden gate in the foreground; and the slender form of the wild grasses; that poplar over there, too tall for the canvas; the leafy trees on the left. But not all the brushstrokes are attempting to reproduce these forms, even imperfectly seen, that one guesses at amongst the thick vegetation.

By mastering the vocabulary of allusion, Impressionism had opened up unlimited spaces for the artist's brush. He could use all his skill to capture the visible world in its most approximate form – since we are in fact incapable of perceiving it in more detail, and this is, above all, a project aimed at pinning down the truth. But to achieve that he cannot simply be content to draw in a vague manner, or to deform what he observes; his point of departure is not so much the landscape itself as the patches of colour which seem to dance before his eyes in the midst of the radiance of nature. He invents, guesses, imagines, allows himself to make arbitrary brushstrokes which can express, far better than the most painstaking drawing, the mixture of sensations which assail him. How can one be sure that, in the midst of all this flickering colour, such a touch of paint is really a flower, or that one a blade of grass, or that one a shadow, or that one a passing reflection? By placing these fine lines of red, green or blue on the canvas as though vaporising them into thin air, Renoir detaches himself from this exterior reality which offers itself to him in such stunning abundance.

No doubt painting never did anything but create illusions. The difference now is that it no longer conceals its methods; on the contrary, it proclaims them loudly and strongly, openly exhibits them, but with the knowledge that the abstraction of the details might pass unnoticed in the general profusion. Could it just be a rustling of indistinct shapes, modified by the open air, the changes in the light or the artist's own difficulty in seeing? But Renoir's painting instantly goes much further. Freed from its traditional purpose of simple representation and now only concerned with inner sensations, it begins to break free from what had aroused these very feelings. The density of the outside world fades away and dissolves. It becomes just the pretext, the original attraction, and is now nothing more than a minor phase in the

●●

Painting the wind

Claude Monet (1840–1926)
Woman with a Parasol turned to the Right, 1886
Oil on canvas, 131 × 88 cm
Musée d'Orsay, Paris

.

.

.

.

.

.

The parasol shakes a little in her hand. The young woman is facing the wind, and her long green and blue-flecked scarf flutters behind her. We can imagine Monet at the bottom of the grassy hill watching her as she stands, observing her every movement, her every fault. She must remain there, motionless, as though nothing exists around her, or rather as though nothing has the power to trouble her. There is time, at least, for the artist to catch the light in which she is bathed, time for the heavily perfumed air to change colour once again. He devours her with his eyes. For as long as this painting takes, she is the centre of his world.

Her surroundings can hardly be called a landscape, more a suggestion, a rough approximation of the outdoors. The canvas is covered with almost bad-tempered brushstrokes. It is as though the young woman has had to stop walking for a moment, perhaps to catch her breath now that she has reached the top of the hill. Or perhaps to look at the great open view, which is what has drawn her there. Maybe a gust of wind has caused her to lose her footing and she needs to regain her balance, and hold on more tightly to the parasol she was about to drop. Perhaps all these things are true, all at the same time. The painting is placed at the junction of all these actions, these movements which link together and become entangled, insignificant actions which mean nothing but together build up a picture. The tension of the wrist, the hem of the dress brushing against the dry grasses, the arched back against the backdrop of the sky, the clouds drifting past, becoming

heavier. All this has struck the artist, and has become, for him, the possibility of a painting.

Although the work appears to focus on the young woman, it does not in fact pay her much attention. She is both essential and absent, her features drowned in the green shade of her parasol. Monet arranges his model as though for a traditional portrait, her full length figure reminiscent of official or social portraits, usually created to honour some great name, rank or position, or some important or elegant personality. But his choice here is quite different: here the individual must efface herself, and submit to the combined forces of wind and sunlight. The reality of her features and clothing gives way to the momentum of the painting, swept away in this great burst of energy. The scarf disappears with a few brushstrokes, the light material of the dress is weighed down by rough stripes of colour, and the hands are hardly sketched at all. And yet Monet is not sacrificing these details with the sole aim of celebrating a fleeting perception of the world. We might think that he is satisfied with very little, just a vague ephemeral shape, about to disappear. On the contrary, he paints that which does resist, that which we continue to see in spite of everything. The whole painting bears the imprint of this willpower, which he appears to transmit to his model.

Thus the young woman under her parasol has, in a paradoxical way, something of the antique figure of Victory, or the figurehead at the prow of a ship. Because the artist has chosen to observe her from below she appears both heroic and prudent, engaged from the start on a perfectly ordinary country walk, an image of happy vitality, prepared for any bold adventure. Although she does protect herself from the sun she does, also, turn towards the light, seeming to advance towards it, prepared to push through some imaginary waves. Whether or not she has been buffeted by the storm, she is ready to face the bracing air, whilst at her feet the grasses undulate like waves on the high sea.

Monet may be taking her further than she might have wanted, prolonging this pause, which creates so many resonances. The crossing has begun. She has no choice now but to hold fast in the midst of the storm. Perhaps we digress, moving away from the young girl in her summer dress, caught up as we are by the energy that runs through this painting. It is just that she seems to be more than an artist's model, or perhaps less. She is not just a simple presence, she is more like an abstract idea of a chosen relationship with space, a vibration in the atmosphere made visible by her resistance to it, a breath of air made stronger by her unshakeable passivity in the face of it.

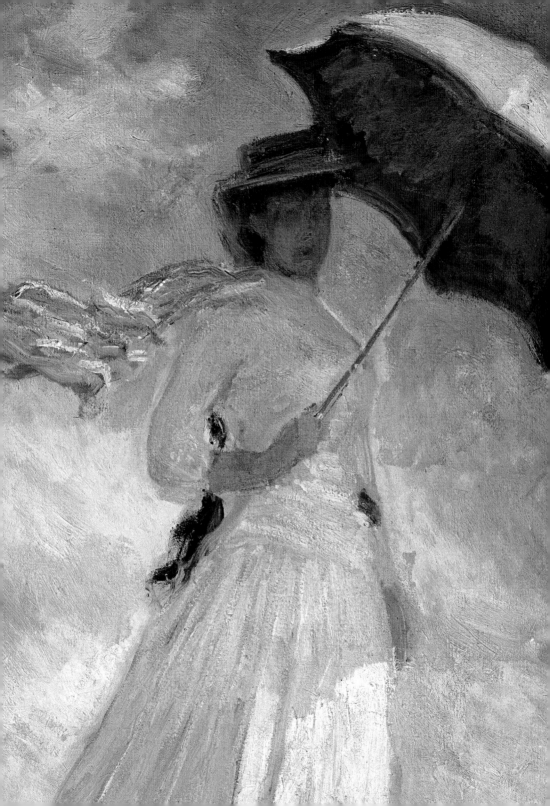

It does not matter who she is at this precise moment. She is familiar to the artist, and all that is needed is that she should lend herself to the work at hand. He wants nothing more from her than this availability, a profile, a parasol gripped in the wind. He struggles to obtain even that, because, ultimately, she is too alive, too full of the need to get away, to escape from this picture in which she is trapped, and to find her own face again, somewhere else. For her the painting is a prison made of wind.

The controlled curve of her dress places us back in the area of the genre painting, both simple and fresh. It is not really so simple, as the white is a mere excuse, a support for the shifting effects of the light. Pink, green, yellow and mauve each play their own part, breaking up amid the folds of the dress as it waves under the shifting breezes. Waves of colour run through the dress as it is lifted by the wind; the texture of the material no longer exists. The brushstrokes soften the picture, spread so thickly that we can feel their weight. And yet the dress still moves in the breeze, as though it is trying to escape from the body that is holding it down, a pure symbol of the gust of wind that the painter wanted to capture, playing with the paint.

Monet, positioned below, is able to observe the confrontation taking place between the young woman and the wind. She looks over the top of the purple and green heather, which brushes against the hem of her dress absorbing what it can of this battle that she is fighting above. She is an upright column, a kind of monument dedicated to continuity, an island of light. Everything that wants to remain in existence finds an echo in her.

How far can Manet go, how much can be surrendered to the erosion of time without losing it all, and himself along with it? The wind still does not drop. The artist quickly paints in the scarf, sculpting it with a few bright strokes of light; he ensures that the picture retains some element of reality. The painting progresses. The young woman will soon be able to go home – this was never her fight.

Monet and the Hoschedé family

Ernest Hoschedé was a wealthy fabric merchant and art lover. He was one of the first patrons of the Impressionists, and bought many of their paintings, until a spectacular bankruptcy in 1877. At that time his wife Alice had already left him, taking her six children; she was involved with Monet and looked after his two children when his wife Camille died in 1879. When she in turn was widowed in 1891 she married Monet the following year, after having lived with him for some time. When they went to live at Giverny, the painter very often painted his step-daughters, for whom he always felt a great affection. Thus he ended a letter to Alice in 1889: 'Kisses to all, to the gracious Suzanne, the charming Blanche, the sweet Germaine, my dear little ones ... my regards to the beautiful Marthe.' Suzanne, his favourite model, who posed for *Woman with a Parasol*, was the third of the Hoschedé sisters and reputed to be the prettiest. She married the painter Théodore Butler in 1892 and died prematurely in 1899. Blanche married Monet's son Jean, who died in 1914. She settled at Giverny and looked after the artist until his death in 1923.

Several women with parasols

There are two canvases, of the same size, of women with parasols. The one we see here represents a woman 'turned to the right', the other 'turned to the left'. In the first the signature is placed on the right, in the second it is on the left. There may have been some decorative purpose here, and we should also take into account the idea suggested by such an arrangement of a dialogue between artist and model: in both cases the name of the artist faces the model, symbolically confronting nature, whilst she cannot escape the artist's gaze. The long posing sessions were tedious for the young Suzanne, but also for the artist, who ended up kicking one of the canvases (the 'left' one). After repairing the tear, he exhibited the paintings together in 1891 under the title *Essai de figure en plein air* (*Study of a figure outdoors*), alongside the series of fifteen *Haystacks*. The work originated from a simple outing to the Île aux Orties, where he kept his boats, and also from an earlier memory which is superimposed on the figure of Suzanne: the silhouette of his first wife Camille, also carrying a parasol, in a gust of wind on a cliff, accompanied by their son Jean, which he had painted in 1875.

The parasol of an 'honest woman'

Suzanne's natural elegance is in no way intended to be seductive. Monet had no time for anecdotal or worldly images: he made his choice of forms and colours purely out of aesthetic requirements. He is therefore flying in the face of advice from the manuals of good style, which counselled against green parasols as being unflattering to the complexion. Years earlier, the Goncourts remarked amusingly on this subject: 'At half past twelve Madame arrives, with a fine dress and one of those parasols that could only belong to an honest woman - a green parasol, a housemaid's parasol, a parasol which says housewife.'

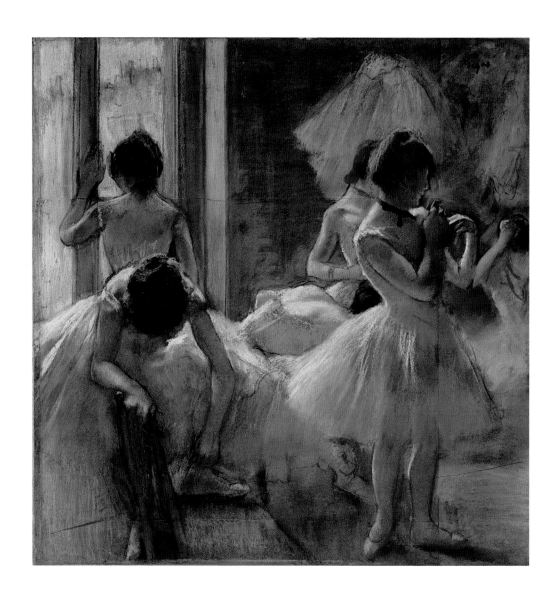

Caressing the light

Edgar Degas (1834-1917)
Group of Dancers, c. 1884-5
Pastel, 75 × 73 cm
Musée d'Orsay, Paris

·

·

·

·

·

·

·

·

Each dancer is busy with her small but essential task: adjusting a strap, tightening the bow on a shoe, pulling up a belt perhaps, impatiently pushing aside a lock of hair, putting it back, her mind elsewhere. She thinks about a more difficult step to be learned, a weak ankle, an old sprain – the fear of falling suddenly returns. Nobody will know. Nobody will even see their faces. Their expressions will be lost in the false vapour of their tutus, amongst the tulle that seems to mimic the softness of a powdery sky.

The dancers take no notice of the centre space which suddenly opens up. It appears to be empty but there is another ballerina who has just bent down. We can only see her back. Is she picking something up, or pulling up a stocking? Degas has arranged things so as to give the impression that the composition is breaking up, as though there is nothing and nobody to see, so much so that at first we don't even notice her presence. But she is both secondary and central: she acts as a keystone to the structure of the picture. If she were, say, to change position, move to the side, stand up briskly, or lean down further, we can then imagine the other dancers becoming detached from one another, their invisible link having been broken. The image holding them together is poised on a very fine balance which we know will, in a second, disappear completely. Degas is using the space as a choreographer might.

233

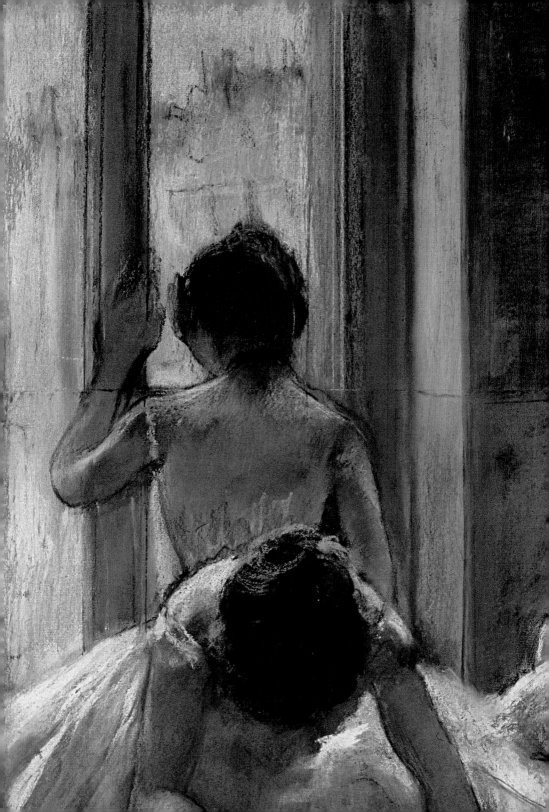

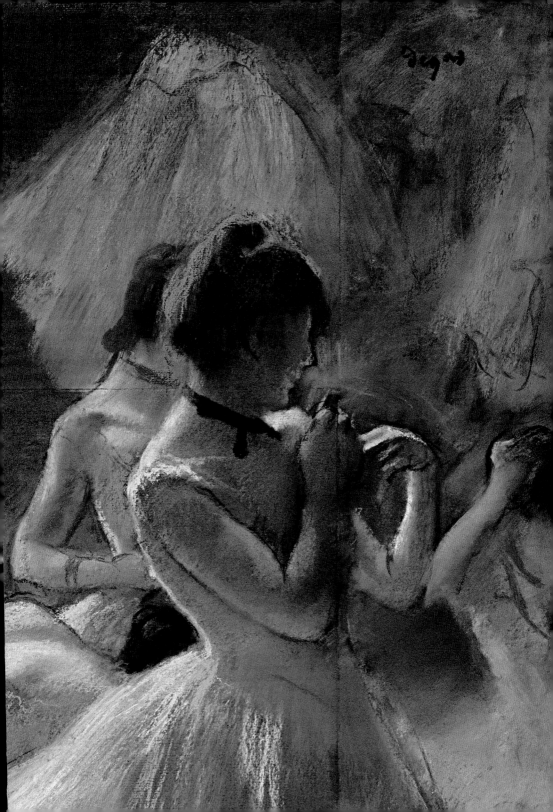

He does not need a performance to see the dancers at work. The composition already depicts a well-regulated ensemble, in which the figures relate to the space around them, approaching one another and then retreating, making the scene blossom around them, then deserting it, and then, in unison, reassembling it. The underlying tension which controls the image is caused by the ballerinas' strong will and tightly controlled energy: both distant from one another and together, they only exist in relation to one another, with no single one taking precedence over her companions. The painter, who loved to concentrate on intervals and gaps, is able to catch the subtle vibrations which animate the scene, like the notes of an almost inaudible tune.

He is not interested in any ballet positions, but rather in the moments of rest, the pauses, the time in between performances. Above all, he observes the language of highly trained bodies, this backstage repertoire which he has observed day after day, and where he has learned to decipher a whole language foreign to the non-dancer. That way of holding the feet, pointing outwards, or the legs parted in a moment of rest, that accentuated curve of the back, the hand on the hip, the bold pose, the tilt of the head. It all produces an extraordinary scene, this unlocking of the body – Degas shows us a whole new range of movements that are inseparable from the reality of his models. He has at his disposal an unprecedented series of figures which belong simultaneously to the world of ballet and to the banality of everyday life, a blend of confidence and chaos.

By illustrating the performance itself as well as the moments before and after, the artist is no longer in the position of the spectator, who is always kept at a distance, and whose viewpoint is controlled. Instead, he has become an integral part of this world, with all the freedom of one who can slip into the wings without having to justify his presence. And his acceptance into this space that he depicts now includes the viewer, who had never before been allowed such intimate access.

The figures seem to be in search of the right note, the precise tonality – everything hangs on this moment in which the image seems to hesitate, these disorderly minutes before the curtain goes up and reveals the dark abyss of the auditorium. Degas paints this intense moment of self-absorption, these seconds which seems to last forever in the twilight of the soon to be deserted rehearsal room with its soft dust and ancient floorboards. The enormous, hardly visible mirror on the right reflects the silhouettes without giving them any great importance – nothing calls for it.

What has not been rehearsed enough won't be done today – they are no longer looking at their reflections. The artist shows us only the haziest of shapes, like a worn-out echo suspended in mid-air. Another ballerina in the background is doing her hair, washed out in the pastels; she already seems ephemeral, hardly real.

In the sea of white, the figures appear disembodied. The dancers' work is described here by the presence everywhere of elbows, of arms folded, unfolded, folded again. Angles and articulations are everywhere, submitted to the obsessive regularity of the training. And the tutus seem to be made of light, like smooth unsubstantial apparitions. The materials that Degas loved so much seem to dissolve the body and its hard work, substituting for it all the phenomena of this diffuse luminosity, broken up like a precious substance over the surface of the image, alternately and simultaneously silky, crackling, powdery, slippery, shiny, broken up, subtle and sparkling, and as soft as icing sugar.

The light in the room breaks up reality and transforms it: as soft as talcum powder, both attentive and indifferent, it sits on the skin, mingling with sweat, overlaying it with a dreamy silkiness.

The pastels seem to take pleasure in gliding over the women's shoulders, and they do not convey much of the hardship they endure unflinchingly each day. Perhaps they have all, each in turn, rubbed the tips of their ballet shoes with a reassuringly scented resin. Or perhaps it was just one of them, always the same one. Never still, quivering, inhabiting the whole painting, coming, going, checking a ribbon again, practising a step. The light trapped in the tulle denies the body its true weight, and in the end becomes more real than the flesh itself. Illusion has won. We no longer know anything. How many are there exactly?

At the end of the room a window draws us towards another kind of light, the light of day, blue, gray and cold. It is the light of an outing in town, a bit of real life that suddenly seems desirable, somewhere where we could breathe. One of the ballerinas has turned to look towards the street outside, at real life.

Degas at the Opera

In the 1860s Degas was already regularly attending the Opera. A familiar figure at the theatre in the rue Le Pelletier (destroyed in the terrible fire of 1873) and later at the Opera Garnier, he made a great many friends amongst the performers: over time he came to know musicians (Dihau, Pilet, Altès, and the composer Emmanuel Chabrier), choreographers (Jules Perrot, Louis Mérante), singers (the baritone Jean-Baptiste Faure) and dancers (Eugénie Fiocre) all of whom became connected to his work, as patrons, models or both. However he only managed to obtain a season ticket in 1885, something he had long desired. He was allowed to use the 'private entrances', the sacrosanct 'connecting door' which gave him free access, through the garden entrance, to the dancer's green room. Like all the other habitués – he spent seventy-seven nights at the Opera between 1885 and 1892 – Degas rarely sat through a whole performance; he would arrive late, leave early, and often go backstage in the midst of a performance.

Painting and photography

Since 1820 photography had been constantly developing, and it already played an important role in the Great Exhibition of 1855, a few years after the foundation of the Société Française de photographie in 1851. In 1849 Baudelaire fought fiercely against the insulting equivalence made between photography and art: 'From that moment onwards this vulgar society rushed like a single Narcissus to contemplate its trivial image on a piece of metal ...' He admitted, however, that 'it is permissible for photography to take the place of art in some of its functions,' and stated, 'it must therefore assume its true duty which is to be the servant of the sciences and the arts.' This is in general how most artists viewed photography at the time, as useful particularly as an aide-mémoire for portraits. It is the case that some framings, combined with the influence of Japanese prints, did provide inspiration for certain compositions. The layout of this pastel, for example, is the result of the reworking of several photographs, since Degas had in fact only one pupil of the Opera school posing for him. As in most of his work, including those depicting dance exams, this is an imaginary scene. After 1895 Degas took up photography with great enthusiasm.

'The dancer is not a woman ...'

Huysmans, who admired Degas enormously, could only see in the figure of a dancer, 'the decline of a mercenary brutalised by her mechanical disporting and monotonous leaps'. Mallarmé, on the contrary, saw poetic perfection: 'On the subject of ballet, this is my firm belief, my axiom: to whit that a dancer is not just a woman who dances, for the following reasons, which are linked: that she is not a woman but a metaphor that embodies some of the basic forms, that of a spear, a bowl, a flower etc; and that she does not merely dance, but suggests, with all her short cuts and leaps, a kind of bodily language that would need whole paragraphs of prose, both dialogue and description, to convey in writing: she is a poem liberated from any need for a writer.' (Mallarmé, *Divagations*, 1897)

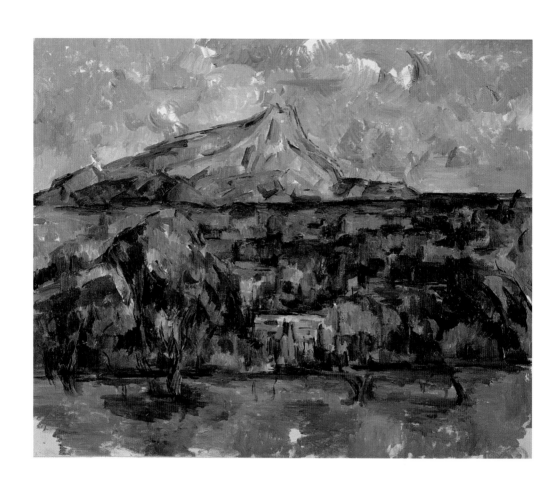

Building a home

Paul Cézanne (1839–1906)
Mont Sainte-Victoire, 1902
Oil on canvas, 65 × 81 cm
Nelson-Atkins Museum of Art, Kansas City

The mountain seems about to melt into the sky. The low clouds, tinged with green, slide down the jagged line of rocks. The white of the canvas shows through, between the feathery masses, as though resisting the colour, as though the earth could float to the surface, nourished by the light.

The artist stays here for such a long time that, gazing at the sky, he sees there the colours of the earth beneath his feet. No doubt he is painting what he sees, and what he remembers, and those moments overlap like the many shades of green or blue on his palette. That blue, which appears to invade the canvas with such abundance, occasionally seems to hesitate. It appears, and then goes no further, to make way for the ochre or become lost in the shady green. Mostly it breaks through. The air is green, the rocks are purple. There is no other space but that created by colour, which seems to muddle the sense of distance.

The uncertain contour of the mountain does not define its shape, but simply places it in the landscape, without attempting to provide anything more. Cézanne is working on a solid presence whose details are of no interest to him: or rather, for him, the precise forms cannot properly exist until he has explored them and penetrated them, and eventually absorbed and reconstructed them. Even if he were to achieve that, he still might not believe that he has grasped it all. Above their trunks the trees themselves

disappear as their branches divide and become lost in the surrounding shades of colour. They become absorbed by the distant landscape into the solidity of the earth. The scattered brushstrokes overlap, contradicting one another, at times mixing together, lingering at various spots as though suggesting some trace of possible reality: they are like so many possibilities gathered together for a picture, but which will need re-examining over and over again. Each time, we are offered no more than a hypothesis for a landscape.

Cézanne sets off again, following a path known only to him. Day after day he reinvents his own landscape, and the painting bears the traces of his long journeys. Without needing to move he looks around at the mass of rocks and shrubs between the trees and the few buildings which stand between him and the mountain. He records every shade he sees, without separating the wheat from the chaff; his painting absorbs everything that is visible, whatever it is, whether substantial or not, whether truthful or deceptive. Each brushstroke bears witness to this, simply stating that somebody has experienced this, at this moment and in this place.

The intense nature of this landscape can survive the break-up of the forms, but it is a difficult journey. The constant changes caused by nature disrupt the work in progress. There is a gust of wind, the light disappears, gradually darkening the scene, and then returns, all of a sudden, radiantly. The artist patiently carves out a road over there, regroups a few trees, and finally reaches the impenetrable façade of an old house buried in the undergrowth. Perhaps he should have gone a few steps further, past those opaque shades of brown, and worked on the surface of those ochres to let in a new ray of light. The artist constantly questions what he sees, but he is no longer worried about the volatility of things that dissolve before his eyes. Cézanne has moved beyond the Impressionism of his youth, when he was just awakening to the idea of the instability of the world around him. He has realised, for some time now, that the subject is not an easy one to capture on canvas, even free of obstacles, and he is able to persist until nature finally gives in. He manages to pin down small certainties until he has accumulated enough to construct, from area to area, some kind of breathable space. At the moment it does not matter if some of it escapes him – he must just work with what is left when the moment has passed.

The painting harbours its own inner light, which exists even without the image. In every part of the picture, Cézanne allows the naked canvas to show through, so that we can see this steady light shining out from beneath the

colours. It is not just empty space, but more like another colour, but a colour of a completely different nature. It is the only one perhaps that is totally certain, and in some places it is the only one that it is possible to use. It exists as the solid foundation for a landscape otherwise open to every kind of suggestion and distraction. What might threaten the integrity of forms elsewhere is here a promise of their security. The exposed canvas acts like the gold backgrounds of the past, and it has the same power. Here, however, there is no sacred role, and it operates simply as a base for the construction of the picture. Just as in this landscape, or any of the others Cézanne painted, the stories set against those gold backgrounds were in the end little more than accidents, not affecting any absolute truth. The timeless impassivity of the heavenly space represented by the gold is here attributed to the canvas itself: the canvas simply as its own reality, not a work intended as a more or less faithful representation of the visible world, but an object in itself, a simple cloth stretched on an easel, which refuses to be concealed. At the top, at the bottom, close up and far away, the canvas is in a dialogue with the image, never allowing us to forget the reality of its two dimensions, and doggedly supplying its own light. Beneath everything and beyond what we can actually see, the colour of the canvas appears as an unwavering constant.

And so what he paints has to be measured against this unified light. It will represent the everlasting nature of the world, whether the colours touch it, skim over it or even try to take its place, whether they overlap with one another, become diluted, become exhausted or even drown in their efforts to show what is there. The canvas is now similar to those mirrors traditionally used as symbols in still lifes or vanitas paintings: receptacles of a fleeting image of the world, an image which can do nothing but change, and which is destined to disappear. But ever constant too, like time itself.

The artist's impressions are thus imparted on the canvas. No doubt its inexhaustible glow, which could have overwhelmed him, does also act as a kind of consolation for all his doubts. Between the two of them a story is emerging, from one landscape to the next, of his home at the foot of Sainte-Victoire, like a metaphor for what must be achieved and for the heights still left to climb.

Mont Sainte-Victoire

Sainte-Victoire owes its name to the victory of Marius over the Barbarians in the first century AD. The river that runs around the bottom of the mountain on the south side was said to have turned to red with the blood of the victims. It is likely that it was painted for the first time at the end of the seventeenth century: its silhouette, although simplified, is recognisable in one of the paintings in the gallery of maps at the Grande Chartreuse of Aix-en-Provence. It was thought to have appeared in the background of some fifteenth-century paintings, such as the *The Coronation of the Virgin* by Enguerrand Quarton, or Nicolas Froment's *Moses and the Burning Bush*. This is now contested, but it does demonstrate to what extent Sainte-Victoire had been for centuries the archetype of the mountain in Provence when Cézanne came to choose it as a subject. This mingling of reality with a dream of Jerusalem combined in his mind's eye with the model of the great Italian landscapes of the seventeenth century, as well as those of Poussin, to create a synthesis of formal and symbolic elements. Cézanne's close links with the mountain remind one of Gustave Geffroy's words in 1880: 'An artist must be from a place. A place where he was born, or where he was brought up, if that is possible. If he has left, he must return, he must seek out his memories and gently recreate them, conjuring them up from the country paths . . .'

'For a long time I remained powerless . . .'

Joachim Gasquet, a poet and friend of Cézanne's, wrote a poetic account of the artist's fascination with Sainte-Victoire: 'The great classical countries, our own Provence, Greece and Italy, as I see them are places where the light has a spiritual quality, where a landscape is like a smile filled with sharp intelligence. Look at this Sainte-Victoire. What energy, what a demanding thirst for sunlight, and what melancholy in the evenings when all the heaviness of night falls upon it. Those blocks of stone were made of fire, and the fire remains within them. The shadows, the daylight, all seem to draw away, quaking with fear; up there is Plato's cave: see how, when great clouds pass over, the falling shadow quivers on the rocks, as though burnt, swallowed up at once by a fiery mouth. For a long time I remained powerless, not knowing how to paint the Sainte-Victoire, because I imagined the shadow to be concave, as others do who do not look properly, when in fact – look – it is convex, it comes forward from its centre. Instead of compressing itself it evaporates and becomes fluid. It embraces, in all its blueness, the very breath of the surrounding air.'

'Without changing position'

Cézanne painted the Mont Sainte-Victoire dozens of times, without conceiving it as a series in the strict sense of the word, in the way Monet had done with his haystacks in 1891. On 8 September 1906, a few weeks before his death, Cézanne wrote to his son Paul about the inexhaustible richness of this unique subject, which was by now completely sufficient for his work as an artist: 'Finally, I can tell you that I have become, as a painter, more clear headed when observing nature, but that for me realising on canvas what I am feeling has always been very hard. I cannot convey the intensity of my sensations, and I do not possess the magnificent richness of colour that exists in nature. Here, beside the river, there is a multitude of themes, and the same subject seen from a different angle offers a powerfully interesting subject of study, and so varied that I feel I could remain busy for months without changing my position, just leaning slightly more to the right or the left.'

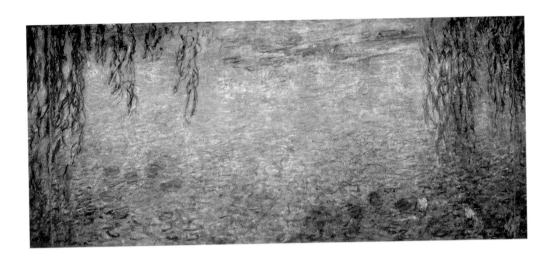

Giving shape to time

Claude Monet (1840–1926)
Waterlillies, Morning with Weeping Willows, triptych, central section, 1914-26
Oil on canvas, 200 × 425 cm
Musée de l'Orangerie, Paris

After all his travels, the artist has packed away his suitcases, folded his umbrella and put down his old straw hat. He no longer needs to protect himself from the weather. He is no longer naïve enough to expect that he will arrive at his destination, without having to first plan his route. For so long his paintings have expressed the idea that the world is always escaping, falling to pieces, hiding and then disappearing. They convey both his despair and his wonder at this slipping away of all things.

He had made himself a garden full of flowers of every colour, in which he freely juxtaposed pink and green, blue and purple, white, yellow and red. He made another one, this time full of green turning to blue, brown shades darkened by transparent greys – the soft quivering lines of his water garden, a little pond beyond the flowered paths and hedges, on the other side of the railway line that passed in front of the house.

This is where he came to settle himself, away from the domestic comings and goings, a place which, once he had painted it, turned into an enormous space, as though his easel had made it grow larger, making bigger and bigger circles until one could no longer see the edges. Already the elegant, well-controlled shrubs hid the edges of the water, and it was hard to know what to hold on to, how to avoid falling in, drowning. No matter, this is how it would

be. And if he really wanted to lose himself, if that was what he had dreamed of from his very first painting, he could wipe out those traces, or blur the lines, or create new ones, and set off again, without saying a word.

At the top of the canvas we can see the long branches of a willow, the traditional symbol of grief, pouring out and disappearing into the greenery. The artist is drawn to the simplicity of the symbol – it gives him all the space he needs, but he takes care not to illustrate it too fully. Why suffer too much? The finest of gestures soon vanish into the clouds, and the painting seems to have forgotten what is being mourned by the time the branches reach the surface of the water. As for the peaceful waterlilies, they continue unawares, opening a little more in the daylight, and closing again every evening. The whole image becomes a little more relaxed thanks to this rhythm of life which does not fear the dark. Who will ever remember what was being mourned?

The artist submits himself to nature, but he has considered and composed it before allowing it to become part of his painting. He is no longer tempted by chance encounters along the way when painting a landscape. Everything here is intentional, carefully calculated to create the resulting absence of restraint. The shapes and colours that Monet assembled at Giverny provide him with enough material to see and paint, and in enough variety to last him until the end of his days. He has chosen every tree and every plant, he has created this lake and the path that encircles it, along which he sometimes takes visitors, even though in truth there is really only room for him. His water garden is an inner garden. He plunges into it, not to go for a walk, but to get away, to exist. A little Japanese bridge links two banks, springing up like a dream above the surface of the water.

His water garden, which is both an outdoor studio and the subject of his painting, is also something of a laboratory. Monet, who for so many years worked on pinning down what is elusive, has here organised a space in which he can peacefully observe how things gently drift apart from one another. He has sought out the little bit of visible reality that was there, tracking it down in order to give his paintings some truthful existence. For Monet, time is like a wild animal to which he refuses to surrender. All the turmoil, everything that struggled to escape the present moment, has now dissolved into this pond which can now, for him, absorb all the commotion.

We gradually lose awareness of what separates the surface from the depths, the outer from the inner. The reflections in the water threaten nothing more

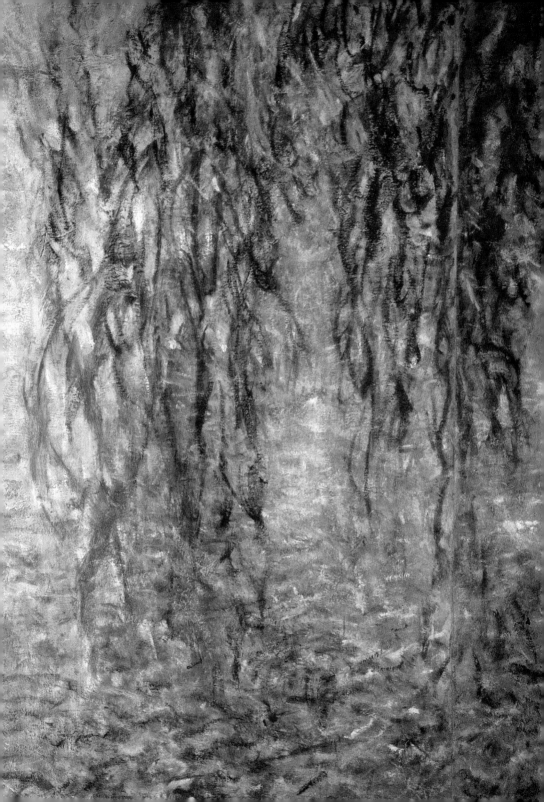

than the imaginary substance of the clouds. The water caresses the branches, drawing them down and softening them. The sky descends and disappears. There is no longer any sense of distance in this space, where all the elements are intermingled: the bottom of the lake, the bank hidden beneath the long grasses, the drooping branches and the brightness of the sky glittering on the water. The sun occasionally adds its voice to the chorus of colours itself. Just at the moment when it seems as though everything is going to disappear, that all is lost, that he would have to give up, defeated by the passing of time which undermines, encroaches, wounds and finally kills, Monet's painting has reached its apotheosis in this union of earth, air, fire and water.

The colour covers the canvases of the triptych, which link together, follow each other, and soon stretch further than his arms can reach, further than his strength can carry him. He pursues nature through one painting, and then another, and another. And now an entire history comes to life, it follows him, repeating the same refrain. Once upon a time, many years ago, there were four young women around a tree . . . later there was a young woman standing obediently in the wind, with the light whirling around her. They have gone for ever. There is nobody left, just the haystacks in the field, where the shadows begin to turn and turn until they can no longer. The waterlily canvases become confused with one another, the first, the last . . . there can never be a last one. And so his paintings describe a long line which ultimately returns to its point of origin. It is the journey of a whole lifetime. The artist at the centre of it all buries himself in the colours of the waterlillies. He remains there, invisible, within his unique picture, which alone created this place.

Within this vast studio, Monet builds a fortress made of light, in which time seems to stand still. Whilst young men are dying out there in the trenches of the Great War, the old man searches his memory for the light that he saw long ago, the light he had still not been able to capture. He must tear it from here, prevent the irises with long stalks from snapping, he must depict despair without conceding anything to it, he must make the light flare up. He must present it to the world. If need be, he will create another burning bush somewhere else, over on the bank. People must know that his work is a work for peace, that he is celebrating nothing other than the joy of time regained, beyond suffering and death. He must reconnect with the present. The surface of the lake shimmers a little, perhaps the light is dimming. The willow quivers as evening falls. There will be another day.

A complete space

The work reproduced here is one of a group hung in the Orangerie in Paris. Gustave Geffroy described the hanging, which was designed by Monet himself: 'This new series was not composed as a series of paintings but of several canvases forming panels which were part of a mural decoration. Each panel, about four metres long by two metres high, was designed to be joined to others. The whole thing showed the entire circuit of the lake and was to be hung low down on the walls of the room so that it could be seen from above by the spectator, as in real life one sees the surface of the water and the edges of the bank. This placing and this arrangement, if not completely oval or circular, at least rounded at both ends, were the only conditions of the constantly increased gift that Monet was making to the nation.'

The fashion for panoramas

At the end of the eighteenth century the Scottish painter Robert Barker was the first to conceive of the idea of using an enormous canvas with a 360 degree view, producing a unique circular painting, a panorama – a 'view that embraces everything'. It was painted in 1787 and it was edged by a balustrade and lit through an opening at the apex, invisible from below. It showed a view of Edinburgh, and this new technique, which made the artist's fortune, was subsequently copied in other countries. It became very fashionable in the nineteenth century, and was used to represent cities, battle scenes and exotic landscapes. Paris became the capital of the panorama after Pierre Prévost bought the patent, but unfortunately none of his paintings survive there. There are around thirty in existence, some of the most remarkable being in Thoune, Lucerne and The Hague. Louis Daguerre invented the diorama, a variation on the theme, animated by light effects, and later became a key player in the development of photography. It is quite possible that, although it was seeking to achieve something quite different, the highly popular panorama format might have been an inspiration for Monet's *Waterlilies*, providing as it did a technical solution to the problems faced by the artist in his pursuit of a depiction of time.

Mallarmé's dream

'Tell me, oh dream, what am I to do? How can I sum up with one glance the virgin emptiness of this solitude, and as one picks, remembering a certain place, one of those magical waterlilies that suddenly appear there, enveloping emptiness within their hollow whiteness; they are made of untouched dreams, unreached happiness, and of the breath that I hold back in fear of some apparition. Quietly rowing back smoothly so that no bump can shatter the illusion, nor can the splashing of the visible bubble of foam that follows my flight show anyone the transparent reflection of the theft of my perfect flower.' (Mallarmé, *Divagations*, 1897)

Time regained

Monet's long years spent working on the *Waterlilies* correspond to the period during which Marcel Proust was writing *In Search of Lost Time* (written between 1908 and 1909 and then 1922, the work was published between 1913 and 1927) which in itself constituted the apotheosis of literary Impressionism. The seventh and last volume, entitled *Time Regained*, is presented as a beginning: 'It was this notion of integrated time, of years gone by still being a part of us, that I now intended to emphasise so powerfully in my book.' Thus the book ends at the point where it begins, in a similar manner to the circular space of the *Waterlilies*.

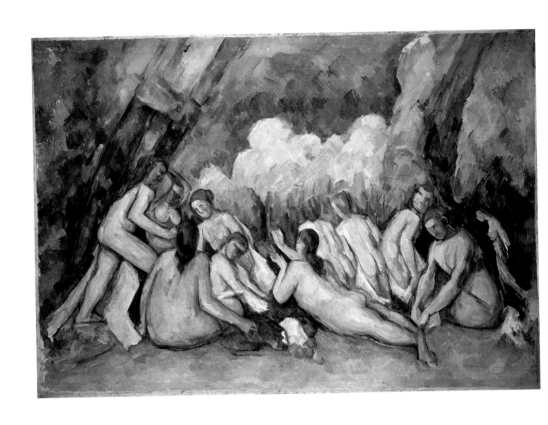

Starting again

Paul Cézanne (1839-1906)
Bathers (Les Grandes Baigneuses), 1898-1905
Oil on canvas, 130 × 193 cm
National Gallery, London

They have arrived from a distant past. Their gestures are memories. Thanks to this painting, which brings them back to life, they re-enact the poses and postures of those ancient nudes in museums, although their awkward bodies are hardly capable of appearing graceful. They meditate, they walk, they display sensual pleasure, impatience, curiosity. There is an arrival, hands placed on an ankle – but what for, exactly? They cannot compete with the sacred choreography of past centuries. Their healthy vigour is just another obstacle: a mass of flesh and muscle bundled up in its own weight, quite surprised to have to move, stiff with heavy limbs and blank faces.

They probably have no idea what is to become of them. The artist has not yet allowed them the power of thought. This listless moment is also the image of an attack on nature, which is being forced by the artist to make way for these clumsy creatures, only recently emerged from the antediluvian mud.

The eye is drawn to a sliding away of the earth, as though we were witnessing erosion at work, and rocks in the process of being formed. There is a slow accumulation of matter, surfaces gradually change colour. The trees, lightly sketched, like the bodies, bend down hesitantly. They seem prepared to change their shape, or constrain their roots, or tear them out, if any of it were necessary for the harmony of the painting.

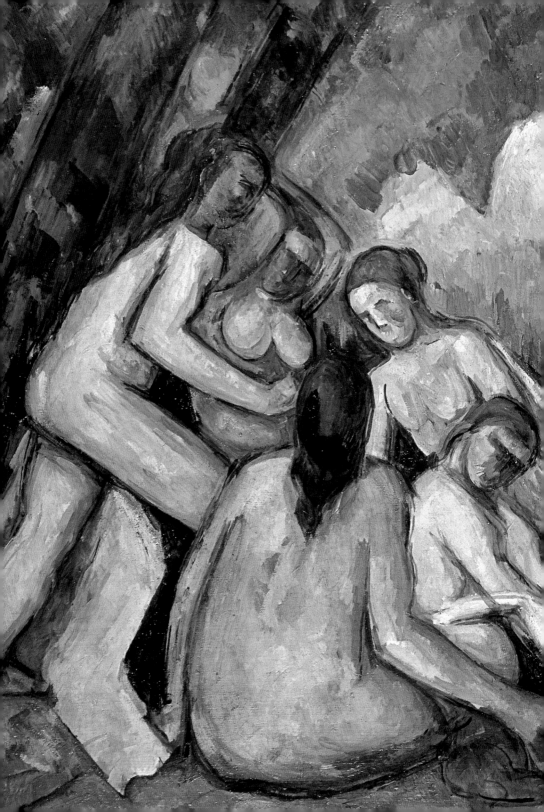

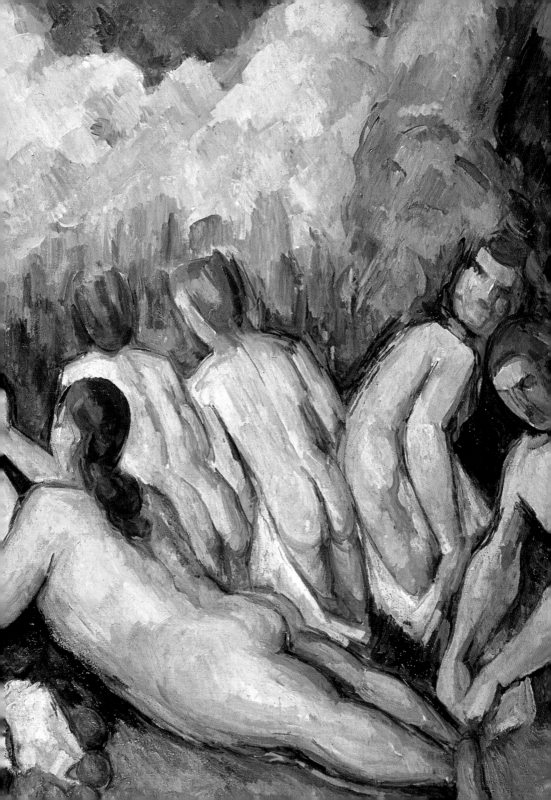

Venus rising from the waves, careless insubordinate nymphs, goddesses from the heights of Olympus – the artist's memory had been filled with this bacchanalia, which had haunted his youth and his early work. These bathers are hardly nudes, hardly even women. All traces of the sensuality he had learned in the studios have been removed from their bodies, which are now merely evidence of some kind of life. He is indifferent to any seductive ploys and wants nothing more to do with the traditions of the Academy and the aesthetics of the Salons. Of course he learned to draw a nude according to the rules, like everybody else. But none of that makes sense to him any more – anatomical accuracy, perfect or imperfect proportions, the correct distribution of light and shade to emphasise a particular muscle – it is all just the unending illustration of a story that is so well known that you no longer bother to read it. The obligatory display of beauty and feeling, of exemplary forms or situations, the luxury of those intrigues which imprison painting in an anecdotal rut, the admiration for detail and the craft – can all of human existence be reduced to this panoply? What is the point of clinging on to such wretched traditions? Bodies themselves no longer hold any mystery for the artist. Surely it is what animates them that should be what really counts. He must begin from a position of ignorance, stripped down, knowing only what he saw before learning, before having developed his way of looking and judging.

Cézanne is in search of a new beginning. He had been working for years on these figures, teaching them, from one painting to the next, how to sit, walk, raise one arm and then another, giving some meaning to each gesture. Finally, and with unexpected flexibility, they manage to avoid awkward collisions, bending gently to imitate the movements of the branches. Trees and figures salute one another. Perhaps this is no more than a mirror image, a reflective phase necessary in the course of this apprenticeship. It does appear, however, that both objects and figures, which appear to be made of the same substance, regard each other with mutual approval. It almost makes them tremble, the fact that they are in the process of discovering that they are alive, and the whole painting resonates with the shock of it.

Other shapes spring from the space and form themselves on the canvas, overcoming the fragility of their existence by setting themselves in stone: arches and columns, a door up there in a place that does not yet exist. This world has no name, and does not yet know its own history; it is not ready yet.

Cézanne has gathered the women together as though they are about to open up a path at the centre of the painting. Their round heads are echoed in the curves of the clouds. The air seems to be moving, as though crowds are about

to emerge from it. The brushstrokes rummage in the paint, sometimes coming up against a figure in gestation, leaving it time to emerge. The bodies can only develop slowly, restrained by their awkward bulk. Several of them, sitting or lying down, do not seem to know what is required of them. Is it necessary? Is it possible? Why are we trying to imagine a future when in fact the only possible reality is this present gathering?

They must come together and harmonise, as best they can, the positions they have in the space allotted to them. They must stop trying, abandon all passing impulses. They must be free. Painting is no longer a place for certainties, rather it provides the setting for constant exploration, based on the artist's integrity as he illustrates both the world's longing for existence and its self-doubt. In this sense every canvas takes the risk of reaching a dead end.

Cézanne struggles, in his own way, against the void. He shows us, in colourful splendour, the new beginnings of a nature that knows nothing of artifice, which does not seek beauty and is not afraid of ugliness. It is a world that is born from the clay and the wind. One of the bathers, with her arms in the air, will be a Venus rising from the waves, another sits engaged with lacing or unlacing a sandal. Some have adopted a relaxed position, another is trying to push herself further forwards into the painting. Somebody goes by, far away. Some of them will never be more than extras, mere followers. But each in their own way, like so many of the forms in creation, is an incarnation of the will to live.

If there was a tree in the centre of the Garden of Eden, it has long since disappeared. However, a few fruits remain, two or three apples wrapped in a piece of drapery. The fruits of original sin, the price of all knowledge. Cézanne leaves them on the ground, like an offering to the bathers who still have so much to learn.

The old man is starting all over again. His first steps were obviously errors: it had been wrong to think that paintings should simply tell the world beautiful stories, or, especially, to believe that they could make something more beautiful than the real world. Why did art need to show the terrors of the afterlife or any life beyond this one, when everything was here already. All he needed to do was to be aware of his own excitement, to keep within his own limits, to restrain his desire to go further. He suffered from the frustration of being only himself, so insignificant, like these great shy nudes gathered here for an unknown celebration beneath a glass-like sky.

Three large compositions

Cézanne had worked on the theme of bathers for forty years. From the mid-1890s he began to explore the subject on a grand scale. He continued to develop the theme until he died, ending in 1905 and 1906 with three monumental canvases, a veritable summing up of his life's work. These three paintings are very different from one another, and are now housed in the Barnes Foundation, Philadelphia Museum of Art and in the National Gallery, London. Studies of Bathers (Les Grandes Baigneuses) demonstrate that they represent a synthesis and development of subjects explored by the artist since his youth, both in a literal sense and in terms of the allusions: The Temptation of Saint Anthony, The Orgy, Bacchanal (The Fight for Love), Pastoral, The Luncheon on the Grass, Afternoon in Naples or A Modern Olympia. References to classical iconography – the birth of Venus, the baptism of Christ – operate alongside images which celebrate the fundamental harmony, rediscovered at last, between man and nature. Bathing itself (although water is practically absent from the London version) was above all a signal of the dissolution of opposites.

Cézanne and the nude

The approximate anatomy of Cézanne's nudes, whose value is largely symbolic, is also a result of the artist's great reluctance to use live models. He found it difficult to face a model for an ordinary portrait, but when it was a nude it became impossible, as Emile Bernard tells us, after a visit to the artist in March 1905: 'I asked Cézanne why he didn't use models for his nudes. He replied that at his age it was one's duty not to denude a woman in order to paint her, that he could possibly ask it of a woman of fifty, but he was more or less sure that he would be unable to find such a woman in Aix. He went over to his boxes and showed me drawings he had done at the atelier Suisse in his youth. "I have always used these drawings," he said "it isn't nearly enough, but at my age that is all I can do." I thought that he was clearly a martyr to extreme convention, and that this martyrdom had two causes: one that he did not trust himself in the presence of these women, and the other that he had religious scruples and felt strongly that these things could not be done in a small provincial town without causing scandal.'

An echo of Wagner

Like Renoir or Fantin-Latour, Cézanne was an ardent admirer of the music of Wilhelm Richard Wagner, who had been booed at the Paris Opera in 1861 for his Tannhauser, and about which Baudelaire had written a magnificent eulogy. In 1868, when the Wagnerian controversy was in full force, Cézanne wrote, 'I had the great joy of hearing the overture to Tannhauser, Lohengrin and The Flying Dutchman.' At the time he entitled two small canvases Ouverture de Tannhauser, but it was only much later, in the sumptuous construction of the Bathers that a true parallel between the two artistic universes could be seen. 'The vast mass of growing liquid sound in the Wagnerian tetralogy (the prelude to Rheingold) evokes the creation of the world,' wrote Michel Fleury in terms which could equally well apply to Cézanne's work. He continued: 'This gradual awakening of the life force also incorporates some of the innocence of the original creation: that innocence which Impressionism aspires to rediscover upstream from all the knowledge which has turned man away from connection with the world.'

The heirs of Impressionism

Impressionism, as a style, was no longer confined to a handful of painters: all those things that had contradicted the accepted rules of art – the clear light, the vibrant colours, the choice of familiar scenes of contemporary life – they had all, in just a few years, become common currency, the obvious way of looking at things. Despite incomprehension from the general public and resistance from conservative circles – still at the turn of the century referring to it as 'France's shame' – the artistic vocabulary of a generation had become established as a language in which working in proximity to nature was essential to anyone embarking on an artistic career.

By the middle of the 1880s, other developments began to come to the fore, setting out a new range of responses to what Impressionism had brought into play. Whilst the pioneers, Monet, Renoir, Degas and Cézanne, continued to deepen their own explorations, others took up the challenge and moved forwards. Between 1886 (the group's last exhibition) and 1905, when Fauvism appeared at the Salon d'automne, the post-Impressionist decades witnessed a new overlapping of practices and styles rather than a rapid succession of new movements. This means that if we adopt an approximated general overview it is possible to confuse what are, in fact, radically different outlooks.

Although they were working during that same period, Seurat, Van Gogh, Gauguin and Lautrec were not Impressionist painters, any more than were Bonnard, or of course the future 'prince of Fauves', Matisse. But all of them, to a certain extent, owe something, a starting point, a way of seeing, to what was above all an extraordinary liberation for the artistic eye.

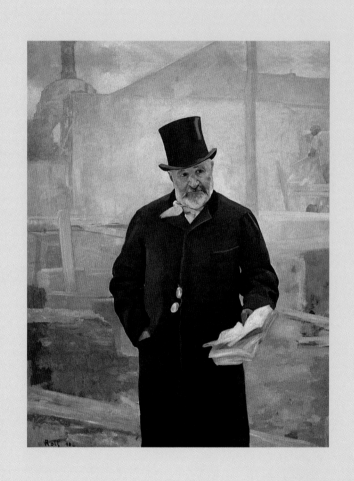

Taking things into account

Alfred Roll (1846-1919), *Portrait of Adolphe Alphand (1817-1891)*, 1888
Oil on canvas, 159 × 127 cm, Petit Palais, Musée des Beaux Arts de la Ville de Paris

.
.
.
.

.

The Great Exhibition will soon begin. The director of works is inspecting the site, holding the plans in his hand: Adolphe Alphand is an experienced man, since the transformation of Paris ordered by Baron Haussmann has come under his authority. His sharp silhouette, cleanly delineated, and the impeccable blackness of his coat leave us in no doubt as to the status of this figure, who stands out so clearly against the modernity of the background.

Behind him, Roll shows a range of all the greys in the city: the grey of the asphalt, that of the slate roofs, the transparent greys of the dawn and of the dust. The canvas seems to quiver beneath the brushstrokes, which appear both violent and muffled, as though trying not to disturb the main subject. It would not do for him to be affected by a trivial reflection or gust of wind.

It is an illusion of the outdoors. The world may be changing but reason must prevail. No doubt Roll admires the freedom of the Impressionist vocabulary, but he still has to compose his picture, and find some kind of compromise. He must steer a path between the frozen academic and wild bohemian, especially when it comes to portraits, always a delicate enterprise, with questions of character and prestige involved. And yet, there is a lot of freedom in those brushstrokes at the back of the painting ...

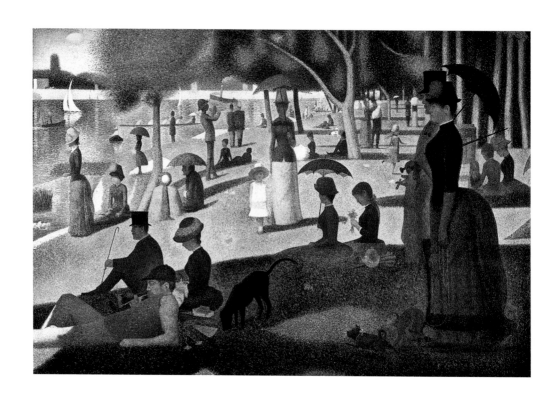

Avoiding chance

Georges Seurat (1859-91)
A Sunday Afternoon on the Island of La Grande Jatte, 1884-6
Oil on canvas, 208 × 308 cm
Art Institute, Chicago

.

.

.

.

.

.

.

.

Afternoon has arrived. The actors have entered the scene, one after another, in pairs, side by side or arm in arm. They glide along the ground, as weightless as shapes cut out of cardboard. Sun and shade have each claimed their territory, and the island of La Grande Jatte seems to breathe in their rhythm.

The peaceful Sunday crowd waits for time to go by. But here, time no longer passes. Each person plays a role, frozen in his or her allocated position, with precise gestures, and clearly visible actions: sitting down, standing up, in profile, facing forward, from behind, half lying down, with or without a parasol, alone or accompanied, by the water or under the trees with their velvety trunks. The image sets out to draw up an inventory of every possible position, as one might offer a choice of clothes suitable for a particular age group, or a certain season or occasion. Everything is possible within the confines of the conventions of society: women alone, wooden soldiers, couples with or without monkeys, mothers and children, an elegant man in a top hat, a workman in a cap, dignified nannies . . . One figure bends his head a little, another raises his chin, some direct their stare into the distance, enough to suggest the mood they are in or the general nature of their thoughts. If they are in the grip of any emotion, they keep it to themselves, or subsume it into this transparent relationship between angles and curves, subject to the incontrovertible discipline of geometry.

The intense colours are scattered equally over the canvas in a mass of tiny brushstrokes. There is no longer a question of a sudden surprise at the apparent variations in nature, even less at its particular impulses. This is why the petit point which prevails throughout the image controls it with its own discipline. It supplies a movement and texture to the painting, whilst creating a kind of indifference to the subjects depicted: the grass, the silk dress, the hair, the material of the umbrellas, the lace on the hats, the dog's fur, the freshness of the water – they are all one. The paint evens out all the visible upsets of the world, which is now blanketed by a homogenous seedbed of paint. There is nothing beneath what one can see of the landscape and the figures to contradict this controlled scattering of colour. Seurat's world is not just coated with a blanket of fine confetti, it is actually made up of these multi-coloured particles. They are both imperceptible and visible to the naked eye, and they suggest an infinite swarming of the very substance of matter.

The rigour of such a technique, beyond the constraints imposed by the artist, is also striking for the formal character that it lends to the picture. It would also be correct to see in it the artist's sharp curiosity as he observes the world as if through a microscope, fascinated by the ungraspable multiplicity of its composition. By working in this way he achieves not an accurate scientific picture of the world, something people have often been tempted to see in his work, but more the dream of a world one day rendered completely comprehensible thanks to the evolution of science. Although his priority is to bring order to what is visible by concentrating on the regularity of its structure, the analytical dimension of his work also explores an awareness of the profound reality of things. So much so that the extreme stylisation of the image is in fact the opposite of any pursuit of artifice: what it does in fact is explore the possibility of displaying the very essence of things.

Seurat, no doubt, like everybody else, saw things slipping away from him, and splitting up into an exciting whirl of colours and shapes. But unlike the Impressionists, whose passionate interest in the modern world he shared, he did not let this become the subject of the painting. What he was looking for, by cultivating this distance and detachment, were the tokens of a possible classicism, perceptible both in the strict shapes and confident contours as much as in the sensitive rhythms of the image. His approach to the image is that of an architect: we could never imagine an architect constructing a building with great waves of brick and stone, throwing materials around at random. That is why he has, as a matter of course,

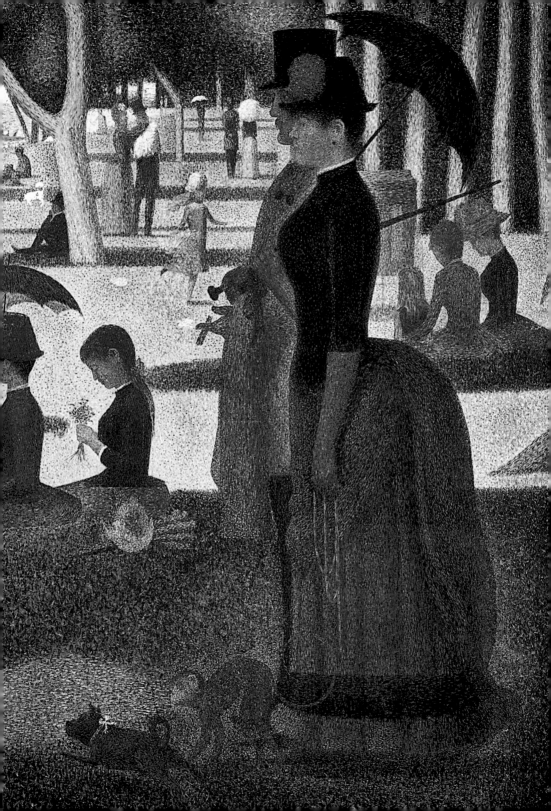

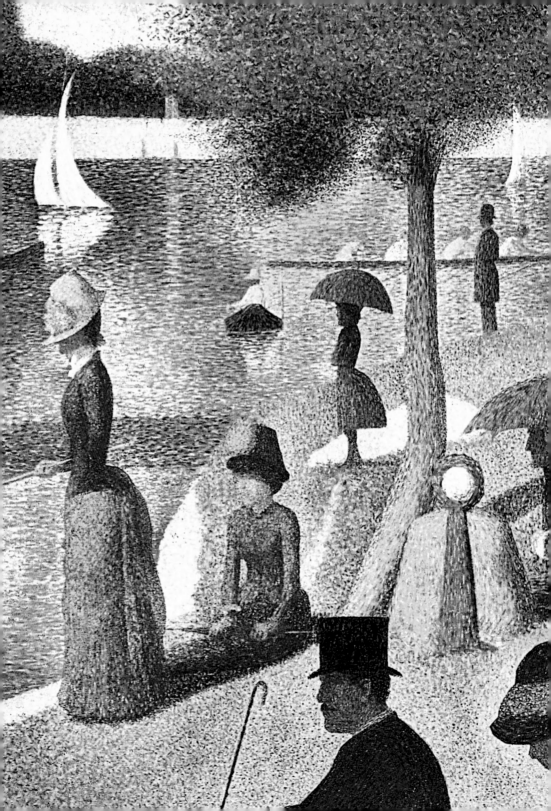

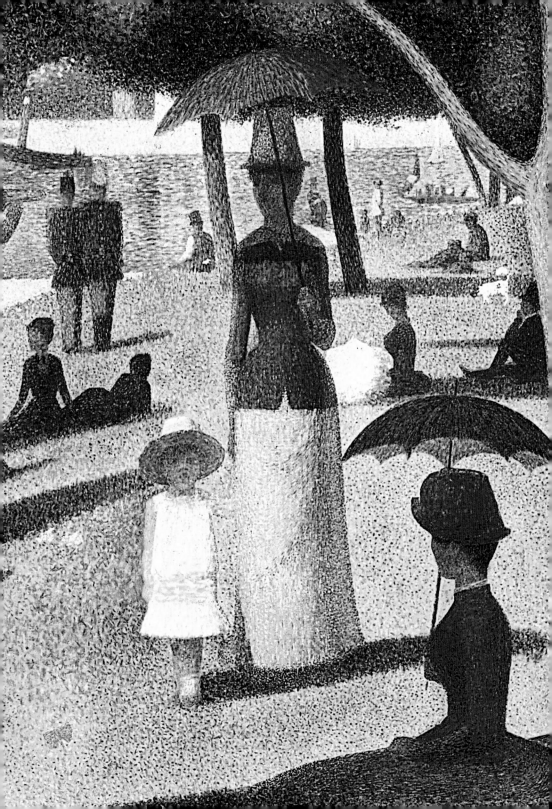

eliminated from the painting any active element which could imply a romanticism or simplistic sensuality. Whereas one could detect the echo of a sensation in every one of Monet or Renoir's brushstrokes, the purpose of pointillism is to emphasise the homogeneity of the visible world, and assumes from the start a definitive eradication of the accidental.

Where Monet or Renoir would have thrown us into the heat of a summer afternoon, Seurat presents us with a theoretical exposition, a résumé of the habits of regular visitors. But, paradoxically, one could not imagine anything more subjective than the sombre orchestration of the way he constructs the image, and the fact that he has made it so purely emblematic. Although the apparently spontaneous élan of Impressionist painting disappears under the discipline of the small spots of colour, and the unsettled nature of an outdoor scene gives way to unassailable geometric rigour, the final result still takes no account of a commonly held vision of reality. The lines that encircle the figures and the landscape, reducing them to a few basic shapes, make up the elements of a personal signature rather than any attempt to convey the visible world. The artist in this work shows us his desire to discover a lasting form of expression.

The heart beats like a metronome. The stylisation of the world around him, taken to its logical end, takes a form in which the signs of things take the place of the things themselves. A simple suggestion, a line, a colour, are henceforth enough to convey a world, shown on the canvas not by any description of its appearance but by codified signs. A dome decorated with a circle and a vertical band of colour indicates not the appearance of a nursemaid dressed in her large cape and ribboned hat, but a hieroglyphic sign meaning 'nursemaid'. The humour in a spiral-shaped tail tells us of the timeless nature of monkeys. The line of a skirt spares us the hazards of anatomy and transforms the body into a perfect profile, a symbol of fashion. Whether reduced or raised to this ensemble of simple shapes, Seurat's world attains an indestructible calm. It is as though his fascination with modernity has led to his giving a shape to silence itself. It is as if he has decided to reconcile the world of everyday life, in which people go for walks on a Sunday, with the world of essences, the abstract world of numbers in which the spirit, unhampered by matter, can indulge in eternal equations.

At the back of the painting, a little girl in red breaks out of her position and runs – Seurat has thought of everything.

The last Impressionist exhibition

Seurat worked on *A Sunday Afternoon on the Island of La Grande Jatte* from May 1884 until March 1885, making dozens of studies along the way. The painting was the great attraction of the eighth and last Impressionist exhibition in 1886. Although many critics saw it as an 'Egyptian fantasy' or an 'error', it was also much admired. With the help of explanations supplied by Signac and Pissarro, the critic Félix Fénéon wrote several perceptive articles on the subject: 'M. Seurat, who is known as an innovator, paints not by using colours prepared in the correct shade on the palette, but by juxtaposing a series of tiny brushstrokes of pure colour, which, when you stand a few steps back, melt together and produce the desired optical effect in the desired shade. So it is that in M. Seurat's paintings, each patch of apparently unified colour looks like a polychromatic stippling in which one of the pigments dominates by the number of its brushstrokes; from a distance it is that pigment that one sees, modified by the reactions and the mingling of the other tones.' A few weeks later, after the painting had been hung at the second Salon des indépendants, Seurat was already regarded as the leader of a new school of painting.

The founding texts of neo-Impressionism

Very early on, Seurat had studied certain authors whose works would help him to clarify his own thoughts about the scientific uses of colour and drawing. Amongst the most important of these was *The Grammar of Painting and Engraving* by Charles Blanc, which appeared in 1867, through which he discovered the studies of the chemist Eugène Chevreul, *The Principles of Harmony and Contrast of Colours, and Their Applications to the Arts* and Humbert de Superville's *Essay on Absolute Signs in Art*. Seurat would consequently use the three primary colours (red, blue and yellow) and the complementary ones resulting from blends (purple, green and orange), which had an intensifying effect on one another. Also the expressivity of lines ('happier' or 'sadder' according to their orientation within a space) became one of the essential elements of his vocabulary. Seurat died at a young age. His ideas were later interpreted in an important essay by the painter Paul Signac entitled 'D'Eugène Delacroix au néo-impressionisme', which appeared in 1899.

The island of Le Grande Jatte

Le Grande Jatte is one of the largest islands on the Seine, about seven kilometres from Paris. It is two kilometres long, but at most 200 metres wide, and is situated mostly in the commune of Neuilly-sur-Seine, and downstream in Levallois-Perret. Its shape is roughly that of a boat ('*jatte*') – hence its name. In 1818, the future king Louis-Philippe bought the chateau de Neuilly. Its park stretched down to the Seine, and included the island. By Seurat's time it had been considerably transformed by the renovation works carried out by Haussmann under Napoleon III. There were several hundred inhabitants, and many artisans' workshops. The early days of leisure outings brought the opening of numerous bars which attracted a very mixed clientele. Other artists, such as Monet, Sisley and Van Gogh, created works inspired by the charms of the place, but none would become as famous as Seurat's great composition. In 1983, Stephen Sondheim created a Broadway musical, based on a novella by James Lapine, *Sunday Afternoon with George*, which developed, in a romanticised form, an extremely subtle analysis of Seurat's art and his vision of the world.

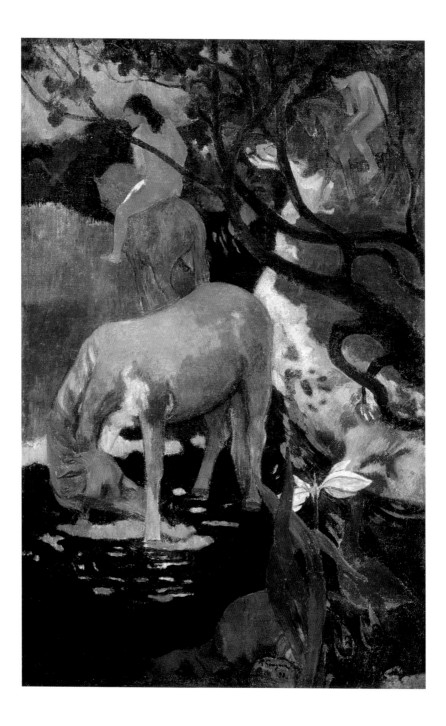

Away from there

Paul Gauguin (1848-1903)
The White Horse, 1898
Oil on canvas, 140 × 91 cm
Musée d'Orsay, Paris

To go away, as far away as possible; to lead a green-grey horse to drink from the deep blue water; to watch the light in the water forming yellow curves; to see naked riders go off into the distance on their red and brown horses; to follow the line of the branches as they curve delicately beyond the edge of the picture; to be there, over there, beneath an invisible and weightless sky.

Reality shifts without disappearing altogether. The artist is not trying to forget it but rather to transform it, or, better still, to restore it to its former splendour. He wants it to be other than what it seems. He dreams it, but without losing sight of what is actually there. Everything is real and yet everything is different. The horse is green. The horse is white. Who cares any more what colour the horse really is? The painting is not a lesson in zoology, in fact it is not a lesson in anything. Painting no longer teaches people lessons, ever since the Impressionists began daring to reproduce all the uncertainties of light and its reflections. They introduced into painting a new cheerfully amoral world, a world without principles, capable of changing colour at any minute: the dresses of the women in springtime in Monet's paintings, the messy cloths on tables in Renoir's gardens and terraces, Sisley's snow-covered paths.

Painting en plein air had allowed artists to escape, gradually, from the rules of the studio, and question everything they saw. They had to try and hit the

right note, adapt themselves to the unexpected, whilst also keeping in mind their own shortcomings. They had the courage to create approximate forms and faulty perspectives. It was already an old story, but people were not yet accustomed to it.

Gauguin knows perfectly well that the soft green that bathes the horse's body is not of his own making, and that it will dissolve, make way for other tempting colours, and then calm down completely. Eventually there will be no denying that the horse is actually white. We will see it as it is, without any possible doubt. And the world of reason, the proudly scientific world, will have won once again. But should painting play into the hands of all these received ideas of what things look like? Gauguin does not want all these marvellous effects of the light to disappear, leaving him alone once again with these people who have learned their lessons so well. Of course he can reassure them, after all he knows perfectly well that the horse is white. After he has explored all the possible shades, after nature has toyed with the preconceptions of honest people and has shown us all the colours of the rainbow – after all that, we will have to admit defeat, the end of the dream, and resign ourselves to the fact that, yes, the horse is white.

But at this particular moment the tangled greenery filters and colours the light as it passes through, and the brightness of the day becomes tinted with green and creates a mythical animal. The movements within nature have the power to transform ordinary reality. The unpredictability of the colours is a gift to the artist, and he seizes on it and preserves it, since the ephemeral now has greater power than the most truthful of depictions. A trick of the light is enough to create a whole world. The change in colour alters the very nature of things. One begins to imitate it, to accentuate its effects and even invent new colours. The light spreads over the surface of the water in golden patches, setting the horse free.

For an artist to leave the studio and face all the risks of uncertain lighting and difficult and sometimes uninspiring subjects was no longer enough, especially for one so weary of his own times. He needed to escape from himself and travel far away. He needed his painting to become a space in which another kind of truth would be revealed, in which life became less transitory, and settled back into the world of mythology. His work would spring from within himself. All that nature had to offer in the way of forms and colours would be measured by this one yardstick: that everything under the sun is no more than a decoy for a higher reality, some sort of lost innocence.

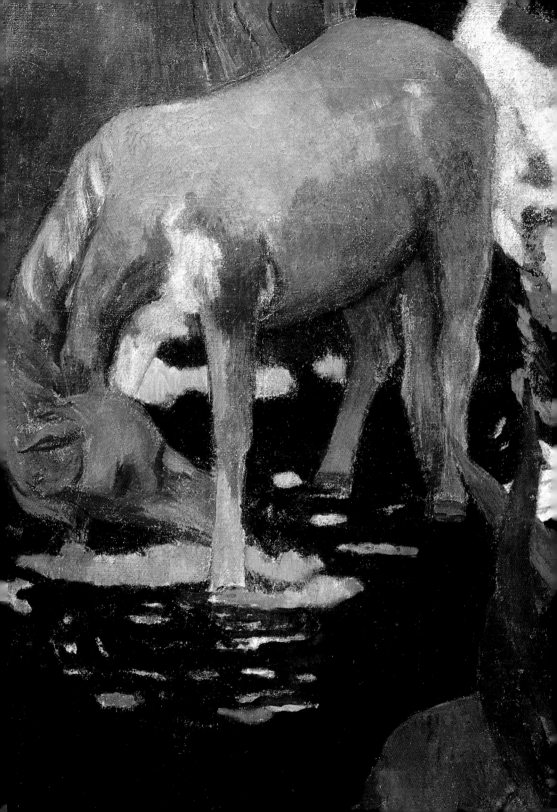

Gauguin's painting does not give us a common experience of the visible world, which is what Impressionism defined as the only proper function of art. However, he too is dissatisfied by the ancient religious or literary sources which in the past legitimised images and the complicated stories they told. By reclaiming the importance of the artist's eye and of his feelings, he placed himself in a direct line from the Romantics, whose influence continued to make such an impact at the end of the century. But Gauguin added a whole new element to this, which was crystallised by his departure to Polynesia: from then on his work would depict a totally unknown and surprising world. Painting became an unexplored country. It was not so much the distance that mattered as the shift into a different mental space, a plunge into an interior universe that he identified as his 'primitive state'. For him the islands were the scene of a new beginning.

What Gauguin was looking for in the tropics was, above all, an anchor within a story that he could make his own; a space in which he could reinvent his own life, giving it an aura of legend, far away from the constraints of conventional life. He added his memories to what he now saw around him, all the images that he had brought with him, models whose presence can be sensed deep within all his paintings: the sculpted forms of ancient Greece find a new life beneath the tropical sun, the branches by the water form a Japanese poem. He would dig out other figures from ancient tales, the ones that said that the gods still existed and that they came to visit men in the middle of their nightmare-filled sleep.

The messianic role of the artist, as envisaged by Gauguin, lies at the core of these works, which as though tired of merely representing nature, appear to re-imagine it in primitive splendour. He endows the young natives with the divine majesty of their ancestors, whilst the animals are bathed in the light of a primeval era, before their colours began to become impoverished and static. It is another Genesis, but this time there will be no sin and no fall. This is what the painting is: a lair containing a terrifying reality, violent, beautiful and naked. He must set off, far away, and paint an extraordinary, unheard of land.

A green horse

The original title of the painting is unknown; it was shown in 1905 in Paris under the title *Cheval blanc dans une rivière* (*White Horse in a River*), and in 1906 as *Cavaliers sous bois* and finally, in 1923 as *Le Cheval blanc* (*The White Horse*), when shown by Daniel de Monfried. It seems that Gauguin was inspired by the sculptures of Phidias on the Parthenon frieze – he owned a photograph of a plaster cast of it. This was a frequent habit of his, showing the extent his relationship with nature was tempered by his many artistic influences, mainly from the classical area. This work was the first in a series of paintings of horses, which he embarked on towards the end of his life. The man who commissioned the work, a chemist in Tahiti, did not like the green colour of the horse, and refused to buy it. But a few years later we can find a direct echo in the work of the German expressionist Franz Marc, whose paintings of brightly coloured animals, mainly horses, also symbolise a connection with heavenly innocence.

Gauguin and the Impressionists

Gauguin came to painting relatively late in life, and he was encouraged from the beginning by Pissarro and Degas. It was they who, in 1879, invited him to participate in the group's fourth exhibition, to which he contributed a small sculpture. He then exhibited in all the later exhibitions, in 1880, 1881, 1882 and 1886. In the early days he often worked alongside Pissarro, who initiated him into the clear vision of Impressionism. He then developed, a few years later, a new 'synthetic' art, exemplified by *Vision of the Sermon* (*Jacob Wrestling with the Angel*) painted in Brittany in 1888. He was a principal figure in the Pont-Aven school of painting, opting for more and more intense colours, often arbitrarily chosen and flatly painted. He was a vigorous opponent of the neo-Impressionism of Seurat and Signac, who also showed at the 1888 exhibition. He had a volcanic and authoritarian temper and would pick arguments with his contemporaries; he was not liked by Renoir or Monet. After journeys to Denmark, Brittany, Martinique and Provence, where he worked with Van Gogh, he finally settled in Tahiti and the Marquesas Islands in 1891, far from the orderly landscapes of the Impressionists.

Gauguin the collector

At the end of the 1870s, Gauguin was a prosperous stockbroker and bought a great many paintings: 'I had a collection of all the Impressionists, which I had bought very cheaply at a time when nobody wanted them,' he later told the dealer Ambroise Vollard. We know that he owned eleven paintings by Guillaumin, eleven by Pissarro, two by Renoir, three by Sisley, as well as works by Manet, Cézanne, Degas and Jongkind. Forced to give up his work by the stockmarket crash of 1882 to 1885, Gauguin was never able to benefit from these aesthetic and financial investments, and he ended his life in poverty.

A childhood tune

Gauguin said, 'I think that man has playful moments, and that childish things are in no way damaging to serious work, indeed giving it a soft, happy and innocent imprint. [. . .] Painters have always understood horses, and Meissonnier, that great Frenchman, depicted all the positions of that noble animal. For myself, I have gone much further back, further than the horses on the Parthenon, back to my childhood toy, my wooden horse. I have also begun to hum those sweet children's tunes by Schumann: *The Wooden Horse*.'

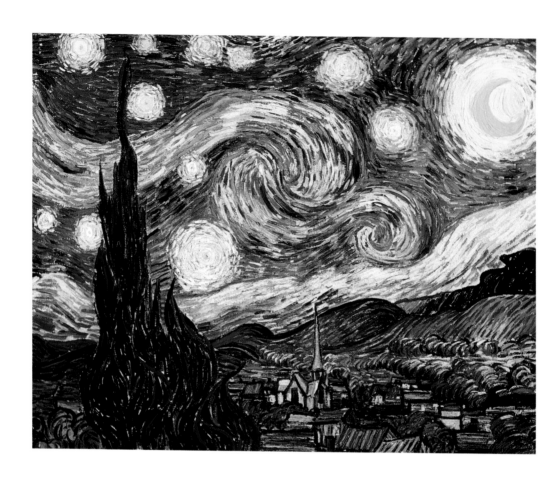

● ● ●

Being strident

Vincent Van Gogh (1853-90)
The Starry Night, 1889
Oil on canvas, 73 × 92 cm
Museum of Modern Art, New York

.

.

.

.

.

.

.

The night is brighter than the day. The darkness has released the light, which will be taken for granted and go unnoticed in the morning.

This is the darkness of the beginning of the world, a dream of Creation. A moment when the earth has hardly become separated from the sky, a memory of the chaos they formed together. The thread-like brushstrokes covering the landscape echo the movement of the planets. The paint seems to toil through heavy earth, reaching into the depths of the canvas to discover the fine webbing that lies beneath, a foundation upon which one could stand. But the great division is not yet complete; it is quite possible that the waters have not yet rolled back. The earth is struggling against all these forces, and the world is still bathed in that deep ultramarine blue that has come from a forgotten place far away.

The artist works as though he does not quite believe that the separation of the elements ever really took place. Or perhaps he is trying to return to that transitory state in which it appeared that life would soon be possible, where everything was being put in place to enable man to one day inhabit this world. This was to become the purpose of painting – to return to the origins of what was visible. The image is thus detached from the rough details of everyday life and avoids any need for ordinary anecdote, seeking only to reach eternity. It imagines the beginning of the world, and in doing so

becomes a world in itself, small and derisory, but a world nonetheless. He could rewrite it all, foretell other endings, create large peaceful paths, calm down the agitated waves of colour, or re-route them as one might do with an overflowing stream – the paintbrush is all-powerful.

The church tower, like a long shard, pierces the flesh of the sky. It is hard for the world to forget about crowns and thorns. In the eternity of heaven they must be remembered and the artist will never allow suffering to be forgotten. A couple of cypresses stand up in the wind; they huddle together, the taller one standing so straight that it seems strong enough to withstand all turmoil, and powerful enough to protect the other tree close by. Perhaps they are both truly separate from the turbulence of nature, simply acting as a link between the earth and the sky, beyond the picture itself, pointing to a direct path for man's complicated desires to reach fruition.

Here, and over there, lights shine from the windows. Some people are sheltered, living their humble lives, but, ultimately, nothing can escape the turmoil.

The stars high above spin on their own axis like toys, like spinning tops or those cardboard windmills that children hold up to the wind, or like fireworks brought from the Far East. Van Gogh rides the shooting stars, the moon flickers but holds on, surrounded by a solid light, denser and more compact than the smaller stars that take up the rest of the space in the painting. The artist has never really seen this unreal light, he just remembers what the Bible said about it, when it described the stars piercing the fragile tissue of the sky on the fourth day. But here it is no longer a question of a peaceful order controlled by divine creation; the balance of these bright lights has not yet been adjusted, and it feels as though everything could collapse in the face of this powerful surge.

It might even be the case that the crash has already taken place and the sky is now worn out and tearing itself to shreds; that everything is in fact coming to an end. The painting has been swept along into its own version of the Apocalypse, showing another kind of truth about the world, only now revealed. Van Gogh can only ride the stars towards death – he cannot reach any higher.

The paint appears to attack the landscape, forcing it to reveal what it is made of, and what dreams and terrors run through it. Here the night, usually a propitious moment for revelation, is not about to reveal gracious archangels

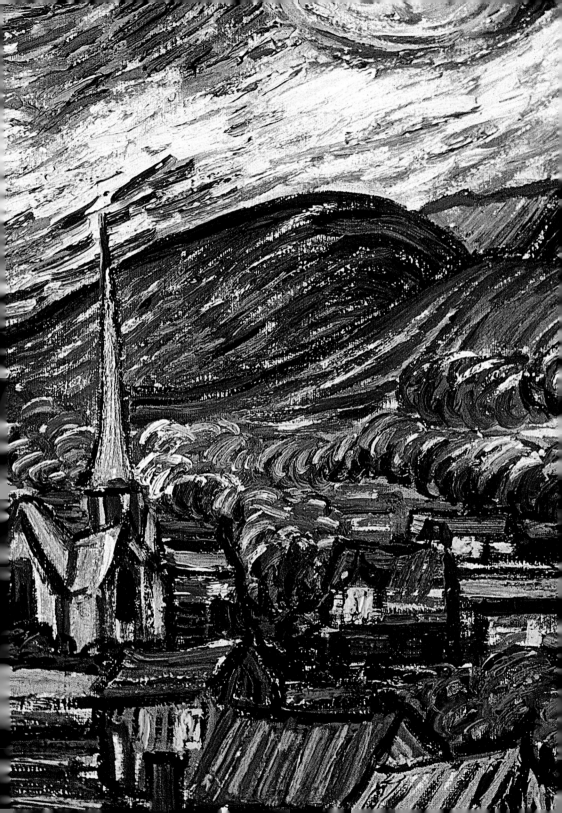

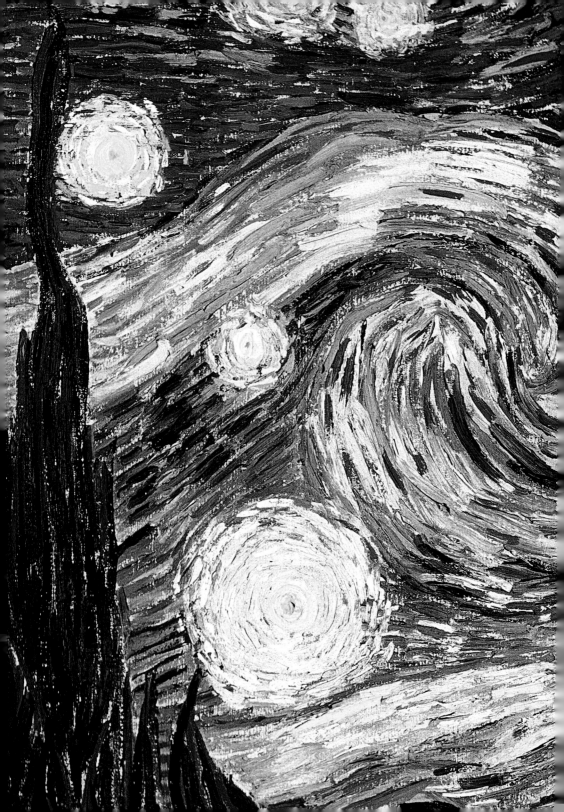

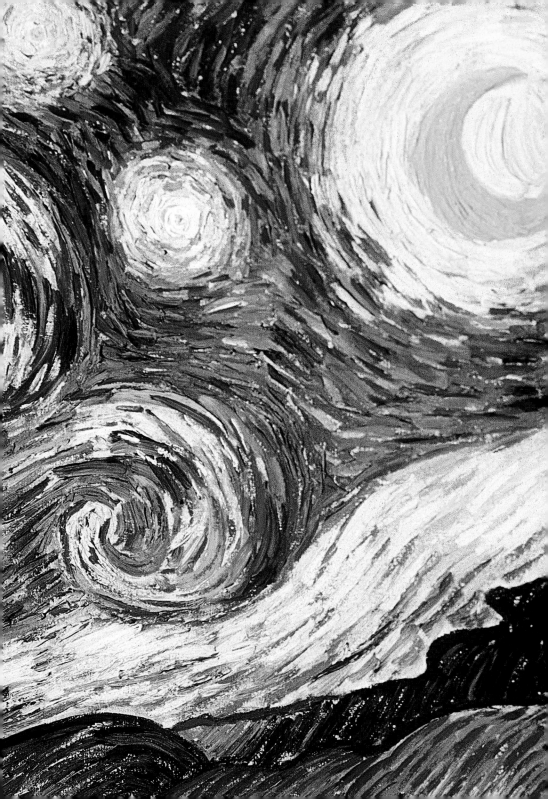

or the hand of God appearing from the heights, nor even the breath of the Holy Ghost through the clouds. There is simply a huge wave carrying away everything before it, sweeping away the remains of the thunderstorms.

The artist is not seduced by the idea of the passing moment, nor by the succession of changes in nature. The forces which are at work within the world of the senses are more important to him, no doubt because he recognises some of his own impulses there. It is a marvellous sight that he will never tire of, and that he must continue to paint, always faster. It must have been wonderfully peaceful to be able to observe the sun caressing a field of flowers, or women in light dresses walking around with their parasols, but Van Gogh could not experience that charm. It always escaped him. He never had the means with which to convey the fluidity of the passing moment, because for him life itself, the whole of life, was that passing moment. And every piece of it that could break away fell upon his shoulders like a heavy stone. That was what he had to work with.

The night inspires a secret palette. In the apparent darkness, all the colours appear, hidden in the folds of the ploughed fields or under the roofs, wrapping around the planets in skillfull brushstrokes, even giving them each a tiny orange heart. The green and the brown stretch out amongst the white clouds carrying with them the light from the undiscovered lands of the sky. Above the solid outline of the Alpilles, the dusting of stars rolls around like hair, as though having a party. It may be that the geography of the painting is a little uncertain, as though not wishing to sacrifice memory to accuracy. He does not want to have to make a choice between Dutch villages and the mountains of Provence, between the heaviness of the earth and those sudden all-knowing flashes of light. Or even between the day and the night that Genesis had torn from one another. Van Gogh seizes hold of his own suffering and traps it in the thick texture of the paint. And the night begins to dance.

An imaginary night

In September 1888, in Arles, Van Gogh painted a first version of The Starry Night, which now hangs in the Musée d'Orsay. He gives little information in his correspondence about this painting and trying to expand the range of colours usually employed to depict nocturnal scenes. Until then, these scenes were fairly rare, with the exception of the work of Whistler, which he may well have had in mind. During Van Gogh's stay in Paris between February 1886 and February 1888, he had indeed adopted the disciplined brushstrokes and pure colours used by Seurat and Signac, completely abandoning the brown earthy palette of his earlier days. He worked from nature for his first canvas, and composed a totally free and invented scene for the second, which we see here. In this period he had been admitted, at his own request, to the asylum in Saint-Rémy. He invented a landscape, seen from the window of a room, which was totally imaginary and combined multiple memories with observable reality: one source of inspiration is Hokusai's The Wave, a famous engraving whose arabesques he transposes to the skies above; another may have been drawings of comets that he saw in the magazine Harper's Weekly.

Stars and death

Van Gogh's father had been a pastor, and he himself had considered becoming, if not a minister, then a preacher. For a man so imbued with religious culture, nature represented a vast book of images laden with meaning. He wrote in a letter to Theo: 'Is this everything or is there more? Perhaps death is not the worst of prospects in the life of a painter. I declare that I know nothing about anything, but the sight of stars always makes me dream, just as, quite simply, do the black dots on a map showing the towns and the villages. Why, I ask myself, should the luminous dots in the firmament be less accessible to us than the black dots on a map of France? We take a train to get to Tarascon or Rouen, and we take death to get to a star. [...] In the end it does not seem impossible to me that cholera, gravel, consumption and cancer are just so many means of celestial locomotion, just as steamboats, buses and railways are terrestrial ones. To die peacefully of old age is to get there on foot.'

The cypress

Like all conifers, whose greenery lasts through the winter, the cypress is a symbol of immortality. In antiquity it was linked to subterranean powers and the cult of Pluto, god of the underworld, and it was seen as the tree of mourning – its flame-shaped silhouette can be seen in cemeteries all around the Mediterranean. Its scent is usually associated with holiness. When Van Gogh arrived in Provence, they were a revelation to him, as revealed in a letter to Theo in June 1889: 'I am always preoccupied with the cypresses, and I would like to make something of them, like the sunflower canvasses, as I am amazed they have never been done as I see them. They have such beautiful lines and proportions, like an Egyptian obelisk. And they are of such a distinguished shade of green. They make a dark patch in a sunny landscape, but they provide one of the most interesting shades of black, and the most difficult to get right, that I can possibly imagine. It is probably better to see them against the blue, or rather, in the blue.'

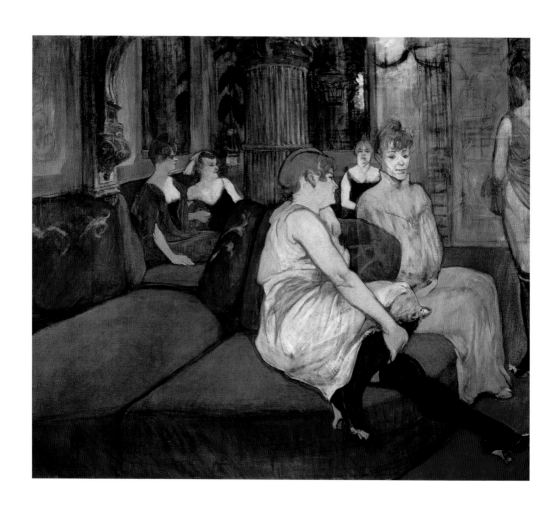

●●●●

Sharpening the line

Henri de Toulouse-Lautrec (1864–1901)
The Salon at the rue des Moulins, 1894
Oil and chalk on canvas, 111 × 132 cm
Musée Toulouse-Lautrec, Albi

The paintbrush seems to drag a little along the plum-coloured sofa. The line sharpens up as it draws the edge of an outstretched leg. The girls are waiting, exchanging a few words. It's a quiet time of day, the hours drag by; time passes slowly and it will be a long evening. Night does not really affect the warm light on the old velvet. Lautrec loves it here.

It is like a stage setting: ridged columns, a mass of panelling, the warmth of lamps that are never turned off. They could pretend to be somewhere else, pretend to be beautiful, or to be someone important – put on a feather boa, a top hat and a monocle, and the story would begin. But there are no performers here and no audience, just clients, some of the time. Today there is the soft atmosphere of a cellar with dimmed lights; it is a sort of shelter.

The sharp lines define a disappearing profile, glide over a light dress, stroke the thigh of the girl who is too warm and who was just about to enter the picture. She will remain between two worlds. Neither in nor out, neither naked nor clothed. Not quite present, just wandering around to get a bit of air. The others prefer sitting down. The passing time seems to sink between their shoulders, and in the end the sofa seems hard, too uncomfortable and old. It is a symphony of purple, black and white, and grey. There is a lot more grey than you might think, because of the colour that has sunk into the

canvas, the light that has been swallowed, digested and lost, exhausted, in the purple. Someone's make-up is running. One pencil stroke rescues it and quietly restores an expression. The artist borrows some powder, adds it to the waxy cheeks, adds a little bit more white, perhaps some pink if there's enough left. That's his job.

Lautrec is a regular here. He knows everything about these moments, these times of rest. The girls allow themselves to be drawn at random, legs in black stockings, chignon collapsing, an uncomfortable smile. He catches what- ever he can, more than they could have imagined at the start; they are unaware of the energy of these fluid lines he captures. They will discover in these images all the gloomy elegance of those endless afternoons. They know he will come back and start again. That is why he comes, he can't stop himself, any more than they can change their lives.

He is a long way from the family gatherings and flowery gardens of the Impressionists. What use would the modern city and its noises be to him? What would be the use of a studio when he can settle on a sofa here, and abandon himself to these girls who pay no attention to him? He remembers Degas who, pencil in hand, would spend his evenings at the café-concert or at the Opera, and who, just before him, had instigated a new world parallel to the recognised artistic repertoire. He too had made countless sketches, brief notations, finally selecting not the most beautiful drawing, but the richest, the most nourished, the one which summed up all the others. Time flies by but he does not seek to hold it back. Let it pass then, leaving no traces, no matter how smooth and richly coloured it might be. If only it would go by even faster, so that you needn't feel it grinding in your bones. But the years pile on, one after another, and weigh heavily, so that in the end even sensation will be exhausted. The spirit will be numbed by the muffling effects of wine. The artist loses sight of himself, his picture stops him from falling over. The girls know what to do, and thanks to them he clutches on to these weightless walls.

The painting has taken possession of this place, taking over the saloon with its velvet covers worn thin by the hours of waiting, with its look, from certain angles, of a disused old palace. Art seems to have become a refuge for transgression, and it is nothing like a dream. Less than half a century earlier, a Romantic such as Delacroix would imagine a marvellous Orient, mingle it with his own memories of travel, and spend the rest of his life drawing inspiration from them for new images. Violence and sensuality played an important role, made acceptable by geographical distance and a

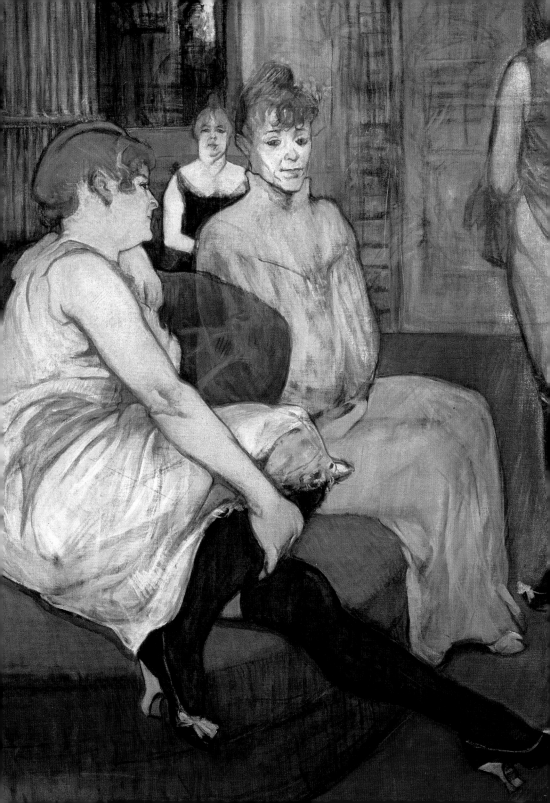

literary atmosphere. Even though respectable society was sometimes shaken, it was able to allow these excesses as the manifestation of a feverish sensibility, for which exoticism offered an outlet. The artist himself remained a highly respectable figure, a well-educated man, completely in control of himself. It was his painting that allowed him to unleash the passion that would have damaged him if he had indulged in it in real life. This outlook was in itself revolutionary, but, seen from the saloon in the rue des Moulins, it already seemed a long way away. It now appeared cautious, and indeed false.

An artist's work is often confused with his real life, and the liberties that were taken with tradition were often seen as proof of a dubious moral nature. In the middle of the eighteenth century, people were already accusing Boucher of being disreputable because he painted pictures of saucy nudes; he was in fact a sensible man, aware of the tastes of the time and the expectations of the public. Delacroix, too, was regarded as a madman be-cause of the savagery of his canvases, and more recently still, the wildest accusations had been levelled at Manet, who was seen as a hairy, foul-mouthed bohemian, shamelessly exposing naked women to the public eye. In fact Manet, with his clear-eyed vision, was the epitome of elegance.

However, what had long been feared had finally come to pass: in Lautrec the distinction between man and artist had disappeared. What he was and what he drew were one and the same thing. Instead of creating another world through his art, he made the paintings the receptacles for his own existence with all its misguided searches, its losses, its tenderness and its cruelty. It would be pointless to look for exact biographical clues: these are simply places and situations, just so many truths being demonstrated. The artist is his own subject, and the space of the painting is a private space in which he will always remain.

The artist marks the surface, almost scratching the girls, but without hurting them. He catches the solid lines of their movements which are defined by mechanical repetition. To that extent the work captures the essence of all their basic gestures with a few clear lines of drawing. The dignified air of an old princess fallen on hard times, a mocking profile, a firm naked arm. A door opens at the end of the salon. With a single gesture the artist draws and crosses out. The contours melt into the pink background, break off, re-appear, and then, imperceptibly, break up.

Lautrec's teachers

Lautrec began to draw when he was very young, and studied painting with René Princeteau, a friend of his father's. Princeteau, who was deaf and dumb, specialised in hunting scenes and horses, and was particularly interested in the expression of gesture and movement. He was a determining influence on Lautrec, whom he would take out drawing, when he was still a child, at racecourses or in the Jardin d'Acclimatation. Lautrec then joined the studio of Léon Bonnat, one of the most famous academic painters of the time. 'Your drawing is atrocious,' he would say to the young man, but this disciplined attitude towards his students in fact suited Lautrec. When he was succeeded after a few months by Fernand Cormon, who had become famous in 1880 for his giant canvas *Cain Fleeing with His Family*, Lautrec was almost disappointed: 'Cormon's strictures are a great deal kinder than those of Bonnat,' he wrote. 'He looks at everything you show him with great encouragement. You will be very surprised to hear that I like this less: in fact my old master's whiplashes used to ginger me up and make me work harder.' He attended the studio for five years, but never passed the entrance examination for the Ecole des Beaux Arts. This was where he met Van Gogh.

The rue des Moulins

The salon shown here was in a luxurious brothel near the Bibliothèque Nationale, at 24 rue des Moulins. The artist would give it as his own address. The French writer Henri Perruchot described it: 'This house, as soon as it was opened, became known throughout Europe, as it offered its clients every kind of service, from the most refined to the most eccentric. Even women, mostly rich foreigners, would visit the richly decorated salons and bedrooms. There were carved or caned beds, beds with canopies, Gothic beds, Louis XIII, Louis XV and Louis XVI beds, laid out in the midst of abundantly over-decorated rooms, full of knick-knacks, statuettes, caryatids, carved candlesticks, with walls hung with satin, draperies, panelling and mirrors. One of the beds, la Paiva's walnut bed, whose headboard was embossed with a long naked woman, was in a room whose ceiling was one immense mirror reflecting to infinity the images from the ones on the walls. A Second Empire bed, shaped like a conch, was enthroned on a parquet floor sculpted with little waves. There was a ducal chamber and a Chinese room. As for the great salon, which was decorated in the Moorish fashion, with arched doors and profuse decoration, it felt like the interior of a mosque.'

Lautrec and the birth of the poster

From the beginning of the 1890s, Lautrec's sharp style of drawing found a particularly effective outlet in the new art of the poster, which was just starting to take off. It was Jules Chéret who, in 1889, had created one for the opening of the Moulin-Rouge. In the same year, the young Paul Bonnard designed a poster for France-Champagne, which, although a much more sober composition, was a good example of drawing that was both attractive and ornamental. A poster created by Lautrec for the Moulin-Rouge in 1891 represented a new stage in the development of this emerging form, embodying immediacy and efficiency of expression. All of Paris would now see the stylised silhouettes of the stars of the Moulin-Rouge, la Goulue and Valentin le Désossé, against a frieze of spectators and Chinese shadows. Thanks to this poster the artist, who had already produced about four hundred paintings and three thousand drawings, became famous overnight. The presentation of the poster to the Indépendants in 1892 and to the Salon des XX in Brussels officially confirmed its status as an art form.

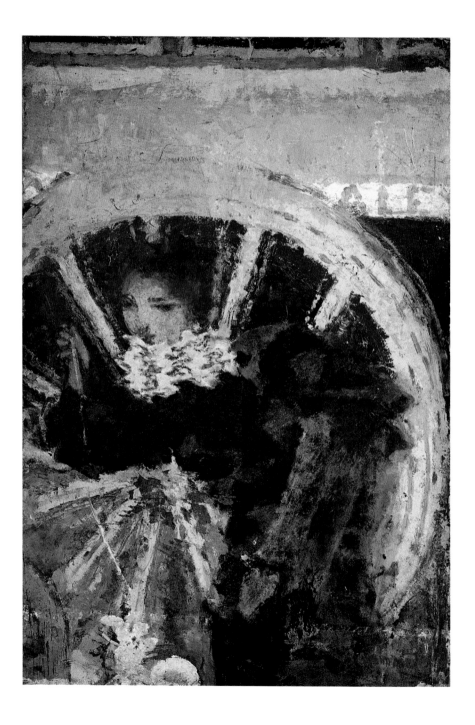

● ● ● ● ●

Wanting to be dazzled

Pierre Bonnard (1867–1947)
The Omnibus, 1895
Oil on canvas, 59 × 41 cm
Private collection

It is just a series of interconnected events, a rapid, confused glimpse of a moment when crossing the road. A young woman pulling on the lead of her little white dog, the bus passing behind her. The creamy white rustle of her collar, the black of her dress, the yellow of the bus. And, that day, the dazzling sunshine.

Bonnard captures what he can of the particular sensations of that moment and the resulting image is a little muddled and uncertain of its boundaries. He seems to be painting by guesswork, feeling his way, not wanting to state anything too clearly or draw any conclusion. He is, to a certain extent, following in the footsteps of the Impressionists, always attentive to passing time, and he reprises their rough framing of the image. But it may well be that he does not entirely share their fascination with the ephemeral: the vague silhouette of the woman and the contours rubbed with colour rather than drawn do not convey a fleeting image of a reality about to disappear. They show, rather, the painter's own efforts, both intense and light of hand, to bring stability to this image. It is as though he is fixing it on to the surface of the canvas in order to prevent it from pursuing its journey. He is gently persuading it to linger awhile, to allow him time to look at it at last. He is painting a space for possibility.

Everything happened very quickly, or rather, nothing happened at all. There is nothing to tell, and it would be difficult to explain the reason for such instability. All the painting does is record a possibility. The artist is attempting to bring everything to a halt at this precise moment. There hasn't been enough time to take a proper measure of what he saw or thought he saw, or sometimes, of what he heard, or an idea which came into his mind and disappeared as fast as it had come. The painting can intervene and enable him to adjust his view of exterior reality and pin down the present moment. He must return to the facts of the matter, and place himself exactly where he first stood, so as to rediscover what he had felt, even though it was nothing too special.

He caught just a glimpse of her. But it is not exactly her that he paints, or not her alone. He is also painting his own feelings of uncertainty, as he was about to pass her, knowing that it was already over and that he would not see her again. The painting captures that quivering moment when he knows that it is too late; that he will never be able to relive the inexplicable, and surely disproportionate, sensation that was unleashed at that moment. She is just a stranger, whose existence he knew nothing of a minute earlier, and whose absence it would be absurd to mourn. The reality which had inspired the painting has long disappeared and perhaps it wasn't that important. But what had to be painted was this mix of attraction and regret, this awareness of being tipped forward in time. He had to show, alongside the failed meeting, the little dog who wouldn't go forwards, or who had to be held back, and the bus stopping, and the splendour of its yellow paint.

For centuries, artists had attempted to capture images of things about to disappear, or to replace what had already gone. Nothing has changed, except that Bonnard also wants to suggest the power of what you see when you know that it is for the first or the last time. In that first imprecise moment, you see it only as a clumsy scrape of colour. It may also be the moment when it is about to disappear: the same spot of colour to denote both the first dazzling moment and the unbearable pain of separation. There is no pathos, no drama, since there is in fact nothing personal about all this. It is just a passing impression, a wrench that takes his breath away.

The passer-by is transformed by the wheel of the bus, but she doesn't notice, as she is too busy with her little dog with its blue ribbon. How could she know that the golden light of the street has surrounded her with glorious rays, providing her with a halo, like the miraculous figure of a saint? This chance juxtaposition elevates an everyday scene into a kind of revelation. It is not

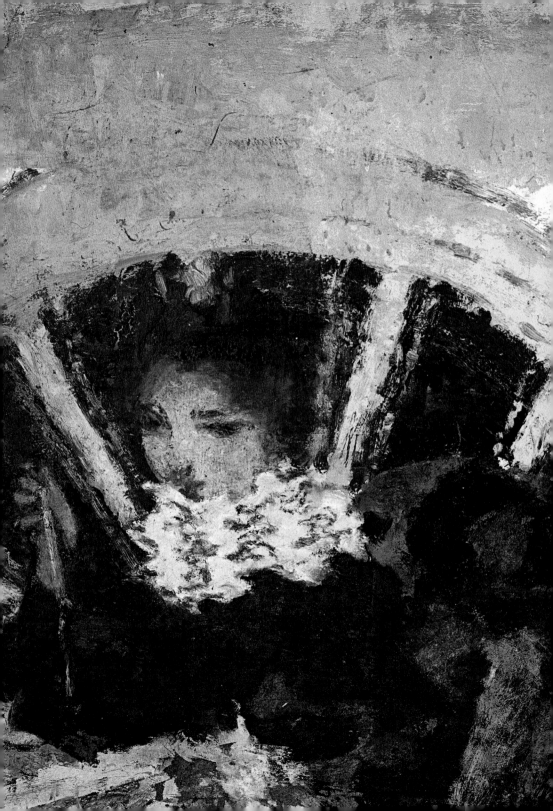

that she is exceptional or has any real significance. She is just the evidence of a sudden striking moment: that point in time, ordinary but beyond value, when everything might change. A change of direction, of nature, anything – a sign has presented itself at this precise juncture. Eventually she will cross the road, the bus will continue on its way, and she will never guess what she represented to him in the space of that short moment. She will never know that she has returned to being just another Parisian woman, charming and almost invisible in the crowd. Something unique happened, which had endowed this young woman with an almost celestial quality. It was a coincidence, an adventure without consequence and one which she was not aware of participating in.

When the artist was composing the image on the canvas, he concentrated on his model. He sacrificed anything that might have been a distraction from his enchanted vision. He seems hardly conscious of the surroundings, but in fact he orchestrates them to the smallest detail. The wheel of a carriage in the background gives an indication of how busy the street is, explaining the woman's posture, bent forward at the waist, weaving between the traffic, guiding her little dog, who is already leaving the picture. The bus is blocking the background of the image, projecting the woman towards us. The bus is also an illustration of the elusive: a slight change of position and we could have identified the name of the station which is spelled out in red on a horizontal band; and it might have been possible, perhaps, to discern other figures behind those windows, which we can only just see the bottom of. But the shapes and faces of the passengers are hidden from us. There is no witness. The writing will remain as it is, as fragmentary as the scene itself, in a state of suspense. As it is, there is no question of going anywhere else, and the artist is not interested in where the bus is going – he has reached his own destination.

She is the only figure that matters, and we come so close that we could almost touch her, so dangerously close that she becomes slightly blurred and unreal. And yet she is as present in the picture as the artist could possibly hope, in this fantasy of an impossible rendezvous.

To a passer-by

Although the atmosphere of the two pieces are radically different, one cannot avoid a comparison between Bonnard's painting and Baudelaire's poem, written in 1860 and entitled 'To a passer-by':

The deafening street roared on. Full, slim and grand
In mourning and majestic grief, passed down
A woman, lifting with a stately hand
And swaying the black borders of her gown;

Noble and swift, her leg with statues matching;
I drank, convulsed, out of her pensive eye,
A livid sky where hurricanes were hatching,
Sweetness that charms, and joy that makes one die.

A lightning-flash – then darkness! Fleeting chance
Whose look was my rebirth – a single glance!
Through endless time shall I not meet with you?

Far off! Too late! Or never! – I not knowing
Who you may be, nor you where I am going –
You, whom I might have loved, who know it too!

(Translation Roy Campbell)

A woman's step

The treatment of the material in Bonnard's painting contains its own powers of suggestion. As well as a summary depiction of a passing moment, reduced to essential forms, it conveys the presence of the figure through a sort of hesitant application and even blurring of colour, which combines with the intensity of the light surrounding her. We can see a similarity with the work of Degas, but tempered with a particular kind of delicacy. Mallarmé, writing at the same time as the young Nabis were working, evokes a similar spirit: 'the subtle secrets of feet coming and going, the spirit carried away by the beloved shadow swathed in cambric, the lace on the dress sweeping the ground as though to cover from ankle to toe, the floating movement of the woman's walk loosening the dress at the bottom, the folds thrown back behind in a double arrow-shape.' (Mallarmé, *Divagations*, 1897)

Emotional impressions

The Impressionists worked hard at accumulating several impressions within one image. Memory played an important part in their increasingly refined and rapid perception of the visible world. Several artists, including Degas for example, found that the use of drawings, sometimes with the help of tracing paper, enabled them to produce a series of works from a single point of departure. Bonnard, too, worked with these kinds of layers, which we can only guess at in a painting. He does not only use the mechanics of visual reminders here – what distinguishes this work is that he interweaves his perception of the moment with the emotional effect that the moment has upon him. Indeed we can see in his work a perfect synthesis of all the different meanings of the word 'impression', both on a physical and a psychological level. Equally, the strength of feeling and emotion succeeds in transcending the ephemeral nature of the image.

Picture credits

Acknowledgements

I would like to thank Fabienne Kriegel, editor in chief at Éditions du Chêne, who was the inspiration for this project, as well as Odile Perrard with whom I once again had the pleasure of working. Her warmth and unfailing professionalism were, as always, irreplaceable. A big thank you too to my assistant Françoise Mathay. My friend Pierre-Jean de San Bartolomé gave up a great deal of his time to read the book as it went along. His clear judgement and generosity were immensely helpful, and I am deeply grateful to him. And of course I can only express my gratitude yet again to my children and to my husband and first reader, whose patience and understanding have never let me down.
Françoise Barbe-Gall

Françoise Barbe-Gall studied art history at the Sorbonne and at the École du Louvre, where she now teaches. She also runs CORETA (Comment Regarder un Tableau), in which capacity she has lectured extensively. She is regularly invited to take part in management seminars in which she is able to draw on her vast experience not only in analysing images but also in marketing and publicity. A collection of her articles was published in Seville in 2000 under the title *La mirada*. She is also the author of several books including *How to Talk to Children About Art*, *How to Look at a Painting* and *How to Understand a Painting*, all published by Frances Lincoln.

Further reading

T.J. Clark, *The Painting of Modern Life*, Thames & Hudson, London, 1995.
Ross King, *The Judgement of Paris*, Pimlico, London, 2007.
Edward Lucie-Smith, *Toulouse-Lautrec*, Phaidon, London, 1992.
John Richardson, *Manet*, Phaidon, London, 1992.
Keith Roberts, *Degas*, Phaidon, London, 1992.
John Russell, *Seurat*, Thames & Hudson, London, 1965.
Belinda Thompson, *Impressionism: Origins, practice, reception*, Thames & Hudson, London, 2000.
Ingo F. Walther, *Impressionism*, Taschen, Köln, 2000.
Daniel Wildenstein, *Monet and the Triumph of Impressionism*, Taschen, Köln, 2000.

Bibliography

General books and essays

Gaston Bachelard, *L'Intuition de l'instant,* Gonthier, Paris, 1975.

Charles Blanc, *L'art dans la parure et dans le vêtement (The Grammar of Painting and Engraving),* H. Laurens, Paris, 1875.

Maria & Godfrey Blunden, *Journal de l'Impressionnisme,* Skira, Geneva, 1973.

P.-L. Bouvier, *Manuel des jeunes artistes et amateurs en peinture,* F. -G. Levrault, Paris, 1827.

Jean-Philippe Breuille (ed.), *L'impressionnisme et la peinture de plein air,* 1860–1914, Larousse, Paris, 1992.

Alain Corbin, *The Lure of the Sea: The Discovery of the Seaside, 1750-1840,* Penguin, London, 1995.

Whitney Chadwick, *Women, Art, and Society,* Thames & Hudson, London, 1990.

Louis Delaistre, *Cours méthodique du dessin et de la peinture,* Carilian-Goeury, Vor Dalmont, Paris, 1842.

Jean-Louis Ferrier (ed.), *L'Aventure de l'art au XIXe siècle,* Chêne, Paris, 1991.

Michel Fleury, *L'Impressionnisme et la musique,* Fayard, Paris, 1996.

Pierre Francastel, *L'Impressionnisme,* Denoël Gonthier, Paris, 1974.

Frédéric Henriet, *Le Paysagiste aux champs, impressions et souvenirs, texte et dessins,* Imprimerie moderne, Paris, 1876.

Charles Hirsch et Marie-Madeleine Davy, *L'Arbre,* Philippe Lebaud, Paris, 1997.

Horace Lecoq de Boibaudran, *L'éducation de la mémoire pittoresque et la formation de l'artiste,* H. Laurens, Paris, 1920.

Sophie Monneret, *L'impressionnisme et son époque,* vol. 2, Denoël, Paris, 1979, Robert Laffont, Paris, 1987.

John Rewald, *Histoire de l'impressionnisme,* Albin Michel, Paris, 1955.

Witold Rybczynski, *Histoire du Week-end,* Liana Levi, Paris, 1992.

Meyer Schapiro, *Style, artiste et société,* 'Les pommes de Cézanne', Gallimard, Paris, 1982.

H. & C. White, *La carrière des peintres au XIXe siècle,* Flammarion, Paris, 1991.

Exhibition catalogues

Berthe Morisot ou l'audace raisonnée, Fondation Denis et Anne Rouart, La Bibliothèque des arts, Lausanne, 1997.

Cézanne, Galeries nationales du Grand Palais, Réunion des musées nationaux, Paris, 1995.

Gustave Caillebotte, Galeries nationales du Grand Palais, Réunion des musées nationaux, Paris, 1994.

Degas, Galeries nationales du Grand Palais, Réunion des musées nationaux, Paris, 1988.

Degas, Sickert and Toulouse-Lautrec, London and Paris 1870–1910, Tate Britain, Tate Publishing, London, 2006.

Gauguin, Galeries nationales du Grand Palais, Réunion des musées nationaux, Paris, 1989.

Gauguin – Tahiti – L'atelier des Tropiques, Galeries nationales du Grand Palais, Réunion des musées nationaux, Paris, 2003.

J. & M. Guillaud (ed.), *Degas. Le modelé et l'espace,* Centre culturel du Marais, Paris – New York Éditions, 1984.

Hommage à Claude Monet, Galeries nationales du Grand Palais, Réunion des musées nationaux, Paris, 1980.

Impressionnisme, les origines, 1859-1869, Galeries nationales du Grand Palais, Réunion des musées nationaux, Paris, 1994.

L'Impressionnisme et le paysage français, Galeries nationales du Grand Palais, Réunion des musées nationaux, Paris, 1985.

Le Japonisme, Galeries nationales du Grand Palais, Réunion des musées nationaux, Paris, 1988.

Les paysages de Renoir, 1865-1883, 5 Continents Éditions, Milan, 2007.

Manet, Galeries nationales du Grand Palais, Réunion des musées nationaux, Paris, 1983.

Le mystère et l'éclat pastels du musée d'Orsay, Musée d'Orsay, Réunion des musées nationaux, Paris, 2009.

Henri Matisse, 1904-1917, Musée national d'art moderne, Centre Georges Pompidou, Paris, 1993.

Nabis, 1888-1900, Galeries nationales du Grand Palais, Réunion des musées nationaux, Paris, 1993–4.

Pissarro, Galeries nationales du Grand Palais, Réunion des musées nationaux, Paris, 1981.

Renoir, Galeries nationales du Grand Palais, Réunion des musées nationaux, Paris 1985.

Sainte-Victoire, Cézanne, Musée Granet, Aix-en-Provence, Réunion des musées nationaux, Paris, 1990.

Seurat, Galeries nationales du Grand Palais, Réunion des musées nationaux, Paris, 1991.

Sisley, Galeries nationales du Grand Palais, Réunion des musées nationaux, Paris, 1994.

Toulouse-Lautrec, Fondation Pierre Gianadda, Martigny, 1987.

Van Gogh in Saint-Rémy and Auvers, Ronald Pickvance, Metropolitan Museum of Art, Harry N. Abrams Inc. Publishers, New York, 1986-7.

Reviews and articles

Guillaume Apollinaire, *Chroniques d'art, 1902–1918*, Gallimard, Paris, 1960.

Charles Baudelaire, *Selected Writings on Art and Literature*, Penguin Classics, London, 1992.

Jacques-Émile Blanche, *Les Arts plastiques, La troisième République, 1870 à nos jours*, Les Éditions de France, Paris, 1931.

Jacques-Émile Blanche, *Propos de peintres, 2e série*, Émile-Paul Frères, Paris, 1919.

Étienne Bricon, *Psychologie d'art, les Maîtres de la fin du XIXe siècle*, L.-A. May, Paris, 1900.

Denis Diderot, *Salons*, Gallimard, Paris, 2008.

Gustave Geffroy, *La Vie artistique*, Dentu, Paris, 1892–1903.

Joris-Karl Huysmans, *L'Art moderne / Certains*, 10/18 (Union générale d'éditions), Paris, 1976.

Émile Zola, *Mon salon, Manet, écrits sur l'art*, Garnier-Flammarion, Paris, 1970.

Monographs

Albert Boime, *Van Gogh, 'La nuit étoilée', l'histoire de la matière et la matière de l'histoire*, Adam Biro, Paris, 1990.

Christian Geelhaar & Marie-Louise Krumrine, *The Bathers*, Thames & Hudson, London, 1990.

Gustave Geffroy, *Claude Monet: sa vie, son œuvre*, G. Crès, 1924, Macula, Paris, 1980.

Henri Loyrette, *Degas*, Fayard, Paris, 1991.

Henri Perruchot, *La vie de Toulouse Lautrec*, Hachette, Paris, 1958, Le Livre de Poche, Paris 1962.

Henri Perruchot, *La vie de Cézanne*, Hachette, Paris, 1956, Le Livre de Poche, Paris, 1967.

Henri Perruchot, *La vie de Manet*, Hachette, Paris, 1959.

Henri Perruchot, *La vie de Seurat*, Hachette, Paris, 1966.

Jean-Pierre Richard, *Proust et le monde sensible*, Seuil, Paris, 1974.

Ralph Shikes & Paula Harper, *Pissarro*, Quartet Books, 1980.

Literary works

Charles Baudelaire, *Les Fleurs du mal (The Flowers of Evil)*, 1857.

Jules et Edmond de Goncourt, *Journal, Mémoires de la vie littéraire*, 1887–96.

Joris-Karl Huysmans, *Les Sœurs Vatard (The Vatard Sisters)*, 1879.

Stéphane Mallarmé, *Igitur*, 1869, *Divagations*, 1897, *Un coup de dés*, 1897.

Marcel Proust, *À la recherche du temps perdu (In Search of Lost Time)*, 1913–27.

Paul Valéry, *Degas, Danse, Dessin*, 1938.

Émile Zola, *L'Oeuvre*, 1886, *La Bête humaine*, 1890.

Artists' writings and correspondence

Paul Cézanne, *Letters*, trans. Marguerite Kay, Cassirer, Oxford, 1976.

Conversations with Cézanne, ed. Michael Doran, trans. Julie Lawrence Cochran, University of California Press, Berkeley, 2001.

Paul Gauguin, *The Writings of a Savage*, Viking Press, New York, 1978.

Portrait of Manet by Himself and His Contemporaries, Cassell, London, 1960.

Julie Manet, *Journal (1893–1899)*, Klincksieck, Paris, 1979.

Matisse on Art, ed. Jack Flam, Phaidon, Oxford, 1978.

Jean Renoir, *Renoir, My Father*, New York Review Books Classics, New York, 2001.

Georges Seurat, *Correspondances, témoignages, notes inédites, critiques*, Acropole, Paris, 1991.

Vincent Van Gogh, *The Letters of Vincent van Gogh*, Penguin Classics, London, 1997.

Ambroise Vollard, *En écoutant Cézanne, Degas, Renoir*, Bernard Grasset, Paris, 1985.

Frances Lincoln Limited
74-77 White Lion Street
London N1 9PF
www.franceslincoln.com

How to Look at Impressionism
Copyright © Frances Lincoln Limited 2013
Translation by Emily Read

Original edition published in French
© Éditions du Chêne / Hachette-Livre, 2010

A catalogue record for this book is available from the British
Library.

978-0-7112-3384-3

Printed and bound in China

1 2 3 4 5 6 7 8 9